TextileStyle

TextileStyle

the art of using antique and exotic fabrics
to decorate your home

Caroline Clifton-Mogg

photography by Andrew Wood

A Bulfinch Press Book • Little, Brown and Company • Boston New York London

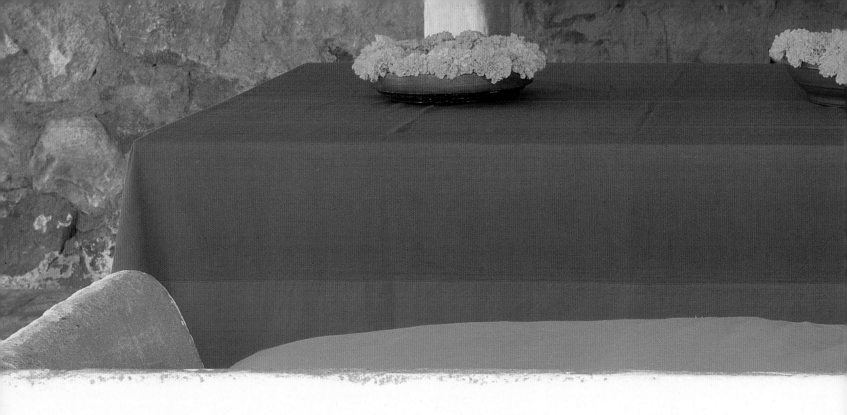

To Handsome Billie

First published in the United Kingdom in 2000
by Jacqui Small,
an imprint of Aurum Press Ltd,
25 Bedford Avenue, London WC1B 3AT

Publisher **Jacqui Small**
Editor **Judy Spours**
Designer **Maggie Town**
Location Researcher **Nadine Bazar**
Production **Geoff Barlow**

First United States Edition

ISBN 0-8212-2684-3

Library of Congress Control Number 00-104492

Bulfinch Press is an imprint and trademark of
Little, Brown and Company (Inc.)

Printed and bound in China

contents

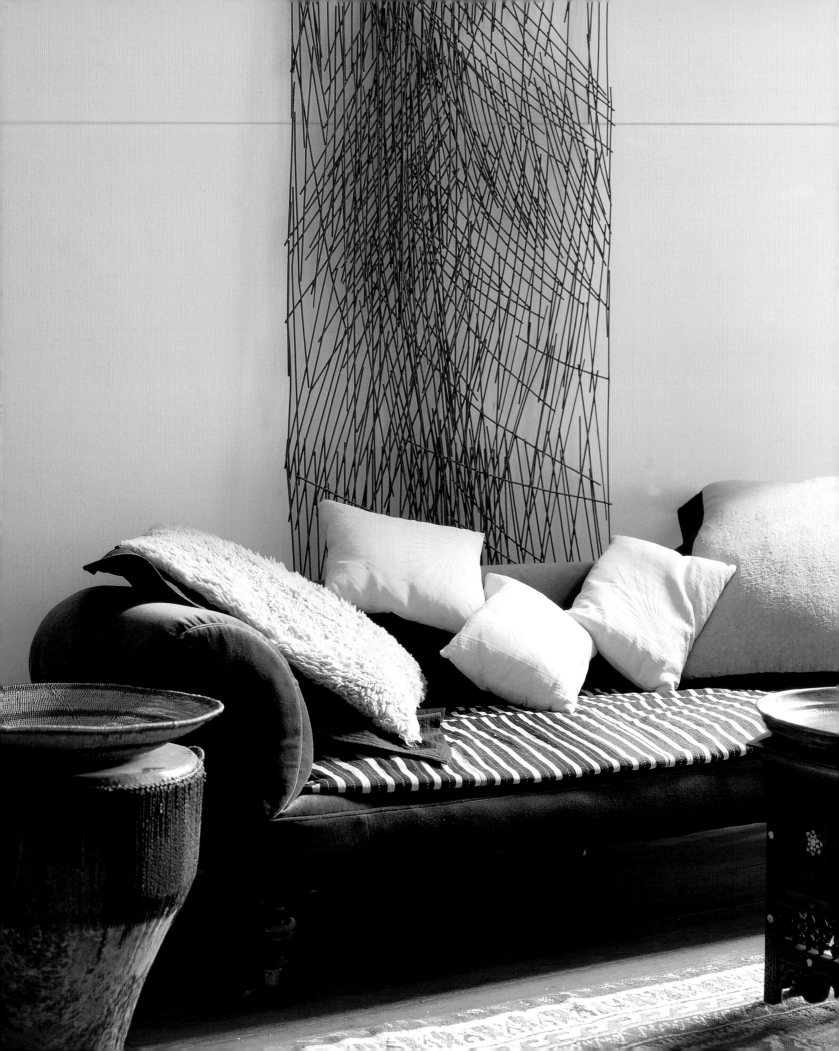

introduction

In his illuminating book, *Seventeenth-century Interiors in England, France and Holland*, Peter Thornton describes the tasks of a fourrier in the Middle Ages. Among the duties of this member of a courtly household was that of devising suitably rich and luxurious settings for the ceremonials and entertainments that were an integral part of noble life. The fourrier created them with the aid of the textiles he had at hand – wall hangings, curtains, carpets, bed hangings, padded chairs, and canopies – using them to transform a typically bare and rather bleak interior into a place of visual delight. And although perhaps not every reader of this book wishes to produce lavish, staged entertainments on a regular basis at home, it is interesting that even five hundred years ago, textiles were recognized as an extremely effective way of instantly transforming a room, no matter how unprepossessing it might appear at first sight.

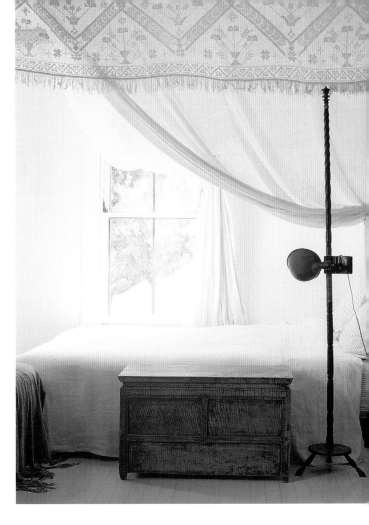

above right Romantic simplicity is achieved in an American bedroom by using a simple bed and base pushed up against the window wall and then hung with a piece of linen to make a draped curtain. A broad band of early eighteenth-century European antique crochet is stretched over it at ceiling level.

left A velvet-covered Victorian sofa is transformed into a decorative piece with a series of pillows made from such exotica as a baby's sheepskin blanket and imitation lamb's wool. In between are scatter cushions made from southern French woven bed covers. Over the sofa seat is a dark, striped *hemdira* – a traditional long Moroccan shawl.

Thornton goes on to itemize some of the ways in which the fourrier might employ his collection of textiles and hangings. He might use one or two as room dividers to break up the large space of the hall; another as a canopy under which the noble lord could sit; and perhaps he would cover the often raw wood boards of the buffet or hutch with a cloth to show off the household's collection of plate to best advantage. And he would also know how to make a retreat for the lady of the house – a bower in an alcove, perhaps, the stone window seats strewn with cloths and pillows.

It seems that the idea of using decorative textiles to change and make your surroundings charming is hardly new; but getting the inspiration for how best to use what you have, what you find around you, does not always come easy, and this book is here to help. It will not tell you to hang every textile that you find on the wall, although if you do own a particularly rare or delicate piece, this may indeed be the best idea. Serious collectors treat their textile finds as art works to be displayed as such, and revered as such.

What we are suggesting is a little less reverent; but, on the whole, we are talking about slightly less precious pieces of material. We are concerned with the chance find, the impulse buy, and how you might use and enjoy it. The advice given here will not emulate a cook book recipe, telling you exactly what to do with this small piece or that. Instead, we hope we can set you thinking by showing you the options, the avenues, and the alternatives that can often

be employed when you are using a whole variety of decorative textiles in the home.

In a way, the principles of this book can be summed up by a single piece of material, purple and white cotton, shown in all its glossy glory on page 160. Now made into a scatter cushion, it reclines, supremely confident and part of a color-toned group, on decorator Christophe Gollut's sofa in an eighteenth-century house in the Canary Islands. But in its past life – before Christophe, on vacation in Gambia, walked by and saw its flashing royal tones being used energetically by the local car washer to clean a windscreen – it was just a grubby rag. Christophe saw, quicker than most of us, it is true, what he could do with something that to others might have seemed a singularly unprepossessing textile. He proved that almost any textile has promise if treated with imagination. Anything can be something, and if you don't use it, something might remain nothing.

There is a particular charm about any textile that has been obviously hand worked. Handmade, handwoven, hand-embroidered, handpainted textiles all have an individuality that repays close scrutiny. Ever since humans first made textiles – and there is evidence that fibers were woven into cloth in prehistoric times – there has been an equal urge to decorate and beautify those bits of cloth. As a result of these endeavors, textiles have become one of the finest expressions of decorative art and they deserve to be looked at very closely. It is fascinating to see, particularly in a fairly simple

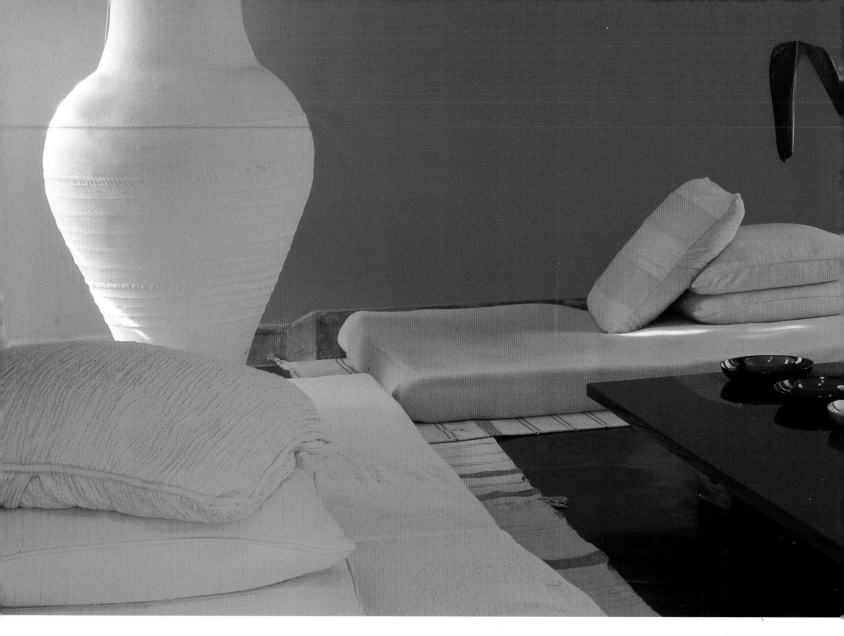

piece of cloth, how the idea of decoration and embellishment becomes all absorbing, whether it is carried out with dyes, or simply with thread and pattern.

Textiles, whether old or new and from East or West, are the elements that give a room focus and depth. Each piece is unique, and when it is used in conjunction with others, can literally transform a room. Textiles bring individuality to a space, making it personal and idiosyncratic. The breadth and range that textiles offer mean that they can be truly inspirational, affecting as they do everything from the color of the walls and furniture to the texture of the surrounding space.

The point about using textiles in interior decoration, on the walls as well as for upholstery and curtains, is that they give a depth and richness that simply can't be created with paper or paint. There is always a variation in the weave, the inherent flaws giving each length of cloth life. Used on the walls, textiles are adaptable in a way that paper and paint cannot be. They not only give a room warmth, but they also alter its proportions, depending on whether they are attached

loosely or tightly or simply used as floor-length curtains that disguise and hide and give a dramatic flow.

Using textiles cleverly is an integral part of interior design and decoration, a fact that in the decorating world quickly sorts out the mediocre from the talented. Good decorators know and understand the importance of textiles within a scheme and use them accordingly and judiciously. Of course, they use new textiles, made and sold by the yard, but almost all decorators also collect and use unusual textiles – old, ethnic, handpainted, rare, beautiful – wherever and whenever they can, as an accent or to set the theme for a whole room.

What is so interesting about using old or ethnic textiles as opposed to new fabrics is that not only is whatever you find unique, but also the way that you combine it with other elements is automatically unique, too. And it doesn't have to be expensive; in fact, cheap scraps of material can liberate you to use them in ways you might not consider if they were more precious. But if you do have an expensive piece, it can look very fine with other, cheaper, battered, and faded pieces, lifting them to its own level, investing them with

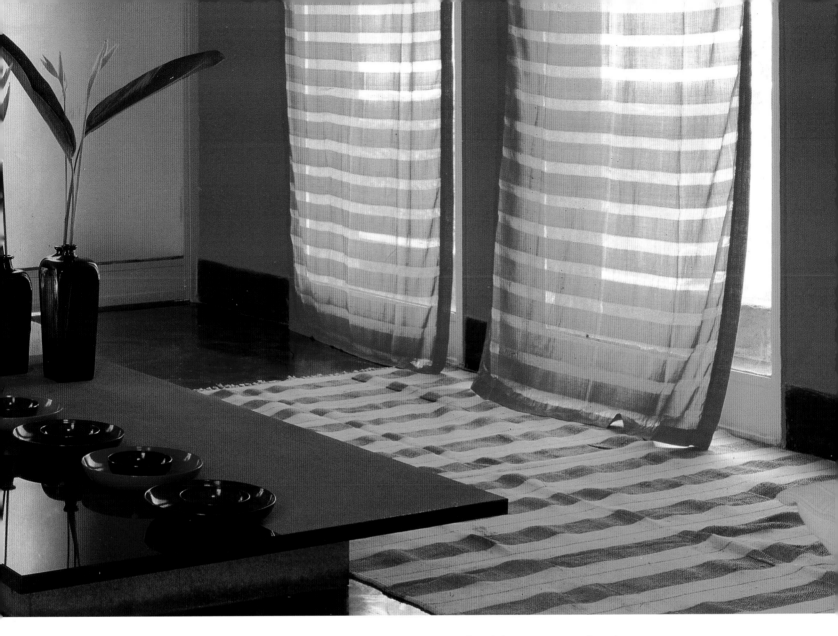

some of its own importance. Incidentally, on the subject of battered and faded, a decorative textile is still decorative when it is frayed or worn. Textiles are fragile, frail by their very nature: they were never intended to last forever and were often recycled mercilessly. In eighteenth-century Europe, rich embroideries were destroyed when they had worn out in order to recover and re-use the precious metals, gold and silver, and stones incorporated in them. The pieces you find therefore may not be perfect, but don't spurn them on that account. Their flaws add to their charm. It may be that for the investment collector, perfection adds value, but for the rest of us, perfection is almost too good.

A group of textile-led furnishings – a bedcover, a pile of pillows, for example – can be put together with reference to color and to similarity and contrast of texture rather than merely by matching them according to their style or period. And the variety of textile combinations is infinite. Within a group, old and new can be used together, particularly if they have another theme in common. For example, printed materials, perhaps old chintz and new chintz – flowers over

everything – work well, and the interest comes from the combination and contrast of colors and tones, some faded, some new-bright. Geometrics, bright new stripes and old faded ones, mixed with varying and various checks of different pedigrees and ages are also attractive. Woven textiles can be mixed together very successfully.

In the textile collecting world, small is definitely beautiful. There is no such thing as too small a piece, as many collectors will attest. Never make the mistake of not buying something just because there is not very much of it. The next customer may be a decorator, and he or she will certainly buy it on the basis that it is better to have it than not and that if it is nice enough, you can always use it somewhere. Actually, collectors of textiles often appear to suffer from remnant fever, a disease akin to that which afflicts people obsessed by yard sales. Remnant-fever sufferers can be found everywhere, snuffling and grubbing through any likely pile of old bits of material – even, shockingly, going through other people's scrap bags! These enthusiasts never turn down the chance to acquire the smallest piece of tapestry, a scrap of

above In a living room in India, textiles are used to create mood as well as decoration. The low mattresses for sitting and reclining are covered in heavy crinkled Indian cotton known as *khadi*, originally popularized by Mahatma Gandhi. The piles of stacked pillows are also textured *khadi*, ornamented with pleats and tucks. Cotton *dhurries* lie beneath windows that are very simply hung with lengths of hand-woven, sheer raspberry cotton with a self-stripe. Although bright, the overall effect is cool and comfortable.

embroidered silk, or even a piece of old and faded but charming chintz. Good hiding or finding places for such treasures are numerous. One might be those daunting mixed lots in boxes and shopping bags at auction sales (try to view them the day before), another might be trestle tables at local garage sales, or it might even be a linen closet. Linen closets, your own and other people's, are, in fact, an almost constantly rewarding source for bits of interesting textile. In the past, most sensible housekeepers kept the leftover bit from the new chair cover or curtains just in case. And in many cases, the extra bits stayed long after the original piece of upholstery had disappeared.

The legendary, brilliant interior decorator Jean Monro, whose line of chintzes, based on early English documents and patterns, are simply the best you can buy, admits to always rooting at the very back of other people's linen closets to see just what small pieces of period, recyclable chintz might be lurking, forgotten in a dark, warm corner. (She also admits to always lifting up the edge of a slipcovered chair or sofa to see if there is an interesting, early textile underneath.) Monro's single-minded pursuit will strike a chord in the hearts of many – not just collectors, but all those who appreciate beautiful things, for most have a pile of textiles, large or small, somewhere.

You don't, after all, have to have an immediate use for a textile. Most people who magpie-buy fabrics put them away on a shelf on the rainy-day basis: better to buy now, as you never know when you will be able to use them. In addition to finding inspirational patterns, enthusiasts like Jean Monro and Christophe Gollut are interested in the history of textiles. Textiles contain, within their weaves, their embellishment, their colors, and their patterns, the whole story of interior decoration. Everything from the type to the size of the pattern or the motif has something to say about the era in which the textile was made – from medieval, heavily embroidered hangings and vestments for ecclesiastical use to Elizabethan and Jacobean hangings and clothing, still copiously embroidered but reflecting the interest of the age in flowers and fauna, nature, and the countryside. The same is true of printed materials – from those first influenced by imported designs from India such as the Tree of Life in the nineteenth century to those depicting new inventions and eminent men. Printed materials demonstrate the progression from block to screen printing across the centuries. The evolution of dye colors is also fascinating, developing from early vegetable dyes to the synthetic, bright dyes that almost literally exploded onto the market in the mid-nineteenth century.

So, look again at your surroundings, from a textile point of view. And look again at the textiles you already have. They may not be similar to those illustrated in this book – an old white tablecloth or a Gambian cleaning cloth – but there is a place in the home where they will please you and make a room or a piece of furniture look better, and where they will take on a new textile life of their own.

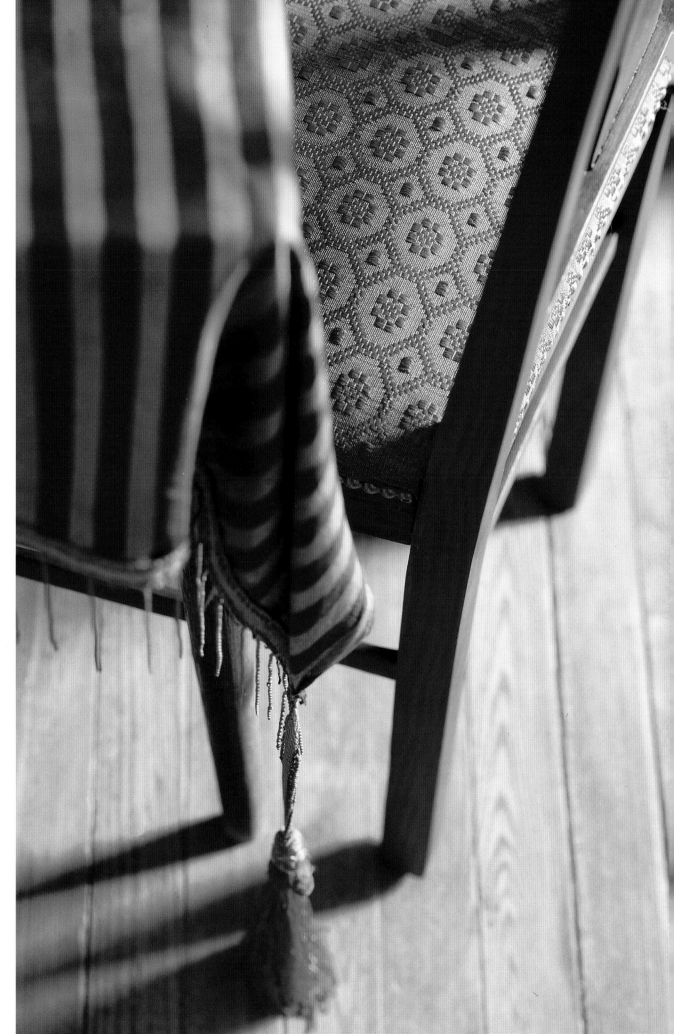

right A chair upholstered with a modern textured weave throws into relief a piece of antique woven silk from Syria, complete with tassel. Unusually, it is draped over a small square table in such a way that the decorative tassel is prominently displayed.

left A collection of valuable, early twentieth-century kimonos are kept with tissue paper between the folds so there will be no crease lines. Instead of being stored in a closet, they lie on a bench where the crisp, white tissue becomes an integral part of the decorative display.

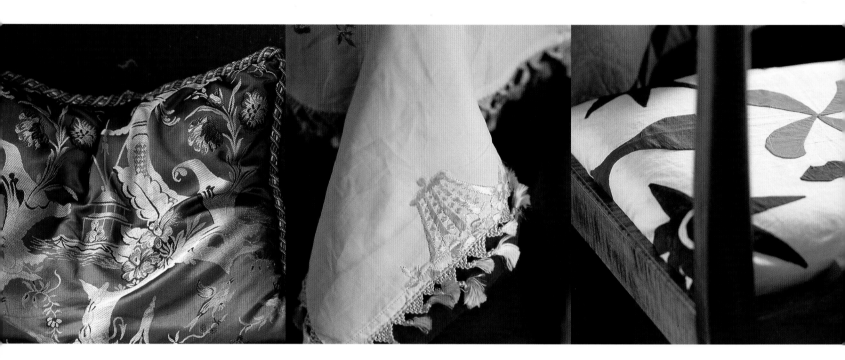

designer portfolio

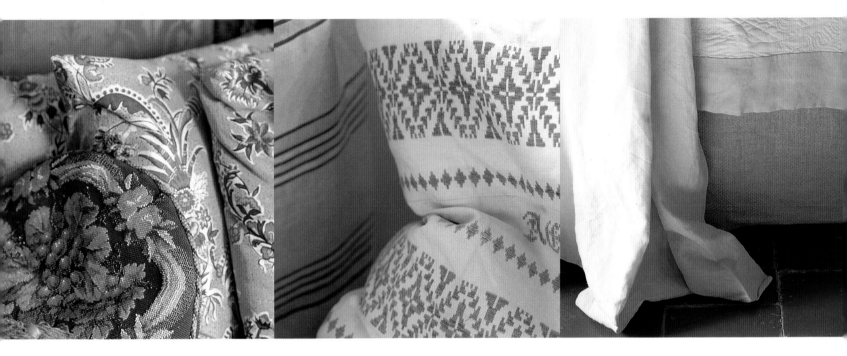

I nterior designers are trained to have an understanding of the spatial relationship between objects and to know the laws of harmony and proportion. They have the ability to make the mental leap from conventional order and balance to one where a touch of the unexpected gives an edge that lifts a scheme out of the ordinary. Designers know that every grouping of objects, every small part of an overall scheme, needs accents of color and pattern. This is why textiles are so important: within their weaves are all the tones and shades, surprises and subtleties that can quickly bring a room to life.

Designers have a highly refined perception of color that enables them to see the difference, say, between an orange-pink and a blue-pink or a yellow-green and a grey-green. Many appear almost to have a color wheel in their heads, with which they devise harmonious arrangements of tone and shade, often without particularly thinking about it. They also have an appreciation of pattern and its place in a room. A scheme put together by a confident designer may have five or six different patterns

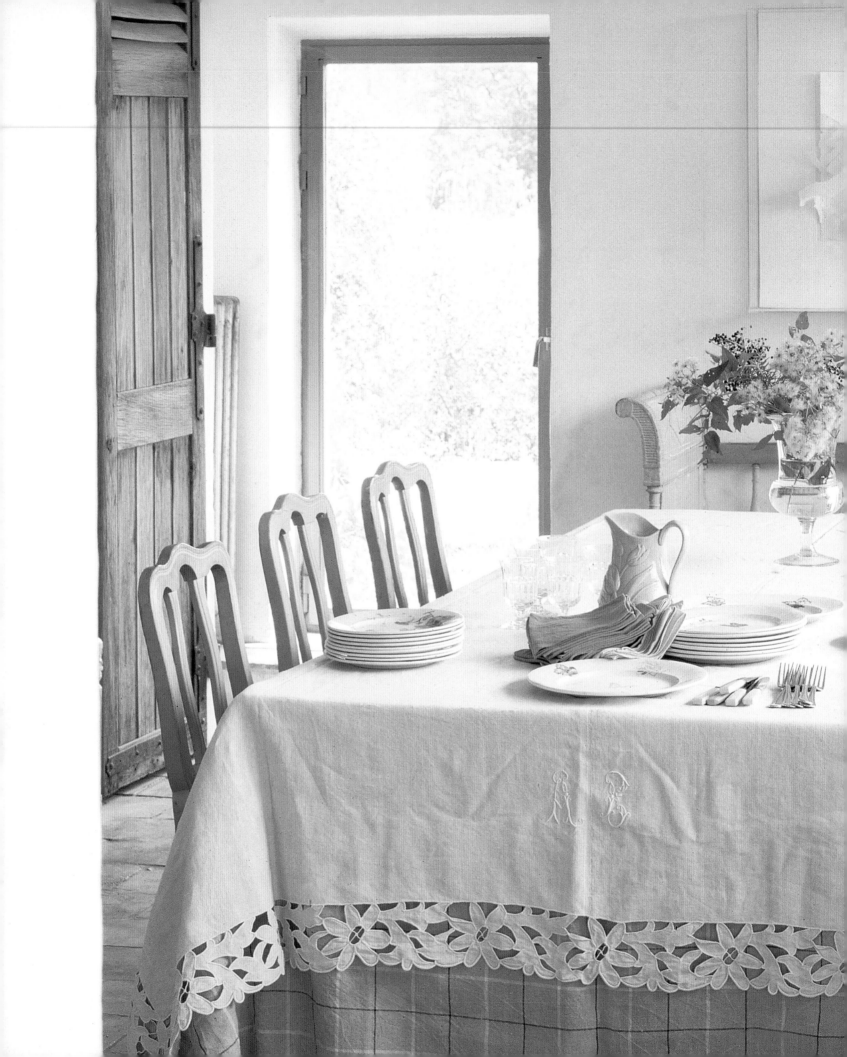

on display at the same time, even fifteen or twenty if it incorporates old and antique textiles. The impression is not one of chaos, but rather of depth and richness, subtlety and interest. Some of the textiles are used in large quantities, while others are incorporated in minute pieces, each considered for its own qualities as well as for what it can contribute to the overall design.

Each of the designers whose work we feature here has a distinctive style, favoring different color palettes, types of textiles, and ways of using them. And yet they share a deep regard for textiles. They collect them avidly and they discuss each tiny piece in detail, admiring its nuances and quirks, and appreciating its miniature charm. And, above all, all the designers understand totally the role of textiles in an interior – the fact that they can transform a room into something completely individual and unique.

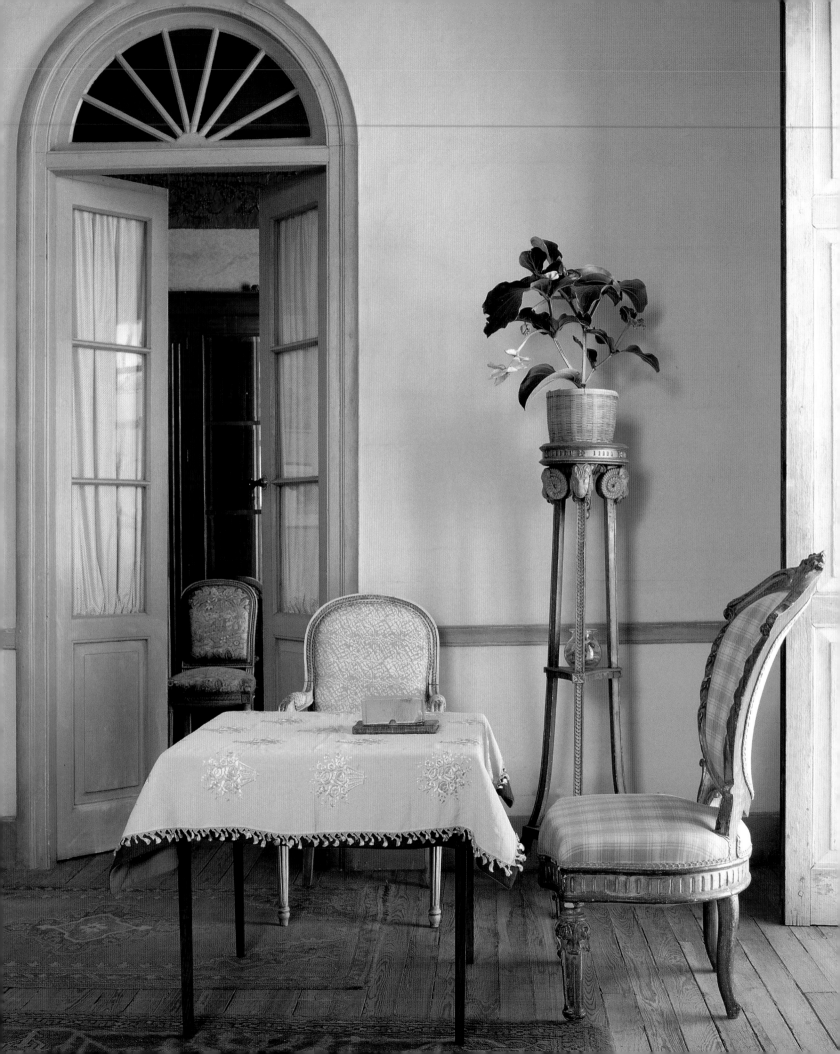

christophe gollut

Swiss interior designer Christophe Gollut, who is based in London, is one of the most confident decorators working in the field today, and in many ways his fine eye has developed as a result of his great love of textiles. His taste is first and foremost European, and he eschews the idea of fashion in interior decoration, preferring to create rooms where "everything will last about a thousand years". His talent comes from an innate understanding of textiles, of their tones and textures. His is an appreciation of the miniature, the detail in the patterns and weaves of textiles, and no piece is too small or too battered for him to make use of.

above right This nineteenth-century silk *broiderie de Fez* is charming and subtle – so subtle that it could easily be missed in a pile of other pieces. Self-colored embroidery always benefits from being used on its own, where its gentle charms can be appreciated, and from a defining trimming such as the crochet fringe used here.

below right This small antique piece is in very good condition, and it has been carefully laundered – a process that not every textile collector follows, but one that makes a considerable difference when the piece is used in a decorative scheme.

left In this interesting, understated room – of dull pink walls and blue-gray woodwork – the embroidered cloth covering a bridge table is thrown into center stage. Its uniqueness is emphasized by the very clever but easy touch of bright blue felt as an undercloth. At the table, one chair is upholstered in a contemporary pink check, the other in a contemporary print. The glass doors are lined with nineteenth-century small-print cotton.

His house in Gran Canaria is tall, cool, and shady, and textiles are used everywhere, particularly in the high-windowed, slightly formal drawing room. This is painted in the most surprising, wonderful tones of flesh pink, with Swedish-blue rubbed woodwork and a white wooden ceiling. It is original, unusual, surprisingly restful, and utterly right. Everywhere in this room there are both small fragments and larger pieces of textiles – some very old and some fairly recent, or even brand new. On a small card table, for example, is a hothouse lush shawl of pink embroidered silk dating from the end of the last century and embroidered with pale gray bunches of ladylike blooms. It was found in a street market in Fez and is a fine example of a local style of embroidery. The shawl is draped over a piece of royal blue felt, a device that has the effect of throwing the rather delicate color scheme into sharp relief, giving it the air of a table ready for poker in a frontier-town madam's parlor.

On chairs and sofas, other pieces of textile are used to striking effect. On one chair, a small scrap of paisley is carefully folded into a thick triangle with the handkerchief point making the seat of the chair. On a sofa covered in blue raw silk, an old table runner is placed with the decorative edge over the sofa seat. Then an ornate, fringed, faded pink damask sofa boasts a folded cotton damask shawl or runner with an even more elaborate fringe. Printed shawls of Indian design hang over blanket-covered tables; faded carpets lie on unvarnished wooden floors. Elsewhere, an ornate, nineteenth-century *portière*, or narrow

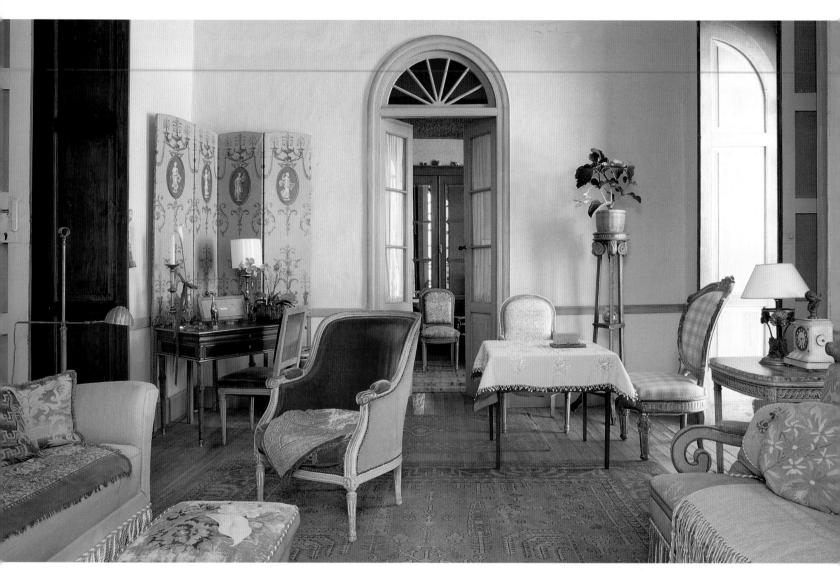

above Harmonious is the first adjective that springs to mind in this room, and it is hard to believe that there are so many different designs and patterns in the same space. One chair is upholstered with nineteenth-century velvet, and a sofa is covered with pink damask of the same period. Nineteenth-century needlework covers a wide stool. Careful color harmonies and subtle patterns make it all work, but the blend is unusual to say the least – wine, pale blue, old rose, and pearl gray.

valance, complete with gold tassels, is used as a curtain heading, attached to a reeded wooden pole and hung over an otherwise bare window.

There are pillows everywhere, unsurprisingly when you consider that Christophe says that he "must have had millions of scatter cushions made over the years". The textiles used to cover them come from all over the world and include a plum-colored cotton car washer's rag from Gambia and a new fabric from Italian designers Rubelli. "There are bits of this and bits of that in the cushions. All the fabrics used remind me of something or somewhere." There are certain textiles Christophe always buys when he sees them – any piece of needlepoint, for example. "I can always use them somewhere, even if they sit in a cupboard for years before I find the right place."

With this cornucopia of pattern and texture, Christophe Gollut shows that using textiles – whether they are old or new, primitive or sophisticated – only works really well if both the whole room and each separate little group of fabrics is considered equally carefully. A close look at the rooms he designs reveals that when different, contrasting textures and patterns are used together, they are linked by one color or tone. This message becomes beautifully clear with a glance at a daybed in the Gran Canaria house. The colors of a multitude of pillows range through every tone of purple and grape, encompassing pale mulberry and blackberry ripple. Each one is distinctive, very different from its companion, but they all live together in harmony. Christophe's philosophy for decoration involves a patience that will achieve such a harmonious look. "To make a

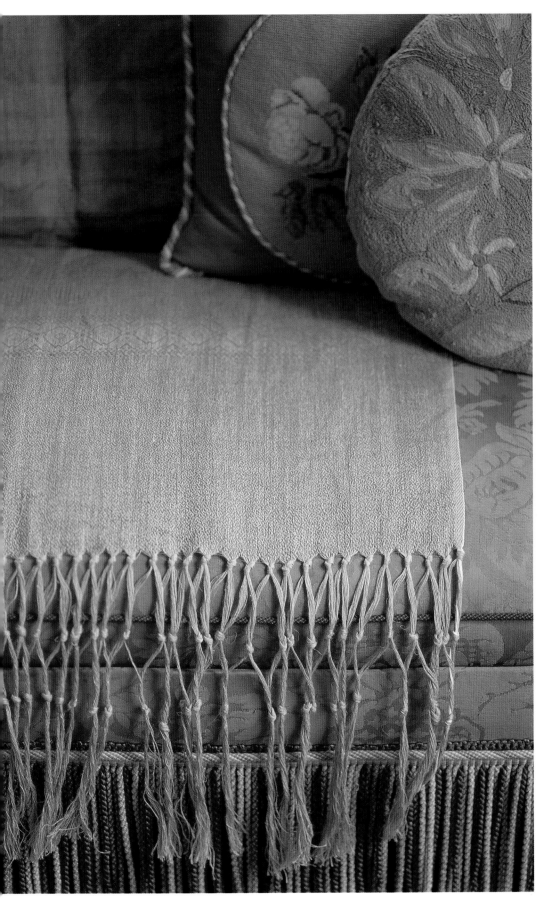

left On a pink-upholstered damask sofa, a lilac shawl with extravagant fringe is draped over the central back and seat. The cushions, ranging from Indian woolwork to old needlepoint, are chosen for their color combinations.

below A nineteenth-century velvet chair has an old paisley shawl carefully – very carefully – folded over it. The shawl is of the same period as the chair, a fact that connects the two.

house you have to add wherever and constantly, in different degrees. You have to vary your pace – too rich is boring and too much. Color is very important, and every house should be a little grand, but it should also be lived in and never precious. And that is where an interesting and changing mixture of textiles comes in – they have an ability to ground a room, to give it a personality and a presence."

left Amish quilting is instantly recognizable for its bold colors. Here the strong mustards, greens, and browns of the table quilt – in a pattern called Turkey Feather – are echoed more delicately in the appliquéd seat pieces.

below On the wall behind the antique wooden chair is a pair of the framed quilt samples that itinerant quiltmakers carried to show their skills to potential customers.

right Although wonderfully decorative, Amish appliqué quilts were originally intended to be used. Mary Drysdale continues the tradition in her Pennsylvania living room, with one nineteenth-century Amish quilt as a tablecloth, part of a baby quilt fragment as a dining chair seat, and a panel from a sampler as an arresting picture.

mary drysdale

Mary Drysdale is one of America's foremost interior designers. She has a flourishing practice, with bases in Washington and New York, where she develops her restrained and disciplined designs. Her style is not at all of the "let's try it anywhere" look. She originally trained as an architect, a background evident in her intelligent use of space and form, and in the balance she achieves in the different elements of an interior.

"Architecture is very important: for me; it's the mother discipline. I think a good home is a combination of art, architecture, and the decorative arts, and without these symbols we are left a little cold, without human reference and personal expression. Within that discipline all the elements should be used in a complementary way, not as a scramble of ideas, but with a clarity of vision, a good balance. When you decorate with textiles, it's important to analyze their character. Look at the texture, the sheen, and the repeat. Use each different textile respectfully. People should think about how to put things together: they should think about the weave, for instance, whether it works with the chair they are covering. Meaningful design is that which reflects a clear vision and shows the piece to advantage – *mettre en valeur*, as the French say."

As a retreat from a life of high-powered design, Mary has a small farmhouse dating from the turn of the eighteenth and nineteenth centuries in a wonderful, bucolic part of southern Pennsylvania, in deepest Amish country. Here she indulges her passion for textiles, for blankets and, above all, quilts – some Amish, of course, but others as well. All have in common a strength of design and color.

In the living room of the stone house, a table is covered with an Amish appliquéd

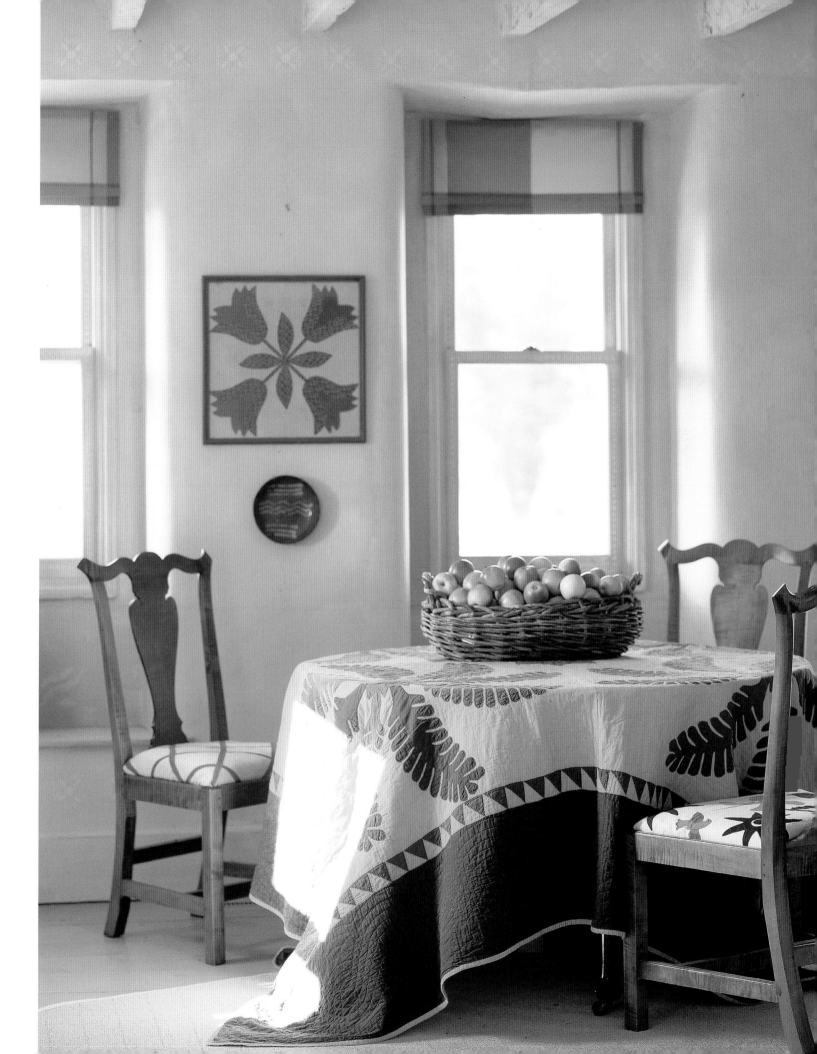

quilt; the sofa has upon it a distinctive Welsh wool patterned blanket; and a striking yellow pillow is of woven ribbons once used to wrap cigars. On the wall is an unusual quilt sampler, the sort of piece that nineteenth-century itinerant quiltmakers carried on their travels to show to potential customers as an example of their stitching repertoire. The style of the room is clean and clear, and all interest is focused on the design of the pieces themselves. Each is chosen not only to embellish and ornament, but also as a form of display, in the manner of pictorial art.

Mary speaks eloquently about her love of quilts and other textiles: "I do collect contemporary art, and that is one reason why I am drawn to Pennsylvania quilts. Quiltmaking and certain forms of art share a strong common bond, as quilts have vivid, exciting color with a clean, simple geometry. What also fascinates me about them is how expressive they are. And who made them? Amish women who wear black clothes, rarely laugh, and hardly communicate; and yet these quilts seem to me to be so strong, to speak with such a feminist voice. They take that which is ordinary, available, and pedestrian and turn it into something that is poetic and meaningful. The quilts connect you with another person's life, and each one has the spirit of its maker.

"I buy them at auction, at little shops – wherever I see them. I always know when I see one I ought to have. It's a very particular moment that you recognize if you are a collector. That single piece separates itself from all the other pieces and is irresistible. You have to look at it, to touch it, and there's another irresistible urge – to own it. I have collected things since I was a teenager, but with textiles I feel differently than I do with anything else. They're so touchable; whereas a painting is distant, a quilt is very personal. You could almost say that I feel my quilts are members of the family.

"I don't think there's anything you should never do to quilts – you can use them

anywhere. They are so practical, too: you can hang them on the wall or over a table, and when you're cold, you can take them down and put them around you! It's the handmade aspect that I like, in the same way that I prefer handpainted finishes to wallpaper."

Mary feels that there will be a renaissance, a new appreciation for handmade articles, and for textiles in particular. "The information-technology age is moving at such a rapid pace that it's tearing us from our past. I feel that there is a new wave of respect for textiles and the pleasure that they can bring."

left This subtle quilt, all soft tones of ocher and green, covers the back of a chair that has been specially upholstered in a modern weave to give the appearance of quilting in order to emphasize the stitching of the antique.

above Simplicity is always the key when using textiles as strong in color and design as these quilts. Nothing here is allowed to detract from their impact: the window has the simplest of shades and the circular rug is the same color as the wooden floorboards.

right Fragments of
faded quilts and pieces
of old Swedish striped
linen work together in
perfect, cool harmony.

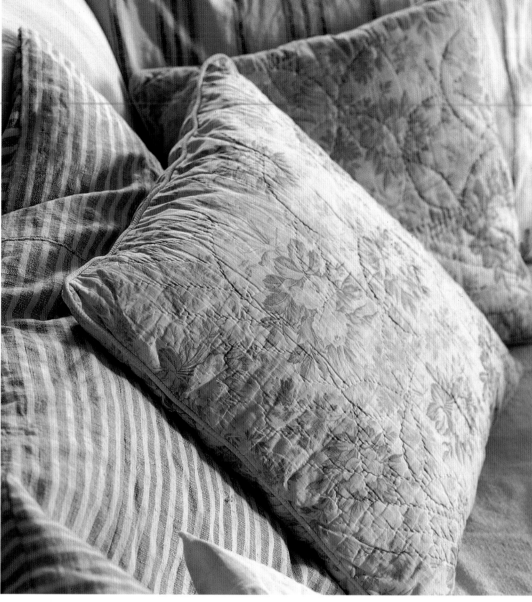

anna bonde

above On a daybed
designed by Anna
Bonde, covered with a
heavy white mattress, is
a group of pillows made
from scraps from her
collection – this time
they are pieces of old
toile de Jouy and faded
striped linen.

far right This room,
which at first sight
appears almost artless,
works so well because
the seeming simplicity is
combined with an
intensely sophisticated
approach to design.
Nothing is here without a
reason – even the apron
and hat hanging on the
wall take their place in
the overall scheme.

Designer Anna Bonde is the original hoarder – a material miser – who keeps stacks of fabric in her farmhouse in Provence. "I do have many boxes literally overflowing with bits of fabric," she admits. "Some are very special, rare and valuable, some are not so special and may be torn and have holes in them. But they are still pretty, and I like to keep them all until I can find a way to use them. The boxes act as a very informal filing system, and I keep the pieces inside very loosely characterized by color or type."

Every now and then, and certainly at the first whisper of encouragement, she takes a box out of the closet and goes through it, exclaiming with pleasure at the site of a faded lilac cretonne, or a piece of linen edged with lace. She tells the history of each – where she found it, what she thinks it might have originally been. "For some time, I had a shop in Isle sur la Sorgue (a nearby town known throughout Europe as the place for French country antiques, textiles in particular).
Now I keep collecting and also act as a design consultant for other companies. I design furniture for a Swedish company – mainly the iron sofas and daybeds that you see in the house." The pieces of furniture have slim,

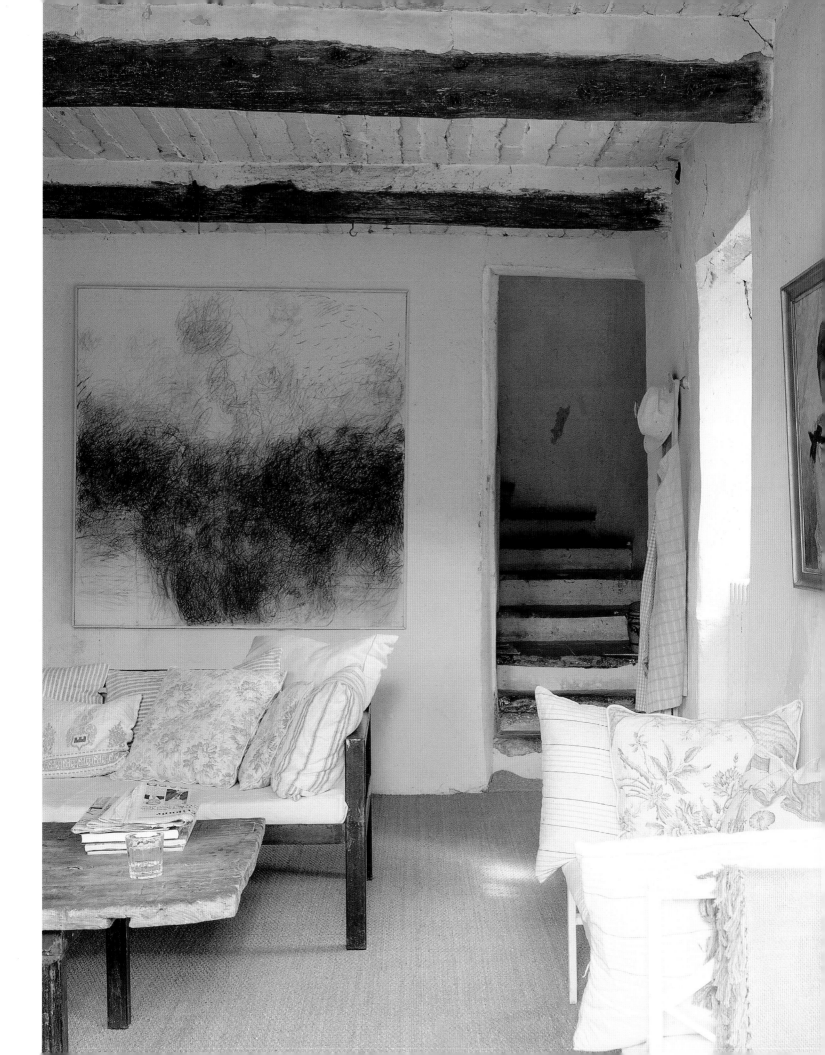

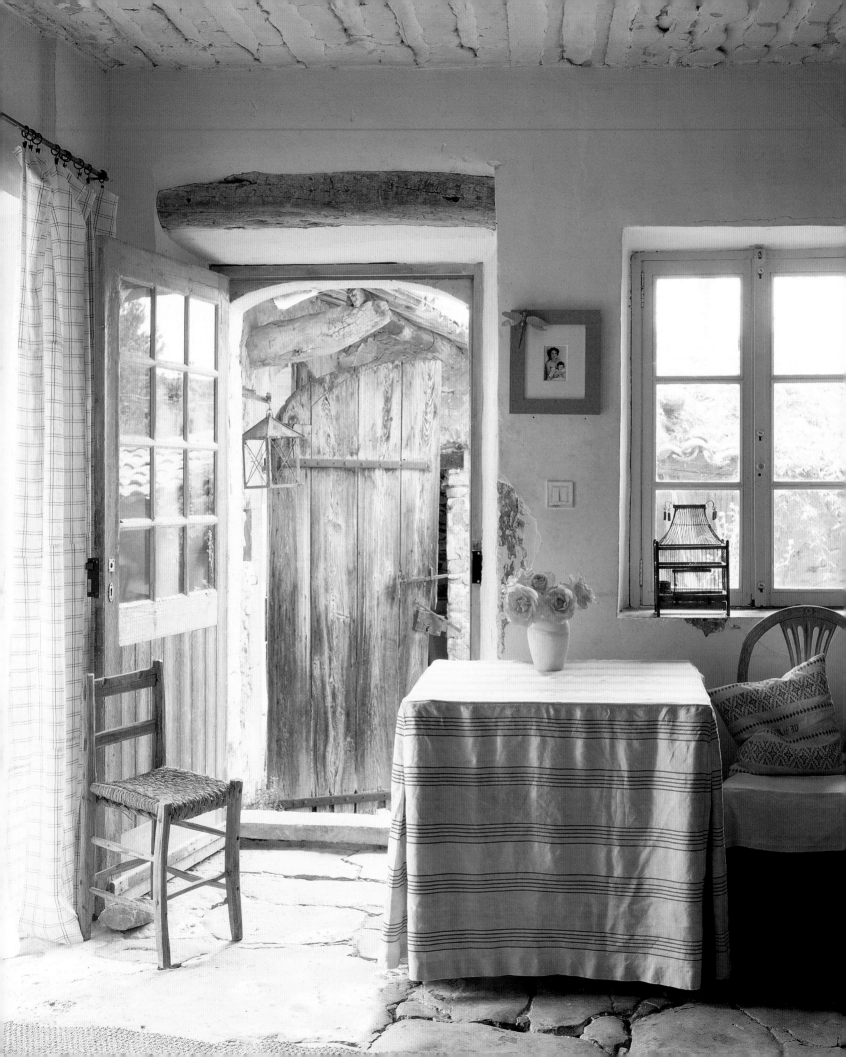

spare lines that are very much in keeping with the design look throughout, and they act as a foil for the textiles Anna drapes over them or makes into pillow covers.

Anna's house is a symphony of neutral shades, all pulled together by tones of natural, unbleached linen. She is Swedish by birth, and the cool and airy setting reflects her origins. The look is mixed with the liveliness of Provence, so the house is restful and cool, but has a powerful sense of the strong southern light that pervades every room and scheme. She combines old textiles and new scraps – often those of a rural or peasant nature – in a very considered way. The arrangement is cool in tone, but instantly attainable and immediately inspirational, particularly in its use of discarded remnants. "I like to see every piece as an opportunity. After all, I bought it in the first place because I liked it. I might use a piece of old chintz as a pillow or incorporated into a bedspread. Or I might take an old tapestry chair back – which I love, particularly the hidden inner side that you don't see – frame it and hang it on the wall. Because of its rough texture and strong colors, and its rounded shape, it looks so interesting under the glass."

Anna Bonde is tireless in finding places for unusual textiles: a very pretty painted canvas is simply tacked to the center of a rough wooden door, and another piece is made to work as a central panel on a cream linen screen. "As you can see, I love the look of this pale linen. I have lots, much of it antique sheets, and it comes in varying grades, from really coarse hemp to a very fine, delicate quality. I like to use it everywhere, both as a background and in its own right. It makes wonderful window and bed curtains, as well as covers for screens and for sofas, beds, chairs, and tables."

It is a creamy sensation of billowing calm that above all else gives the house its sense of peace and quiet elegance. In the light, cool living room, for example, an iron sofa is covered first in an old, woven, coarse linen sheet, then with pillows made from quilts and an embroidered pillow cover made from an ancestral ceremonial towel. Other pillows made from a piece of old striped linen are added. Another sofa consists of a white mattress on a daybed with pillows made from old pieces of toile de Jouy and old striped linen. "As we live here all the time, I have to make the house livable in winter as well as in summer," she explains. By the doorway is a square table for winter bridge games covered for the summer with a fitted cloth of old striped material. The floor-length windows are dressed with sheer, unlined curtains of a small-check Swedish linen woven expressly for the making of dishtowels. It is precisely this lateral thinking that gives her cool house in its sunny climate all its originality, charm, and paradoxical warmth.

above By its very nature, embroidered work is best seen at close quarters where the intricate work can be appreciated. This pillow is made from a woven piece of typically Scandinavian design, complete with monogram.

left In the living room, a run-of-the-mill winter card table is transformed in the summer by the addition of a custom-made cloth of striped linen; it immediately makes the table an attractive addition to the room. At a window are sheer curtains of a Swedish material originally designed for dishtowels.

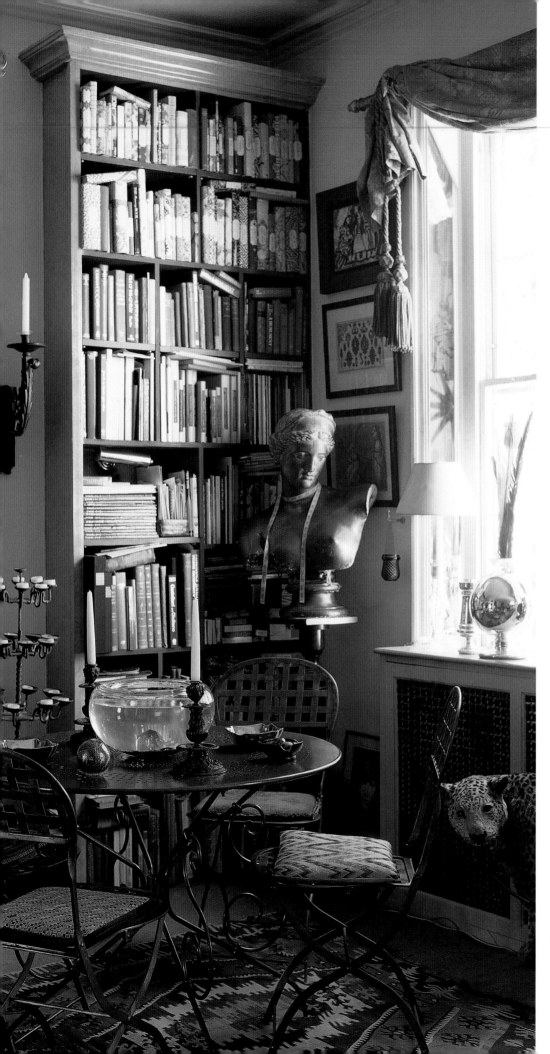

nathalie hambro

So many are her talents that Nathalie Hambro could be called a decorative polymath. She is a successful designer – of books and of handbags, many of which are made of textiles more commonly found in other guises – and she is also a writer, author of *The Art of the Handbag* and bestselling cook books. At the same time, she is also a consummate collector of textiles. Every room of her London apartment, where rich colors and patterns jostle in ever-changing arrangements, is testament to her love of textiles.

Nothing remains the same for long: a room, a corner will change its furnishings and its whole appearance almost overnight. Nathalie explains that "space is a commodity which must be adaptable and non-specific in its role. Every room in the apartment has, at the very least, a dual purpose. The apartment is designed around me and I like to live in every room. The bedroom is part living room, the living room part bedroom, and the dining room functions as an office." Amazingly, the kitchen and bathroom seem to retain their primary roles! "Occasionally I have a sudden urge, usually nocturnal, to change round all the rooms, and that is where the textiles come in; although they seem permanent, they are transient enough to be easily moved."

Nathalie Hambro mixes her textiles with verve and confidence. Although they are of many different textures, qualities, and patterns, her taste and her fine eye for color tone is evident in the way she pulls them together. And since antique and ethnic textiles are usually colored with vegetable, rather than synthetic, dyes, they all tend to fade in the same gradual manner. As a result, however different they are, there is a certain symbiosis in their appearance when arranged together. And, of course, there is a great skill involved in combining such very different pieces.

There is no question of finding that the pillows on the iron dining chairs around the small metal table in the living room are in a

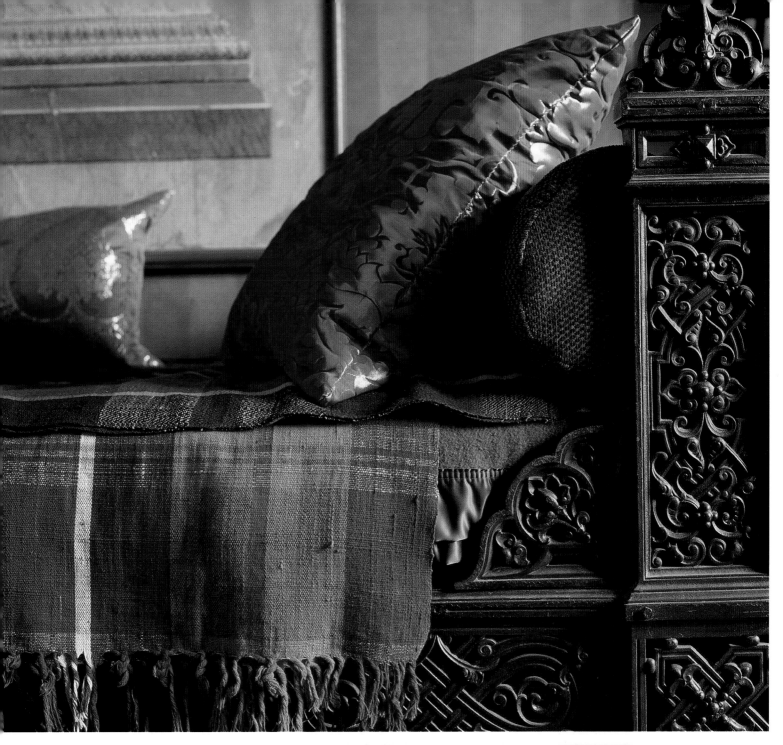

far left In a corner of the living room, a window is dressed with a length of old damask, swagged and looped over a brass pole and finished with a pair of casually hung old tassels. In the bookshelves and on the table, conventional books jostle with others covered by Nathalie in fabric or wallpaper. The seat cushions are each made from a different piece of *petit-point* embroidery, all carefully executed by Nathalie in coordinating shades and designs.

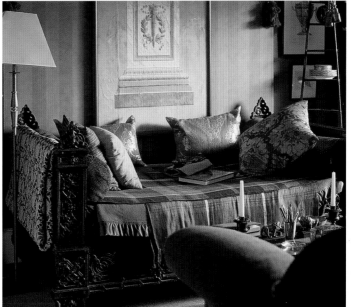

above The green blanket and two checked cotton blankets from Burma laid over each other at right angles are thrown into focus by the ecclesiastical colors of the large cushion.

left An overall view of the ornate, cast-iron daybed shows short lengths of different textiles forming a fabric mosaic, spiced with an assortment of pink and gold and red and gold cushions.

nathalie hambro　29

above and below
On a super-long divan, delicate beadwork pillows jostle with some made from a candy-store assortment of materials: striped and printed floral cottons from Braquenié and Fortuny, and French damask.

right Two single divans are placed alongside each other to become one, covered with late nineteenth-century French curtains connected by a central panel made from an old sari. The cleverest device is to dress the wall behind the divans with yet more textiles.

matching material – all are different. And in the rest of the room, the same careful insouciance links the various textiles together. As is the case with all true textile collectors, there are endless surprises: for example, only Nathalie Hambro would use antique beaded tea cozies as pillows on her inspired Eastern divan. But, after all, why not?

"I know that for many people a difficulty arises when they try to mix too many different patterns together," she admits, "but I think that it works as long as you combine ordered pattern – geometrics, stripes and checks – with the more ornate, difficult antique fabrics."

Her idea is illustrated by a wall-length divan sofa and bed – made by pushing two plain divan beds end to end – that is covered with textiles. A central pane of sari silk is flanked either side by woven ethnic textiles, which are then edged with gold and silver panels. "What I did here was to add, at each end, not bolsters but instead piles of different textiles – folded pieces of material on the bottom and then yellow striped cotton pillows on top. Above them is an assortment of draped tassels, rope, and other textiles." The advantage of such an arrangement is that not only do you have an instant bolster, but you also have portable decoration – useful if, like Nathalie, you like to change things around often. In the same room, a length of old woven damask is swagged and looped over a brass pole to dress a tall window. It isn't permanently attached, of course, and it is embellished with another pair of old tassels.

"I do see – and I know some others don't – costume as being just as important an aspect of using textiles," Nathalie adds. Hanging on a door in a bedroom is an unsettling matador's outfit, with a Venetian carnival mask hung approximately in the same place as a drooping head might be. This isn't just dress as decoration, but rather textiles as art – the addition of the mask makes the costume something that demands notice. "I have also displayed my collection of kimonos in this room. I have folded them evenly on the bench and alternated them with other bright painted silks and lengths of dyed *ikats*. The kimonos are stuffed with tissue paper; this stops the folds from creasing and marking, but also makes of them something to look at – a sort of art, I suppose.' The folded pile is indeed an art object, one wholly characteristic of Nathalie Hambro's style.

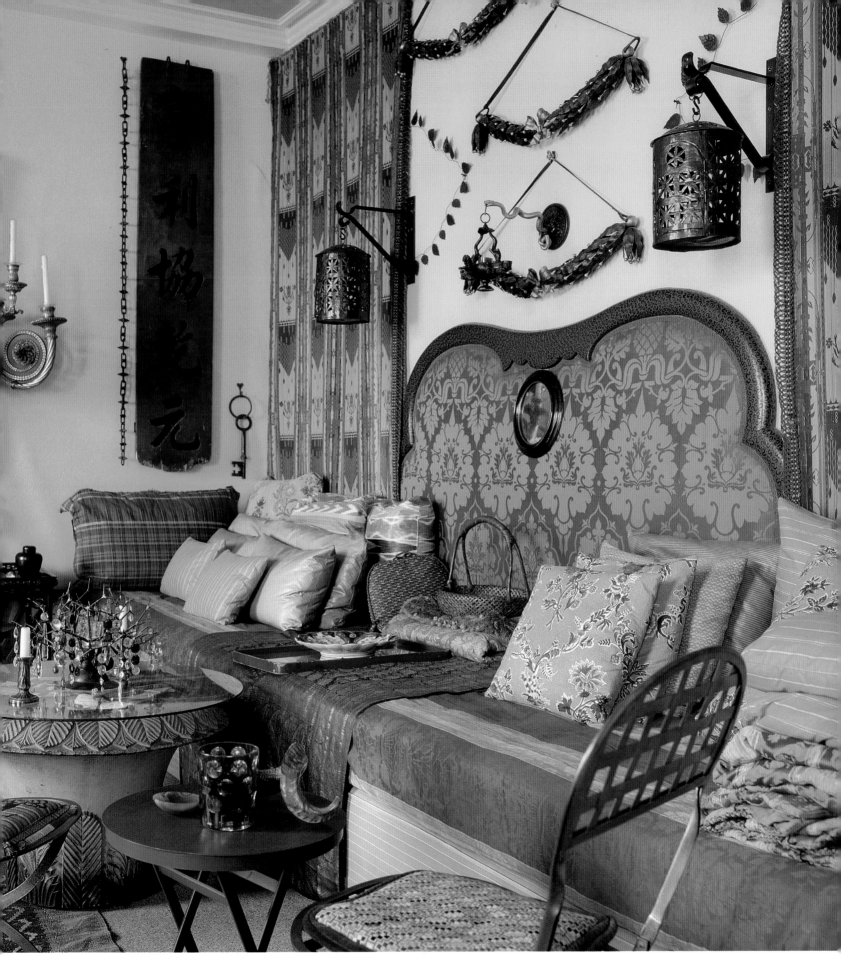

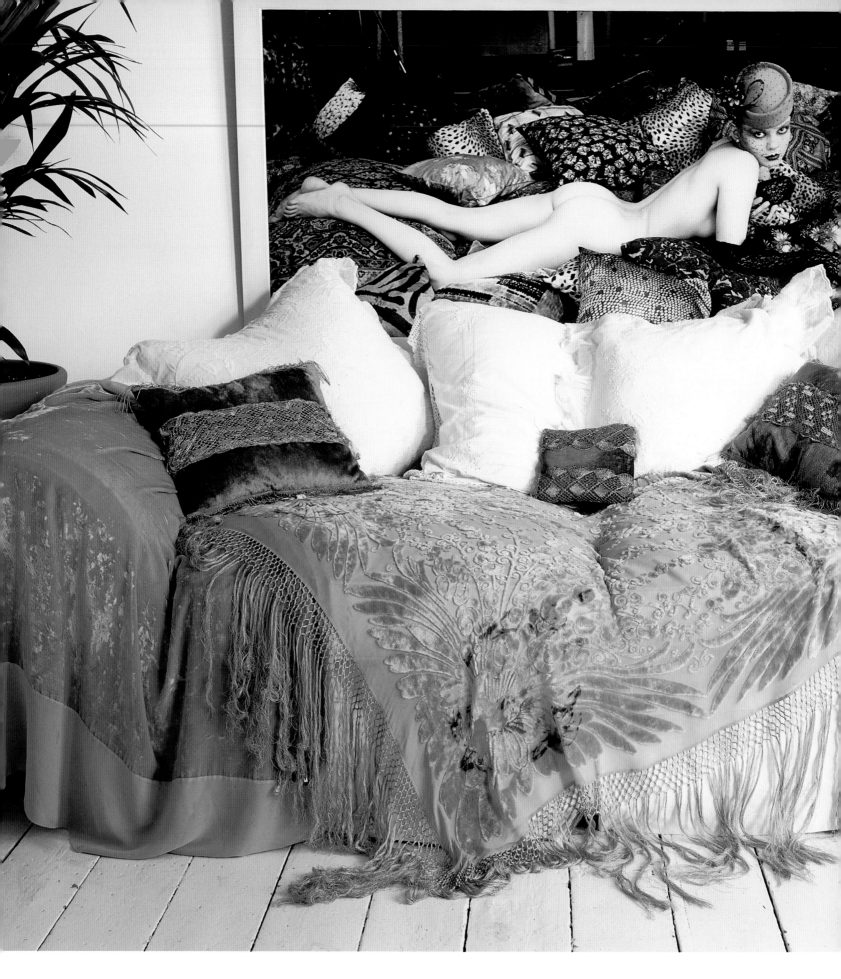

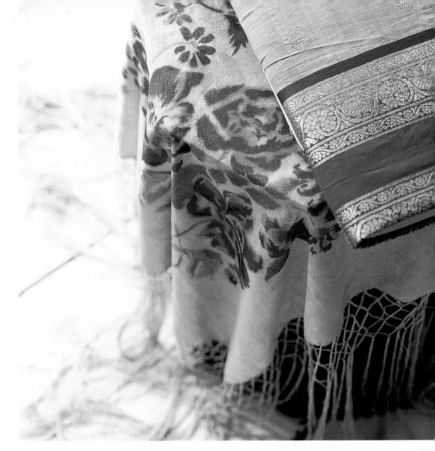

sera hersham loftus

Even in the wide world of design that encompasses so many different talents, there is no doubt that Sera Hersham Loftus is a one-off. Her base in London is an enchanted place, full of fantasy and imagination – which has almost entirely been achieved by using textiles everywhere. Their appeal ranges from the nostalgic grandeur of a velvet Edwardian opera cloak to the everyday charms of an old linen sheet, and all are used in ways that would simply never occur to most people. And even if we did think of such ideas, I doubt that many of us would be able to employ them with the same panache.

For Sera, there is no dividing line between fashion and interior decoration. "At the moment I am designing and selling a line of lampshades and I want to use things that people wouldn't necessarily think of in this context." One is made from black tulle edged with black satin and trimmed – why not? – with full-blown orchids. Another, named Eliza, is of sparkling turquoise Indian tulle, satin edging and more wild orchids. An antique lace valance is draped over more black Indian tulle, edged this time with chandelier drops and bound in satin. Then there is a

black and red rubberized satin pyramid edged with shells and an antique Indian belt. There is even a new use for fishnet pantyhose – stretching them over tulle or nylon to produce another lampshade. But they are not airy-fairy, as Sera points out: "All these shades may look like confections which will blow away in a wind, but they are properly made and firmly attached to a strong wire-based structure: they are made to last."

This romance with textiles continues throughout the house. Draped across the seat and back of one chair is a turquoise Edwardian

cloak with a high ruched collar, giving the air of a rather intricate piece of upholstery. A huge white sofa is covered with the contents of an exotic dressing-up box. On one arm is a Mongolian lamb scarf, on the other a pink silk Edwardian evening dress, while a lilac velvet fringed shawl is stretched across the seat cushions. At the other end of the living room, an iron daybed used as a sofa is upholstered in heavy white denim, covered in a white fur rug and layered with white embroidered pillows and a white marabou shawl. A red bolster is added for contrast.

One of the easiest of instant textile makeovers is to use antique shawls, as Sera does with great abandon. "I love these shawls and their combinations of color. There were so many made during the late eighteenth and most of the nineteenth centuries in both West and East, and they are easy to use today in a

decorative way – particularly since so many of them come ready ornamented with their own deep fringes." Sera likes to use her own large collection both to drape and to upholster: stools and even a large round buttonback chair have been close-covered with bright embroidered shawls. It is true that a chair upholstered in this way won't last for years, but it will look great for a while, and stretching the material across the frame does allow you to see the intricate decorative work in all its glory.

In Sera's opinion, there is nowhere shawls will not work; they can be spread over beds as decorative covers, hung the length of room-dividing screens, or even draped around plant pots. As an antidote to all this draping and swathing, she also uses long linen sheets as simple curtains at the windows and between rooms. Sometimes they are plain, and

sometimes they are topped with pieces of cutwork fringe that works as a simple alternative to a valance.

All Sera's decorative detailing stems from her love for and understanding of trimmings, although so banal a word does not really do these pieces of wonderful frippery justice. The traditional term *passementerie* is a better and more dignified description. "I love all the bits you can find," she says. "Milliner's flowers, for example. I have put a box of them on the wall – pieces of gold fringing, lace, ribbon and tassels, everything can be used." And in her design they sit on the wall like the most meaningful of contemporary art installations. Like a fashionable modern bohemian with flowers in her hair and bows on her feet, when Sera Hersham Loftus mixes and combines all these textile elements, they don't look silly, they just look right.

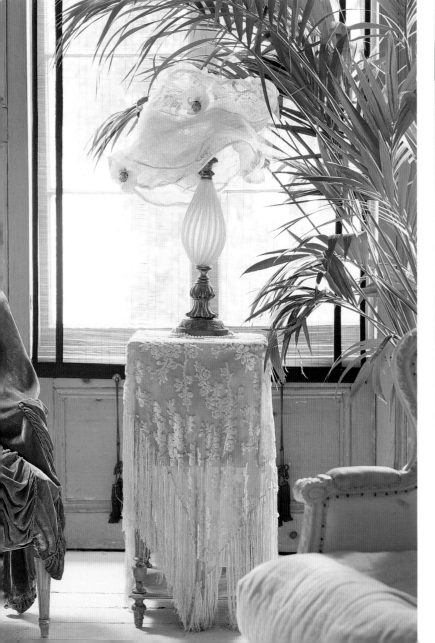

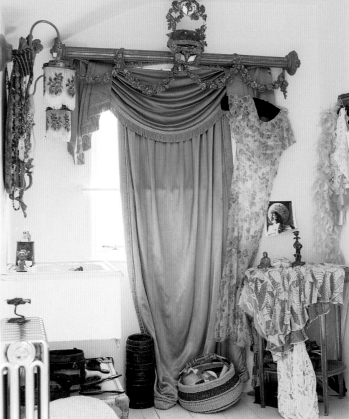

left A faded velvet Edwardian opera cloak with ruched collar dresses a chair; a table lamp sports an original lampshade; and a table is draped with an antique fringed shawl.

above Not only is the antique silk curtain a flamboyant statement, but it also has an ethereal chiffon tea dress hanging from the swagged heading, integral to the design.

right Shawl-mania rules here: a sofa is draped with one; another is full length over a screen; and part of a third upholsters a chair, augmented with a deep fringe, reminiscent of the shawl's original.

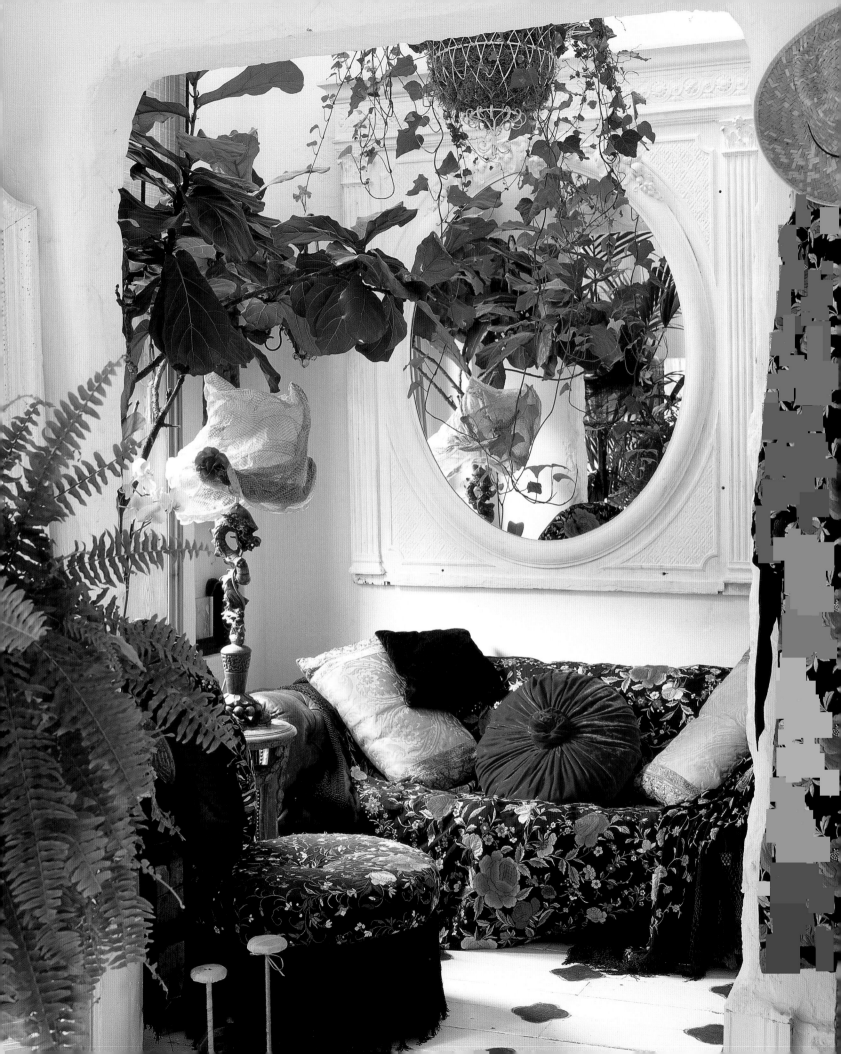

textile gallery

The more you know about a subject, the more pleasure you gain from it. It is all very well to have a broad overview, but an in-depth knowledge gives so much more satisfaction. And it is thus with textiles – the more you know about how they are made, where they are made, and how they were originally used, the more fascinating they become. The enjoyment to be had in searching for new pieces is intensified, and the pleasure of an interesting find is doubled. Small or large, elaborate or simple, each fragment has its own individual story to tell.

There is such a huge variety of textiles around, and so many variations between the different types of fabric, that it is hard to choose what to use or to collect. Luckily, there is no need to make a decision, because if you are interested in textiles at all, why not just collect everything you come across that pleases? That, after all, is what designers and decorators do. It doesn't mean that you will finish up with hundreds of pieces that you can't stand. Everyone, albeit unconsciously, is drawn toward a certain palette of colors or type of patterns or

techniques, or to a certain period or style. You will probably find that your new collection will tend to follow a theme, to develop a look of its own – one that is identifiably your own.

In this section of the book, we give potted histories of all the major groups of textiles: their origins, development, and variations in different parts of the world. For example, we explain the difference between a woven tapestry and an embroidered sampler, and we relate a little about how different manufacturing techniques came about and different patterns evolved. We also suggest imaginative ways in which you might use the pieces you find. The information and ideas are by their very nature not exhaustive, but we hope that, within limitations, they will encourage pleasure in your search for textiles and lasting enjoyment of your finds as part of your interior decoration.

linen and lace

Today's table and bed linens are just as likely to be made from cotton, man-made fibers or even silk as they are from pure linen, but three hundred years ago linen was the dominant household fiber. It was not displayed in impressive curtains or wall hangings, but simply used for cloths for the table and buffet, sheets for the bed, and for other household needs.

right A hard-edged metal daybed is in sharp contrast to the profusion of linen and lace that includes embroidered French pillowcases accented by a dark velvet bolster and sheepskin.

below The severe edges of a Victorian sofa are softened almost to the point of extinction by the contrasting icing of starched white decorative linen and lace.

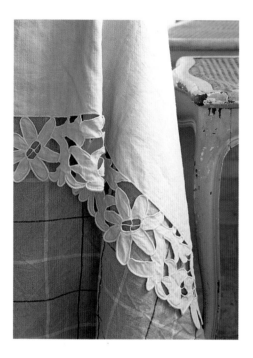

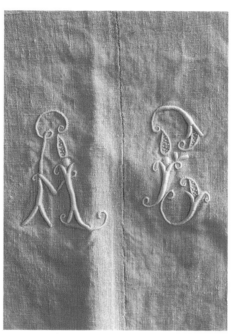

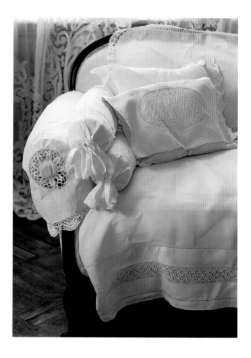

above left This really beautiful example of cutwork on a linen cloth is shown off to best advantage against a simple checked linen tablecloth in muted tones.

above center Many eighteenth- and nineteenth-century embroiderers' work was of an incredibly high standard, as these two elaborate and ornamental raised letters embroidered on a piece of linen clearly show.

For example, medieval bathtubs were often made of wood, and lengths of linen were used to line them for greater comfort; and when the linen was also caught up into a canopy or corona, the bathtub became a sort of primitive sauna. All but the humblest of beds seem to have had sheets of some kind by the seventeenth century, ranging in quality from the superfine to the barely fine. Table linen also came in a variety of qualities, from the coarsest of flax – which might be unbleached, even brown in color – to the smoothest woven damask. During this period, valuable carpets or tapestries were often draped over a table, and linen cloths were used when dining to protect the expensive textile beneath.

Although in earlier centuries households wove their own cloth or gave their spun thread to passing journeymen weavers, by the seventeenth century woven linen was imported into Britain in large quantities and in different weights – the finest and whitest of which came from France or Holland.

Early American settlers also wove linen cloth. The process was lengthy, taking months through all the stages from flax plant to finished cloth. From the seventeenth century on in North America, fine linen represented prestige and status, and it was highly prized, cared for, and handed down to the next generation as an essential part of a trousseau.

Fine linens

By the end of the seventeenth century, fine cloths for the table were usually supplied with matching napkins, and sometimes a set might also include a "handcloth", a long cloth carried by the server. Household linen was something to be treasured, and the aim was to have every

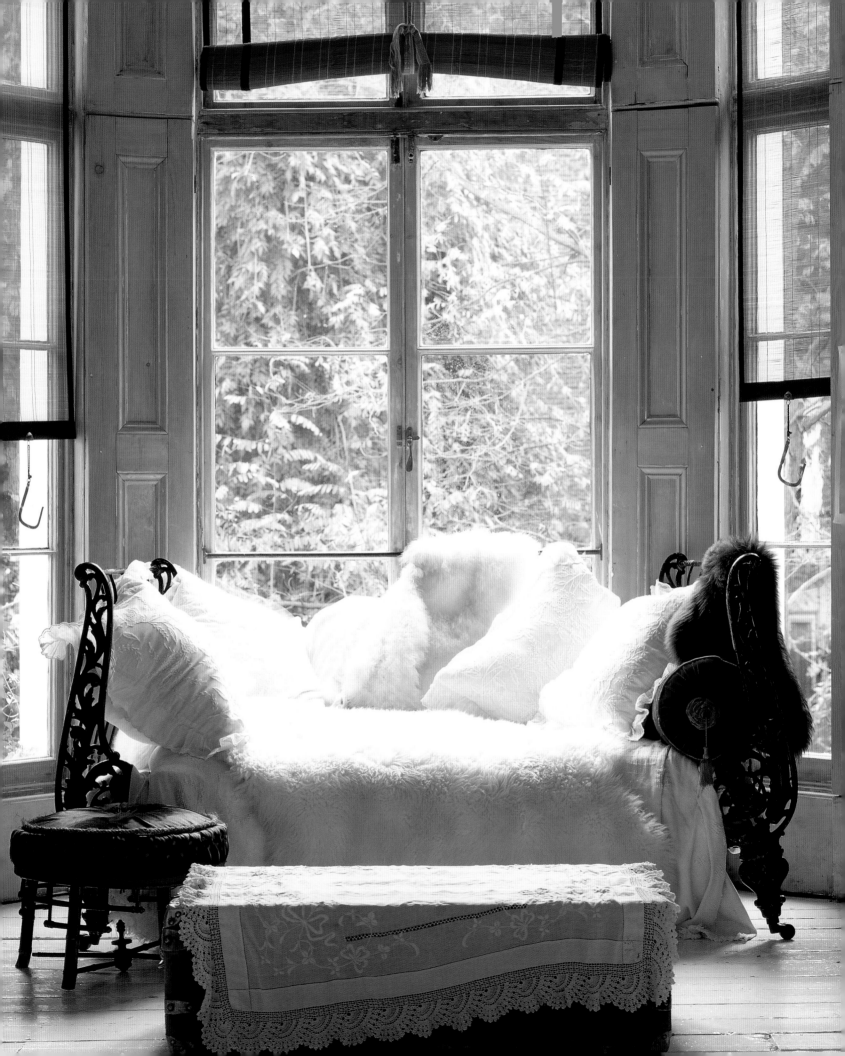

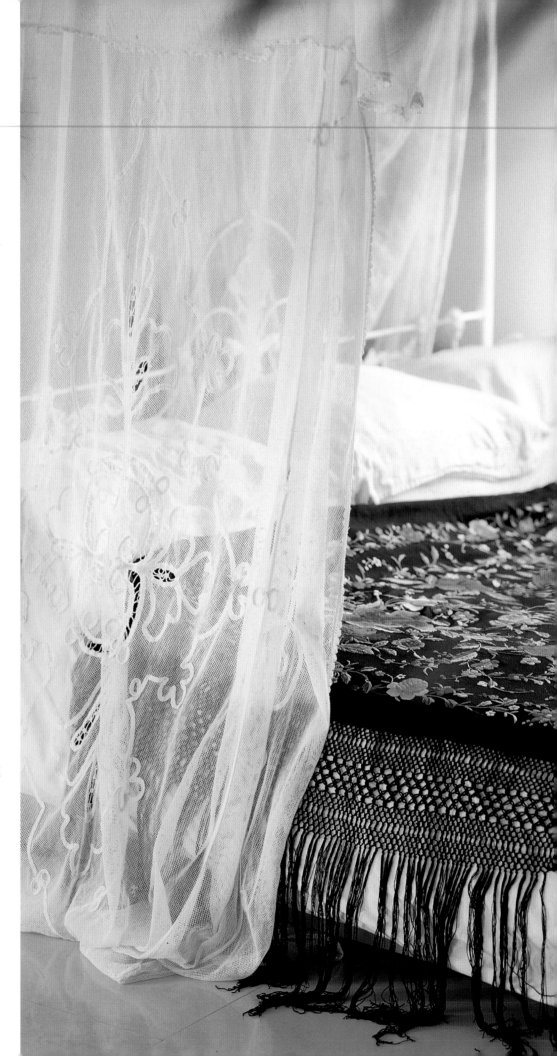

piece as fine and as beautiful as possible. Even
the chests in which the linen was kept were
ornamented and enriched. Embroidery was an
extremely popular pastime, and as table and
bed linen became more valuable and valued, it
became usual to employ on these cloths some
of the needlework skills that were part of every
well-brought-up girl's education. In particular,
those cloths that were to be used on dining
tables were often elaborately worked and
decorated, embellished with cutwork and other
embroidery, with fringes and borders often
worked in crochet as a further decoration.
Crochet work in England at that time was
really a kind of knitting done in cotton or
wool, with a single, hooked needle. In our own
century, crochet as a technique has been much
maligned and mistreated, seemingly most often
employed to create suspect, multi-colored,
wool vests and baby blankets. But in other
centuries it was highly regarded and used to
make articles of clothing and of furnishing of
great beauty.

Not only was table and bed linen
decorated with crochet work, it was also
often embellished with lace – that delicate
confection of threads worked together in
improbably fragile patterns to form an open-
work piece. Lace could be made from many
kinds of thread, including cotton and silk, but
the finest is generally thought to be that made
from fine white linen thread.

The first lace patterns recorded date from
the sixteenth century, and possibly came from
Venice. From that time until well into the
nineteenth century, lace was in huge demand
as adornment for costume and for bed and
table linen, pillows, and towels, hangings and
drapes. Although Italian lace was deservedly
popular, the fine linen woven in Flanders was
such that its linen thread was also of the
highest quality and could be transformed into
the finest lace. By the end of the seventeenth
century, France was also known for its beautiful
lace. Local variations in the designs and the
making abounded, and exquisite and fragile
variations were developed, such as Chantilly
lace, which was made from silk thread and
much prized for veils and other large pieces.

By the nineteenth century, the new age of
the industrial machine meant that – as was the
case for so many other crafts – a mechanical
substitute for lace was made. Machine-made
net, of a type that could then be embroidered
by hand, was also produced in industrial

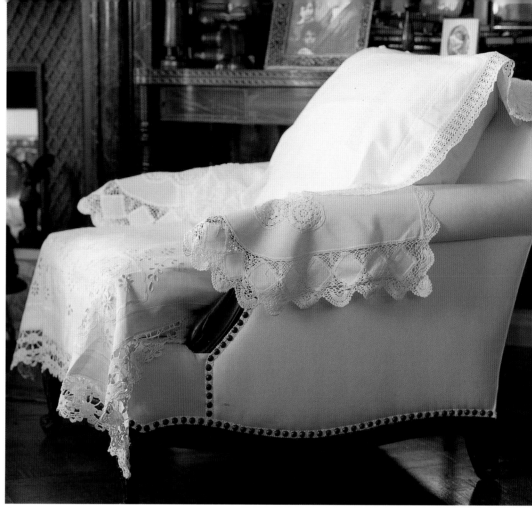

quantitites. In consequence, the technique of making lace by hand had almost died out by the start of the twentieth century.

Lace techniques

There are two main techniques for making lace – bobbin and needlepoint. Bobbin lace is made on a pillow covered by a parchment design with pins stuck through it to follow the lines of the pattern. Threads are looped onto the pins and are then attached at the other end to bone or wooden bobbins. The piece of lace evolves through dextrous manipulation of the bobbin and thread around the pattern pins. Lace was not, of course, always made from white or cream thread, but sometimes also from silver or gold metal thread, and as such was hugely popular in both the seventeenth and eighteenth centuries.

Needlepoint lace developed from the earlier cutwork embroidery. Holes cut in linen or cotton were edged and then filled with fine thread patterns. The cutwork technique is seen today at its finest in sixteenth- and seventeenth-century portraits in which both men and women proudly display the craft on

above One of the most striking and simple images is Lynn von Kersting's treatment of this armchair. It is cleanly upholstered in bleached muslin and then overlaid with an assortment of small pieces of antique embroidered and lace-edged white table linen, including mats and small tablecloths. No attempt has been made to suggest that the additions are in any way permanent.

left For sheer voluptuousness, this bed dressing is hard to beat. Instead of a more conventional cover, an antique silk embroidered shawl is framed by curtain lengths of delicate voile that fall to the floor, unhemmed and unchecked.

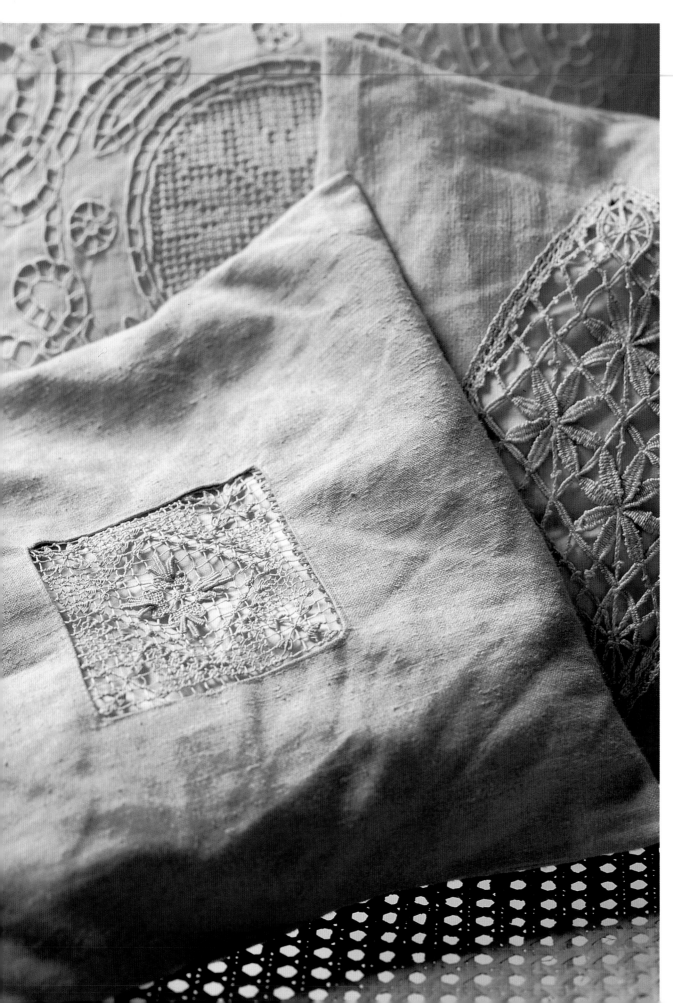

left Pillows are an ideal way to display small pieces of linen, lace, or cutwork embroidery. Here one is appliquéd with a piece of crochet work; another has an area cut from the base linen and a piece of crochet inserted; and a third is made from lace over a pale lining.

above right Monograms can be as simple or as elaborate as the seamstress wishes them to be, but whatever the style, they are always worth using as decoration on a scatter cushion.

centre right These small pillows feature a delicate piece of embroidery and a simple monogram stitched onto old dishtowels of unbleached linen. Such pillows always look better stacked in groups of two or three rather than displayed on their own, when they might appear insignificant.

below right Simple pillows featuring a small piece of lace are often better displayed on a neutral background. Here a lace panel is set into a piece of unbleached linen rather than being used as a contrast.

far right Like a tiny picture in a grand frame, a really small scrap of nineteenth-century red and white woven fabric is given completely new importance set in the center of a large cushion. The cushion itself is neutral, plain white linen in order to draw attention to the central attraction.

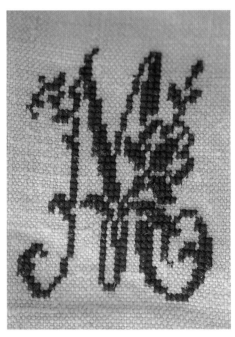

shirts and shifts and as edging for everything from jackets to cuffs, collars, ruffs, and borders. All are finished with intricate, fantastic cutwork featuring rosettes, stars, fleurs-de-lis, and scrolled leaves. From cutwork, needlepoint lace evolved to the point where the thread design was everything, became the lace itself, in fact, supported without the constraints of the existing fabric. Indeed, its design and execution extended beyond the confines of the original cloth.

Those adornments that were not made domestically – and the standard of homemade items was amazingly high then – were produced professionally. These designs were known as whitework, in which there was a booming industry in Europe from the sixteenth century. Whitework is a generic term for all types of embroidery worked in white on white, including pulled fabric work, drawn thread work, and cutwork. By the nineteenth century, a simpler form of the once-great art of cutwork was developed that remains with us today – eyelet lace, a technique that was first introduced at about the time of the Great Exhibition in London in 1851.

All these white-on-white techniques were – and sometimes, in simpler forms, still are – used to decorate bed and table linen to great effect. By the eighteenth century, a large, wealthy household might have owned vast quantities of linen, both for the bed – often, literally hundreds of sheets, fine and coarse – and for the table – cloths of varying sizes necessary for the many different sorts of tables then in use. Formal dinners might require a large number of cloths, since with several courses, two or three tablecloths might be laid one on top of the other, one layer being removed after each course.

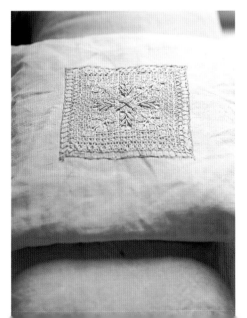

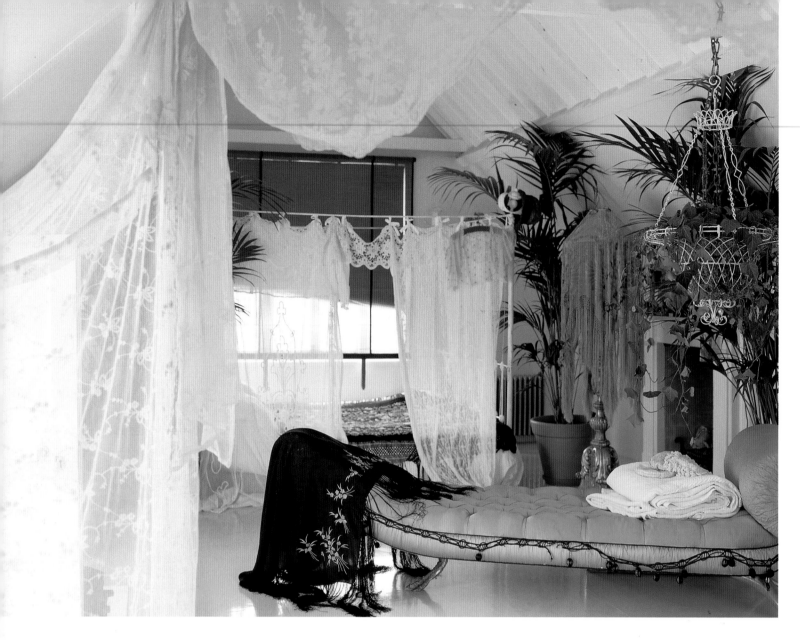

Changing fashions

Napkins have been folded into strange, intricate, and even contorted shapes ever since the sixteenth century. Napkin folding was considered an art at Versailles. There, and at other courts and noble households, napkins were folded into fantastic shapes, such as frogs, fish, and peacocks. You weren't supposed to use them, of course, and other napkins were provided for such practicalities. By the end of the eighteenth century, napkins could measure more than a yard in length, perhaps to accommodate the often rather louche meals enjoyed, particularly in France. Tucked into the chemise, they allowed conviviality to reach its often messy conclusion.

As always, over time fashions and notions developed as to how valuable linen should be displayed to best effect. In the eighteenth century, for example, it was desirable that tablecloths should be shown with sharp-edged creases across them delineating the original folds. A century later, linen was considered to look its best when shiny, pressed, and flat. To that end, on laundry day (or days) it was run through huge mangles with wooden rollers and then screwed into a linen press. In many houses it was stored when not in use by rolling it onto tubes in an attempt to guarantee maximum, no-crease flatness.

Up until the beginning of World War I, etiquette demanded that napery should always be white, although since then – except on the most formal of tables – an element of color has crept in. From the start of the nineteenth century, it was considered correct to embroider free-standing or entwined initials or a monogram on the household linen – either in traditional crossstitch, often done using red

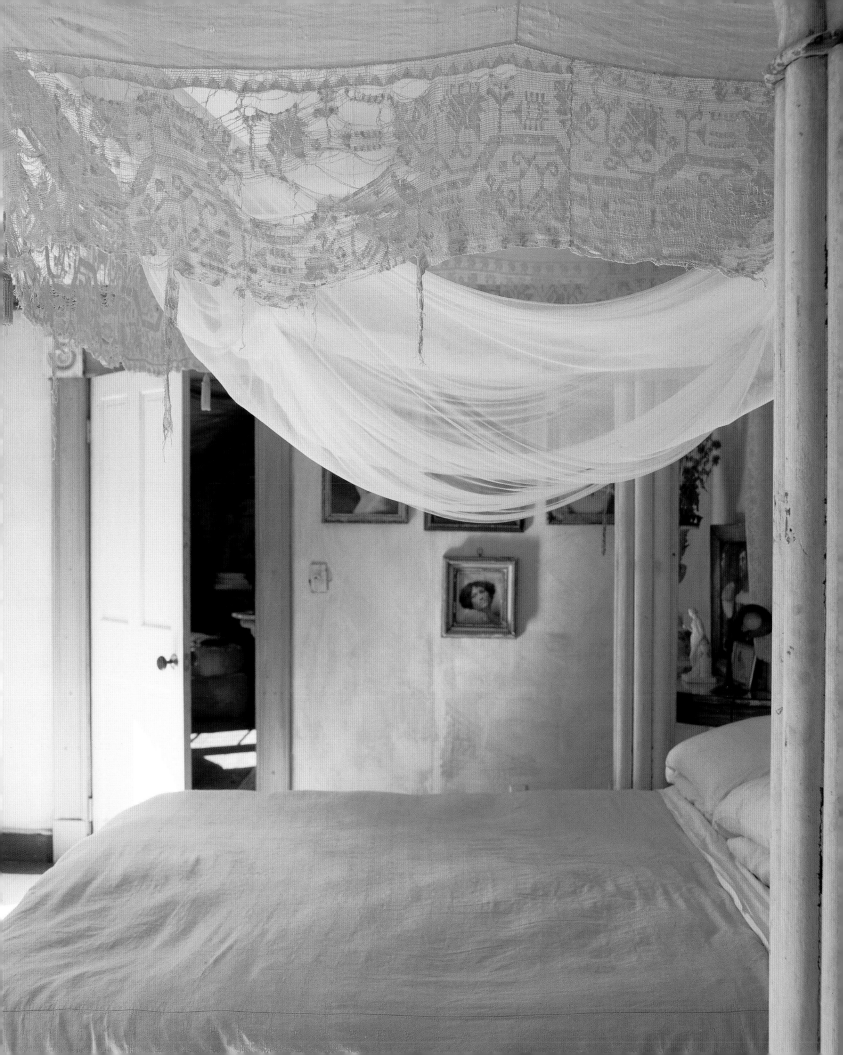

thread, or in an elaborate, white-on-white, sinuous form. There is wonderful variation in the design of these initials, which, of course, very often comprised those of a newlywed couple. The letters themselves might be cutwork or embroidery, and surrounded what often appeared to be almost a fully stocked garden of leaves and blooms. Old linen like this is worth looking out for, since the extravagantly embroidered section can often be removed from the rest of the sheet or cloth and incorporated into or onto something newer. As the nineteenth century wore on, a desire to see the high polish of an expensive dining table became paramount, and the cloth was often substituted by a runner – a strip of linen running the length of the middle of the table, leaving each side bare.

The use of household linen extended beyond the dining table. By the late nineteenth century, almost no room was safe from its genteel influence. In the drawing room, teatime was an opportunity for abundant linen – small tea napkins as opposed to larger luncheon ones; tray cloths, mats, and doilies underneath teapots, plates holding sandwiches, cakes, and cookies; a runner on the polished table. Around the house, linen mats stood underneath show china and glass, vases of flowers, and pots of plants. On sofas and chairs, head and arm rests protected the upholstery; and in the bedroom, dressing-table sets of small round, oval, or square mats were positioned to support pots and bowls and bottles. And near a sink would be an assortment of guest towels of various different sizes. On the bed there might be several decorative pillowcases, as well as slipcovers for nightwear.

White on white

For collectors of linen and lace, there is a huge choice, particularly of table linen. Old, large napkins, some in damask, some in linen, can still be found, along with assorted tablecloths and bed sheets, often sold singly or in poor repair at auctions. The cutwork, embroidery, and other embellishments of such linen could rarely be reproduced today, but the antique pieces can be bought and used, not just kept in boxes and admired. White linens and lace are a remarkably painless way to change the appearance of a room. On a dining table, old linen sheets can be draped so that any embroidery ornament hangs down at each end.

A hand towel with an elaborate edge, for example, can be laid across the seat of an upholstered chair, the decorative edge falling below the seat. Oval mats can be placed on the arms, an elaborate cutwork pillowcase on the cushions at the back. Huge tablecloths folded over can cover sofa seats. A double sheet with a distinctive cutwork or drawn thread-work edge can be used as a sofa throw, tucked into the back of the seat with the decorative edge showing over the top and down the back. A remnant of interesting linen, perhaps one incorporating lace or crochet work, can be sewn directly onto an upholstered seat back – either against a neutral background of similarly toned linen or cotton or in contrast to the upholstery material, bound in one of its colors to tie new and old together. A larger piece, perhaps with a distinctive monogram, can be cut to cover an entire seat or back.

Slipcovers, too, can be made from linen sheets and cloths, and are particularly effective when made to reach the ground covering straight-backed, upright wooden dining chairs, or canvas and wood folding director's chairs. All these are effortless ways to completely change the look of a room. This look, it must be said, works best when there is a strong contrast, over black and wood, perhaps, or a piece of antique furniture; it is important to avoid the impression of sugary femininity.

When embellishing windows, the recesses of the linen closet come into their own. Old linen sheets, coarse or fine, can be used as curtains, either singly or as a pair. They can be sewn to slip onto rods, or they can simply be hung over the rod, unattached, the weight of the material keeping the curtain in place and allowing it to be slid in its entirety along the rod as a screen against the sun. Old linen towels, particularly those with a heavily fringed edge, can be made into shades or simple curtains for small windows, perhaps just attached with pins to the window frame and looped back, and ornate edging can be used as curtain fringe or valance.

As was the case on an eighteenth-century dining table, more is more with old linen and lace. They look their best not when one piece is displayed in splendid isolation, but when many are gathered together, layered up, folded across. Damaged or stained pieces that retain some decorative elements can be used with other more complete, but perhaps less interesting, pieces. Pillows can be made from

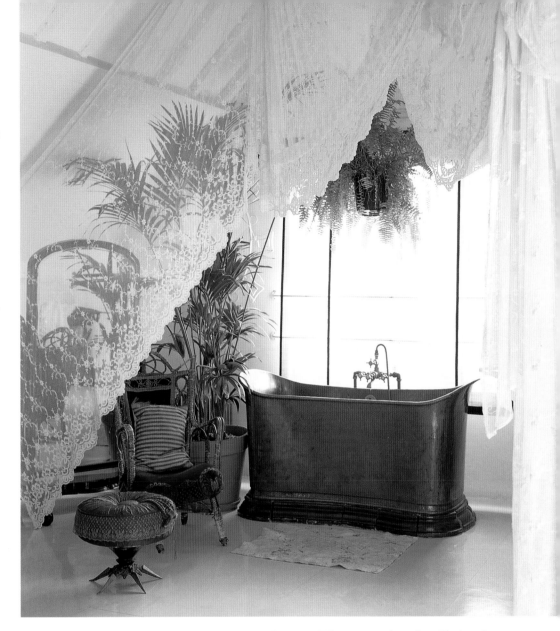

above One of the joys of old lace is that when it is hung against the light, all the intricacies of the work can be seen and appreciated. Here a piece of antique lace is used to mark the division between bedroom and bathroom.

left Antique monogrammed sheets make a fine contrast behind an openwork metal chair. The linen is starched and pressed to show off the embroidery.

far left White floor, white slipcovered, completely plain armchairs, and door curtains made from old sheets with a broad band of fringed lace as a deep valance show the glamour of white on white.

linen and lace **49**

right Old linen sheets are used as simple, but entirely effective, curtains for a bed in southern France. Easy to replicate, the sheets are hung with metal rings onto a simple structure of rods attached to the wall and from there held in place from a central point on the ceiling.

below Linen sheets are cut down to make under-sink curtains. The incongruous chairs – carved wood upholstered with nineteenth-century tapestry panels and white metal with ruffled white cotton cushions – form the mixture of styles that make up this eclectic kitchen.

scraps of linen set as a panel or overlaid on a more complete, but less interesting piece. Ladies' lingerie cases – popular in the late nineteenth and early twentieth centuries to hold precious stockings, lingerie, or nightgowns – can all be easily converted into pillow covers. Using all white but showing different types of cloth, in a way similar to the display of harlequin sets of blue and white china, produces a particularly interesting effect.

One vital necessity: any linen, any white piece, must be whiter than white, as white as it can possibly be. And the more ornate it is, the more it must be starched and crisp to within an inch of its life. Only then will it look as if you meant to use it, rather than it being left over from a ragbag. And if you use it for pillows or on furniture, it must be regularly revitalized, whichever decorative way you have found. Linen has always been carefully cared for, which is perhaps why so much remains.

Luckily, washing and starching linen today is a relatively simple, if tedious, procedure, whereas in the eighteenth century it could occupy a household for several days at a stretch. By the nineteenth century, professional washerwomen might have been employed to

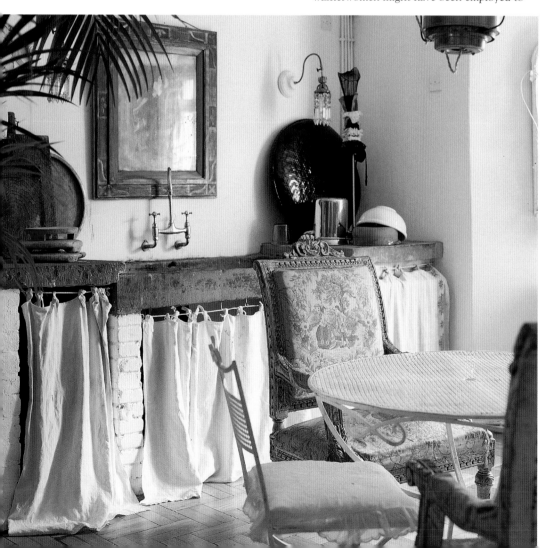

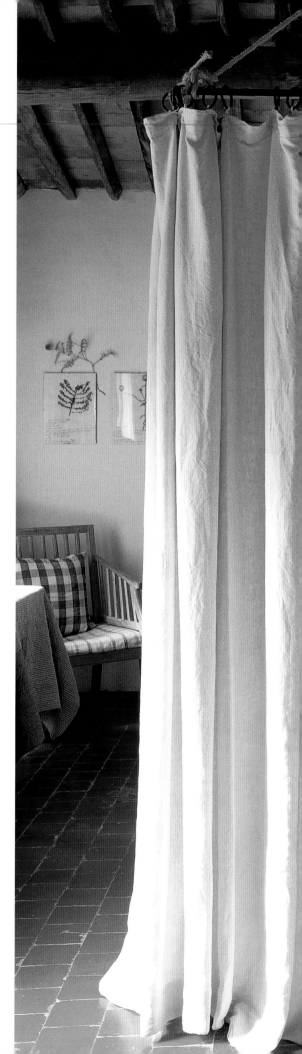

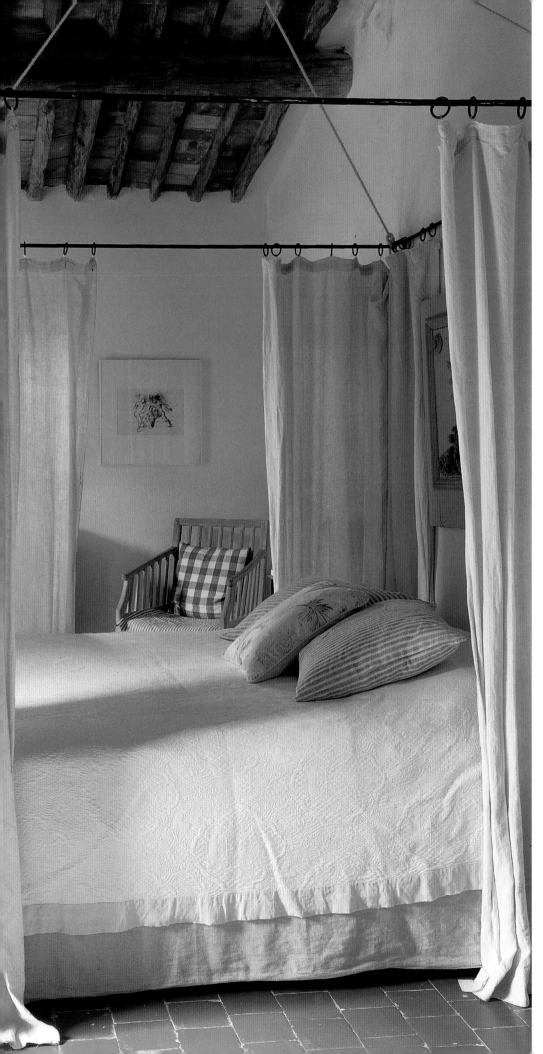

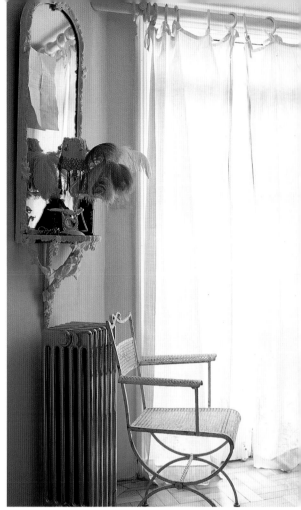

above One of the joys of using old linen for curtains is that the less complicated the style, the better they look. Here the curtain has just been attached with easy cotton ties over a wooden pole. What could be simpler?

wash a wealthy household's laundry. A large house might have had at least three laundry rooms – a washhouse, a room with drying apparatus and the laundry where the mangling and ironing was done. Where and when possible, drying was done outside, the laundry spread out flat on the grass or hung up on clotheslines. After washing and some drying, household linen was rolled through mangles, used as an iron and smoother rather than as a way to extract water. Then sheets and cloths were pressed in a linen press and folded and stored. It all seems a far cry from automatic washing machines and spray starch!

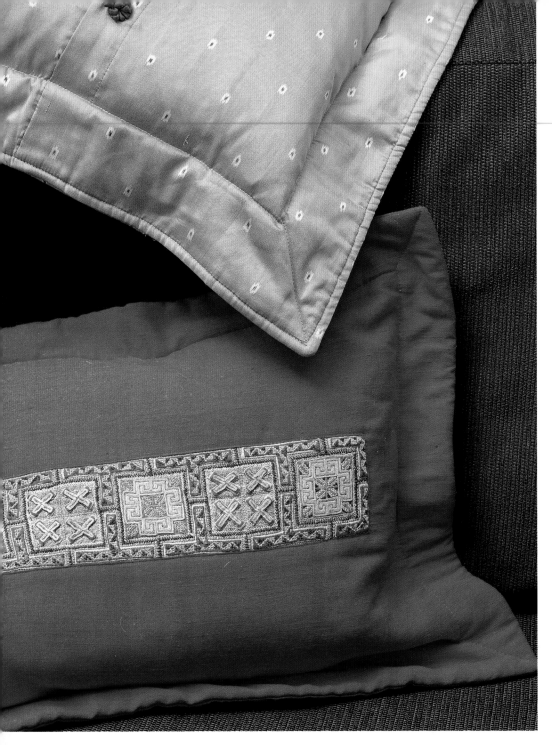

silk

It is little wonder that silk has always carried the costliest embroidery and the most ornate woven designs and that it has been made into the most extravagant clothes. Ever since it was first produced, silk has been more than just another piece of cloth. The difficulty and secrecy of its production; the lengths gone to procure both the manufacturing knowledge and the raw material itself; and silk's role as political and economic currency have invested its story with an importance and a romance that no other textile can boast.

Silk is a unique fiber. Unlike every other thread, laboriously spun into existence by man, silk is conveniently delivered by the doughty silkworm, ready made and in one continuous length. This thread is, however, very fine, so after being reeled from the cocoon, lengths are twisted together to produce a strand strong enough to be woven. Silk is made where silkworms flourish – and silkworms grow fat and happy in the temperate climates where the white-berried mulberry tree grows, from China in the east to Italy and southern France in the west. When King James I tried to start

sericulture in England in the seventeenth century, he failed because he brought back saplings of the wrong mulberry tree – the black one – to which his imported silkworms were not partial.

China has an ideal climate for mulberry trees and thus, from a very early time (certainly before the birth of Christ), it became the center of the Eastern silk industry. The Chinese perfected the art of actually breeding and rearing silkworms in order to get maximum production of thread from each cocoon. Not surprisingly, the techniques and methods were a

closely guarded secret. Remnants of ancient silk have been found which show that, even at this early stage of civilization, Chinese silk-weaving techniques were very highly developed. Pieces of early textiles demonstrate the use of complex and recognizable patterns in the weaves. It is clear that by the seventh century, the Chinese understood every advanced weaving technique known anywhere in the world at that time. In later centuries, they wove silken tapestries to use as hangings to ornament their chariots, to become flags and banners, and to attach to folding screens inside the house.

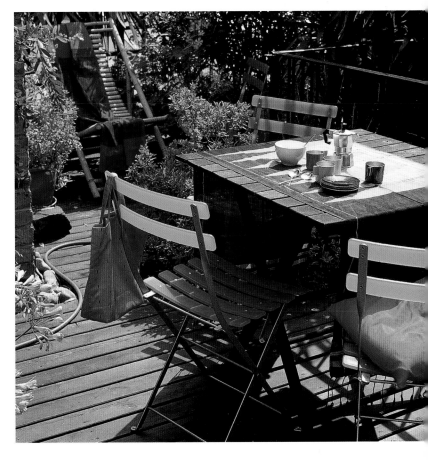

Silk was widely used for the costumes and robes of officials and of the imperial family at the regimented and highly formal Chinese court. It was all very precise: not only were different colors specified for different ranks – only the emperor and empress could wear midnight blue – but even the gradation of the color was vital. Yellow, for example, had to be dyed in varying shades, as each shade of the same color denoted a different rank of officialdom. The embroidered designs on the robes were almost as important as the color itself. There were twelve symbols, each denoting different attributes or responsibilities, and the emperor was the only person entitled to wear all twelve. Much sought after today are the antique embroidered mandarin squares worn by court officials from the fourteenth until the twentieth centuries. They were rather like coat badges and were worn divided on each side

of the front of the robe and in one piece on the back. There were nine classes of officialdom, and each was represented by a particular motif portrayed on the badge; motifs varied from a majestic white crane for an official of the first rank to a tiny quail for officials of the ninth rank.

The Silk Route

The almost miraculous production line of silk has always given it an air of romance and mystery. Originally silk came to the West from China (and some from Japan) along the ancient caravan routes. The romantically named Silk Route, which conjures up visions of roads lined with gently waving silk banners, was in reality several caravan trails leading from east to west across northern China. Over time, trade and cultural influences between East and

West were built up along these routes. Naturally, other countries, particularly Western ones, wished to have access at source to this miraculous textile, but until about the tenth century, China closely guarded its secrets, and Europe was forced still to trade most of its silk from the East, with Persian merchants often acting as middlemen.

Fine silks were woven and ornamented on the Indian subcontinent, too; think of the fragile, delicately ornamented saris, turbans, and veil cloths brocaded with silver and gold to appreciate the high standard achieved in this part of the world many centuries ago. Under Emperor Akbar, weavers in Lahore, Agra, and Gujarat began to produce silk brocade embellished with silver and gold embroidery. The nuances of the decorations proclaimed the position of the wearers of these silk clothes in the complex Indian society.

left A desk of little decorative merit is covered with an Indian silk sari, the colors emphasized by the rich tones of a Persian pot. The arrangement is complemented by the red-painted wall.

below left There is a clean sharpness in the way that this throw – a woven cloth from Laos in mustard and brown – is folded with geometric precision and used to cover the seat and back of a plainly upholstered chair.

right As an exercise in lush decoration, this arrangement could hardly be bettered. An eighteenth-century silk Chinese export hanging is finished with the most wonderful handmade silk tassels in colors just as bright; even the rug is in the same clear, bright tones. The pale cushions covered in antique cottons add a cool note.

The eleventh- to thirteenth-century Crusades produced many significant by-products, including the opening up of the silk industry to the West. Following one particular foray in the twelfth century, captured Byzantine weavers set up a silk industry in Sicily. A century later, the descendants of these same silk workers transferred to Lucca, which became one of the most important centers of silk weaving for the next hundred years, eventually overtaken by rival Italian centers in Venice, Florence, and Genoa.

The variety of silks produced in these weaving centers was wide. There were gossamer fine silks and luxuriously weighty damasks and velvets; silks twills and satins; and the fabled cloth of gold, which was woven with threads of narrow gilt membrane or parchment strip wrapped around a silk or linen core. They became justly famous for their incredibly complex, rich woven silk velvets and brocades, used not only for wall and bed hangings, but also to make clothes: paintings of the time record in fine brocaded and gilded detail these swagger costumes of cloaks, hats, and doublets.

In the seventeenth century, France, hitherto a prolific buyer of Italian silks, changed its policy. Under Louis XIV's Minister of State, Colbert, France decided to encourage its own silk industry at Lyons, in the warm south. French silks may not always have had the serious grandeur of the magnificent woven Italian pieces, but they had a lightness and esprit of design, and Lyons silks were soon the height of fashion. The range of designs emanating from the Lyons looms was immense: a guide published in 1762 in Brussels noted that Lyons' silk production was rivaled only by that of Spitalfields in London. New designs were

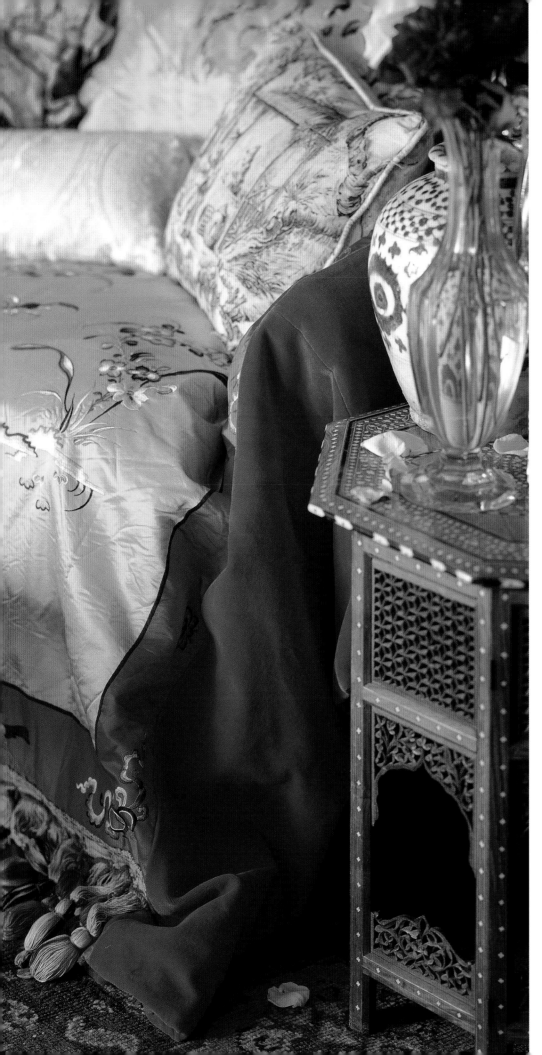

brought out at least twice a year and, by the end of the decade, up to three times.

By the end of the seventeenth century, most elegant European rooms were furnished with textile wall hangings, and many of them were woven from silk. To a large extent, they replaced the heavy tapestry or leather coverings of a century earlier. The colors of the new hangings ranged from rich, dark shades in bold damasks to sky blue, rose pink and pale green in delightful, soft, unpatterned materials. Silk was also used for both simple and elaborate curtains, and for the new, billowing festoon shades that were then in fashion.

By this time, the English silk industry was a force to be reckoned with. Since the 1600s, Protestant Huguenot weavers had been finding refuge in England from continuing harassment in France, particularly after Louis XIV revoked the Edict of Nantes in 1685. Silk centers were founded in Macclesfield, Norwich, and, in particular, in the district of Spitalfields in London. Spitalfields was no poor relation of Lyons; the designs produced there were extremely fashionable, and the quality of the woven silk very high.

Exotic decoration

Finding old silk today is relatively easy; finding pieces in good condition is not. However, it is not quite so difficult to track down newer silks, in particular those from India that were originally woven for saris. In almost any room in the house, the simple addition of a few lengths of brightly colored silk can transform the boring and mundane into an individual and interesting design scheme. At a window, for instance, instead of a single length of transparent Eastern silk, use two or even three, one hung over the other, all three tied back with another piece of silk so the different layers of transparent color can be seen. If the silk is fine, make the most of its see-through virtues, using it over a thicker bedspread to give depth, or as a folded throw on a chair or sofa. Used as a table covering, silk cloth gives an immediate air of luxury.

When using old or ethnic silks decoratively in a twenty-first-century environment, it is important to remember that the textiles are by their very nature fragile. They should be reserved for decorative use in situations where they can have the longest life possible and be shown at their best.

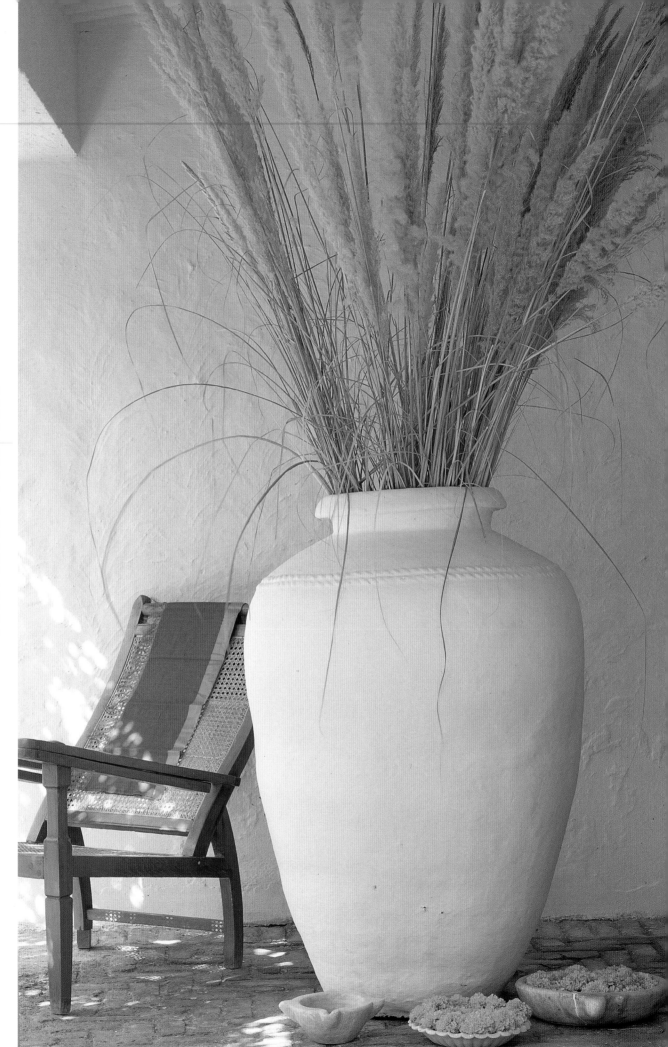

right In a shady corner of a courtyard in India, a cane chair is enhanced by a bright woven sari silk in violet and orange, the shades of which are complemented by the bowls of vivid orange flower heads.

far right These cushions are made by Kirsten Hechterman from fragments of antique textiles, handstitched onto larger pieces of hand-dyed silks. Each piece of new silk is carefully chosen to bring out the charm of the old.

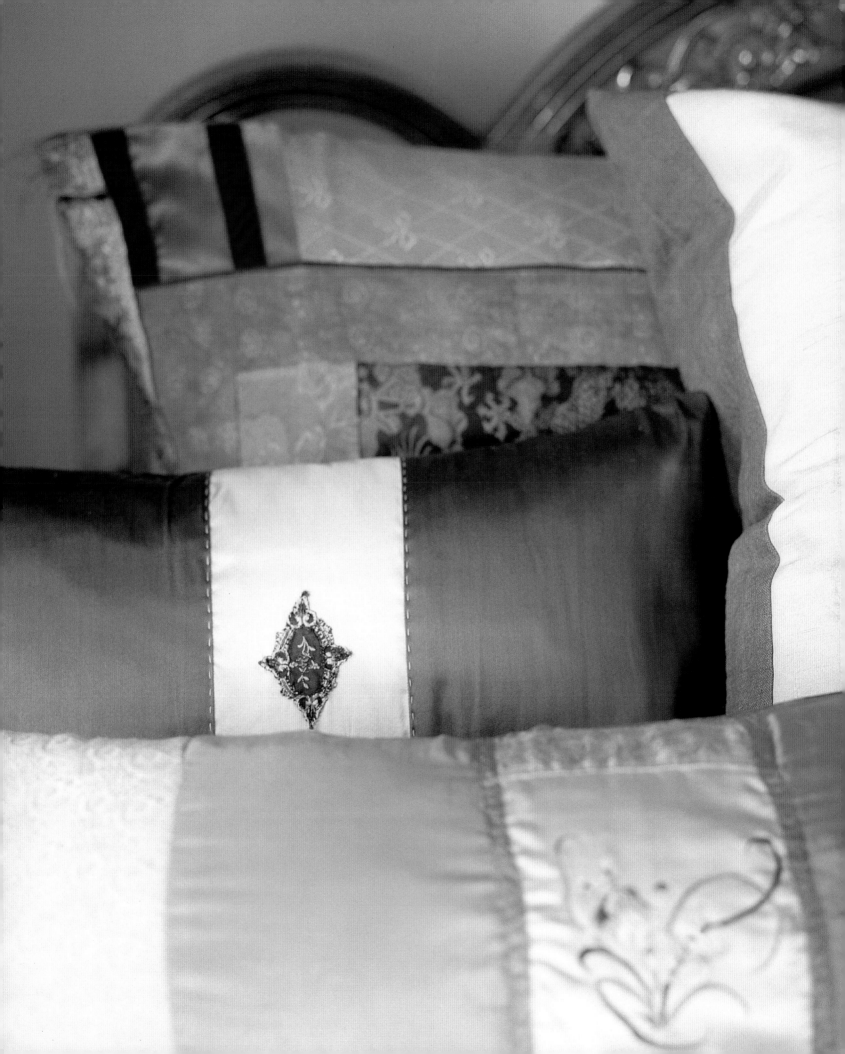

quilts
and appliqué

In many ways, quilts and appliqué really define the pleasures to be found in textiles. A variety of different fine stitches and an exuberance of design are fully apparent in solid-color, stitched quilts. And in patchwork and appliqué, it is a constant surprise to see the almost magical way in which what were no more than odd scraps of fabric have been transformed into objects of beauty.

right Before the modern comforter, in the days of sheets and blankets, eiderdowns and quilts were a necessary addition on cold nights, displayed during the day on top of the bedcover. Often stitched very elaborately in complex patterns, they were an early twentieth-century fashion that now sees signs of a revival. This modern version in Indian cottons is set against a padded and buttoned corner headboard of epic proportions. The contemporary take is the addition of a clutch of bright and sparkling silk pillows decorated with mirror pieces and sequins that pick up the colors of the quilt.

far right A detail of the same quilt shows part of the central panel of circular stitching that emphasizes the appliquéd motif.

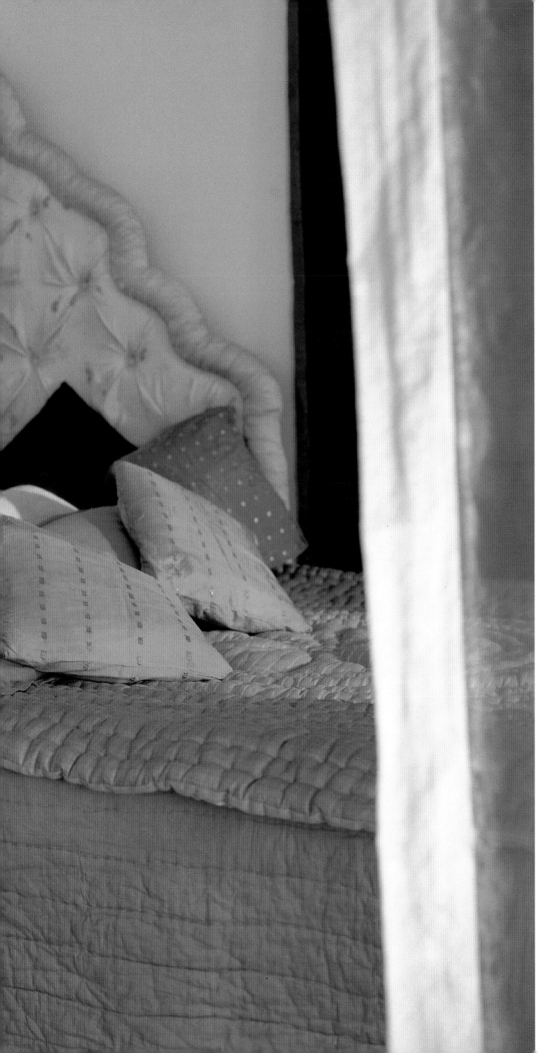

Quilting itself is the stitching together – originally simple, but by degrees becoming more ornamental and elaborate – of two or three thicknesses of material to form something warm, and often beautiful. Quilts made during the eighteenth and nineteenth centuries were a sandwich, a cotton or wool cover with tiny stitches making a design or designs, a lining of a similar material, and a filling, which might have been wool, cotton, a blanket or even old clothes.

The first quilts

Although American quilts are often thought of as the definitive expression of the art, quilting has long been an art form in many countries, particularly in England and Wales. This quilting tradition, as well as many of the quilts themselves, went (along with so much else) to the new country in the 1700s. Made for practical as well as decorative use, an early English quilt might have had as many as six layers of interlining, composed of shirting or nightwear cotton, and was very heavy and warm. Although quilts were occasionally just pieced together, most of them had plain cotton

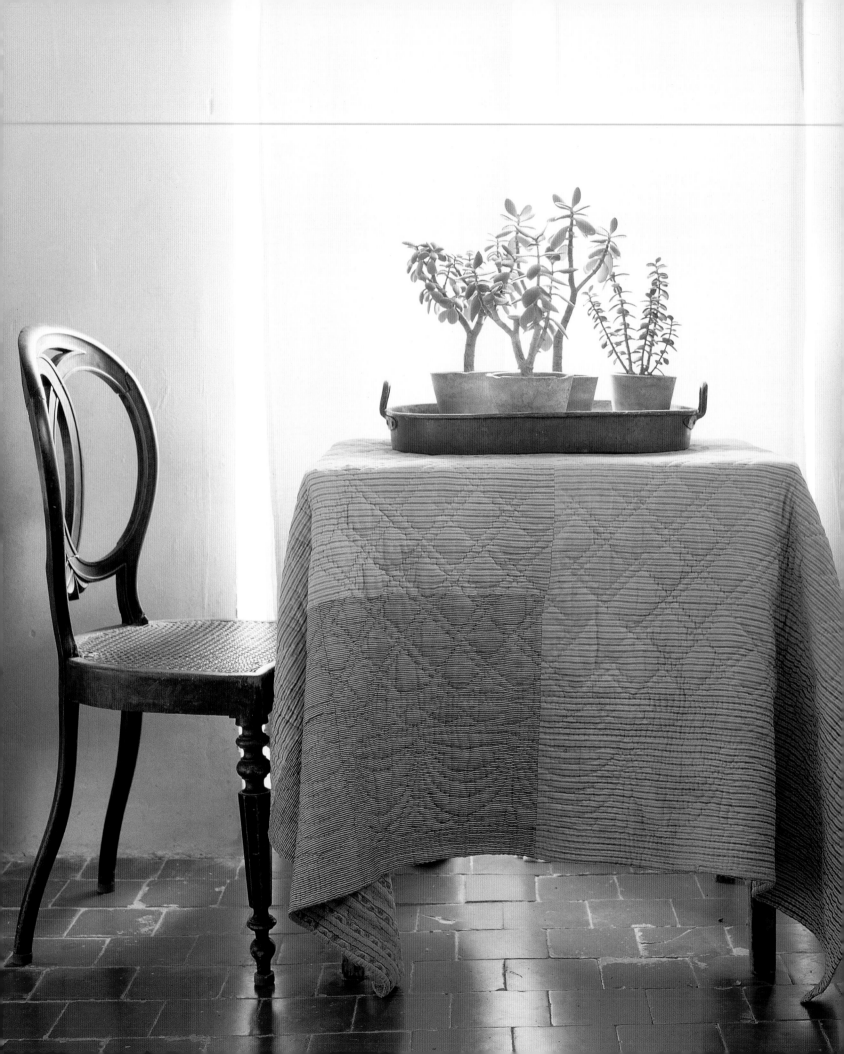

covers that were quilted with waves of stitched leaves, shells, and fans.

These quilts were made either at home or by professional quilters traveling around the countryside, producing new items to order. They are now seen as works of decorative art in their own right and are much collected, particularly those made in Durham and Northumberland and South Wales. Styles and techniques of quiltmaking differed between the regions: in the northeast of England, the quilting was finer; in the northwest, there was more interest in patchwork. A zigzag design indicates that the quilt might have come from the Isle of Man; in Wales, patterns tended toward variations of a spiral or snail's trail and shell; and in the north of England, leaf motifs were favored and tended to be symmetrical in shape. All these different patterns were impressive displays of the needlewoman's art.

In addition to these one-piece, single color quilts, there were also the pieced quilts that we now call patchwork. Early English quilts were often pieced, consisting literally of rectangles of different printed cottons joined together in designs ranging from the haphazard to the formal. Although many of these quilts were made from whatever scraps and cast-offs were available, the materials for others were chosen with care. Even those that relied on what was at hand often show careful choice of color and of the suitability of the scraps to the eventual design.

Appliqué

Appliqué is perhaps the most creative of all the patchwork and quilting techniques, and at its most complex consists not only of cutting out pieces of one material and sewing them onto another, but also of adding embellishments, such as sequins and beads, buttons and braid. At their most complex, appliquéd quilts might also have embroidered flowers and leaves in colored wool and silk.

From its early, practical beginnings, decorative quilting became a fashionable pastime for the ladies of leisure of the late eighteenth century. Lord Byron's mother-in-law, Lady Milbanke, advised a friend in 1798 to "put away your spinning wheel and go out and... spend a guinea on small pieces of linen, borders, all sorts of chintzes, staring flowers and leaves... they are cut into hexagons and mixed with white in particular manner...". These ladies combined pieced and appliqué work, shaping the quilts into sophisticated and intricate designs. As the popularity of quilt-making increased and scraps of chintz were recycled and used for new appliqué designs,

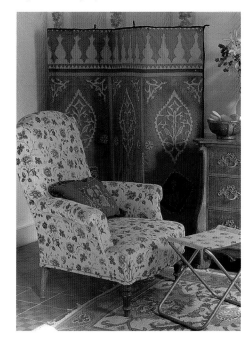

left This quilt is quite basic, and its charm lies in its simplicity. Made from two or three pieces of leftover material and lined with a contrasting pattern of cotton, the design is in the stitching. Anna Bonde uses it here as a cloth for a small table against a background of unlined linen curtains.

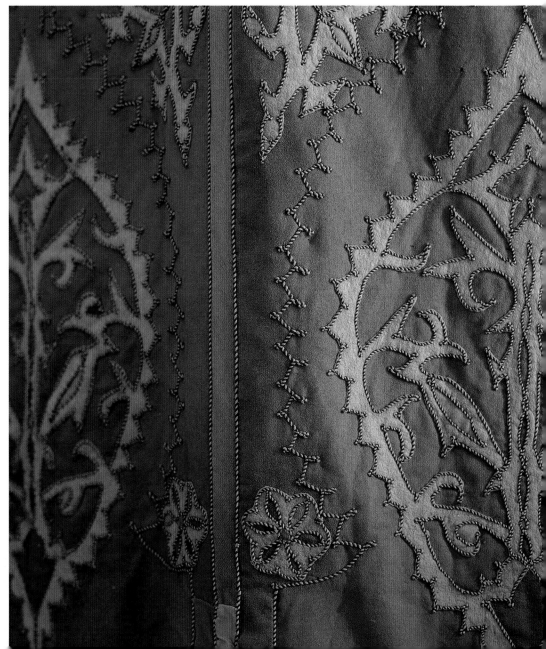

above and right This elaborate and intricate appliquéd screen is made from an eighteenth-century Moroccan textile that was originally made to cover part of a wall in the manner of a dado. It is placed behind a chair covered in an all-over printed cotton from the 1930s, which shows that change for change's sake is not always necessary.

fabric printers in London and North America cleverly began to create special squares of cloth, ready prepared to be cut out for the all-important central medallion of a quilt.

Patchwork quilts can have another fascination, too. They are a telescoped history of pattern and ornament, and of the development of printing and color technology. And they sometimes hold their own secrets – historical bonuses in the form of old pieces of paper used for the templates to which fabric was cut. These not only help to date the quilt, but also add a touch of social history, as old posters and pieces of news-sheet were often used for the purpose.

By the beginning of the nineteenth century, patchwork became a craze, like so many techniques in the history of sewing. Printed materials were easily available as a result of the new roller printing machines, as was a distinctive new dye called Turkey Red. It had been developed in the eighteenth century, and the first dyeworks producing the color were established in Scotland in 1785. This bright, deep red was supposed to be non-fading, and it became especially popular for quilts, particularly when it was used as a contrast to white. Many examples of such red and white designs remain today.

American quilts

The earliest documented quilt in America was a pieced and appliquéd example recorded in Massachusetts in 1685, although it was probably imported. Few quilts were actually made in America during the seventeenth and early eighteenth centuries, and those that were imported, largely from England, were considered expensive items in the average household inventory. Early settlers were not in a position to waste anything; everything was saved and recycled, and naturally scraps and patches of cloth numbered highly among things that could be used again. So quiltmaking was at first a practical way of recycling the good fabric on otherwise worn-out garments.

As life became easier, and fabrics more plentiful and cheaper, quiltmaking was developed into an art by the settlers. Pieced quilts became more ornate, varied, and plentiful, with the creation of specific designs and with groups of people coming together to collaborate on particular quilts. The American Revolution accelerated the growth of home

industries, and for the first time Americans began to manufacture their own textiles. They also began to import more luxury materials, such as calico, silk and chintz. By 1825, the golden age of American quiltmaking had arrived, characterized by carefully constructed designs consisting of a single motif and repeated patterns, or by a more free-form type of appliqué. The names of patchwork designs – Broken Dishes, Flying Geese, Shoo Fly, Bear's Paw, and Log Cabin – accurately and poignantly describe the everyday sights and experiences of these pioneering quiltmakers.

Quilts were also part of a settler's dowry. A bride-to-be, with the help of her family and friends at a quilting bee, would make a quantity of quilts. There were also album quilts, for which each member of a group would make one square in a pattern of her choosing, all then to be pieced together.

Away from the mainstream of American quilt design, Amish and Mennonite quilts are highly distinctive and are particularly noted for the quality of their craftsmanship and their distinctive colors and designs. The Amish are an Anabaptist sect whose followers keep themselves aloof from the vanities of the world. Their original members migrated from southern Germany to America in the nineteenth century, settling in Pennsylvania and Ohio. Both branches of the sect made quilts for home use, and until the end of the nineteenth century, most Amish women continued to make and dye cloth by hand. The different branches developed different traditions, the Pennsylvania Amish preferring strong, dark blue, purple, and green, worked in large geometric designs, the Ohio Amish using a palette of brighter green and pink, sometimes even yellow.

Over the years, American quilts became more complicated, the designs often radiating from a central medallion. Others were designed in block formations, using squares and triangles in innovative ways. It is these wonderful, pieced block quilts that today exemplify the glory of nineteenth-century American quiltmaking.

right This is a fine example of a twentieth-century Shenandoah Valley appliquéd quilt in the Mariner's Compass pattern. It is folded over an equally fine American Federal period chair.

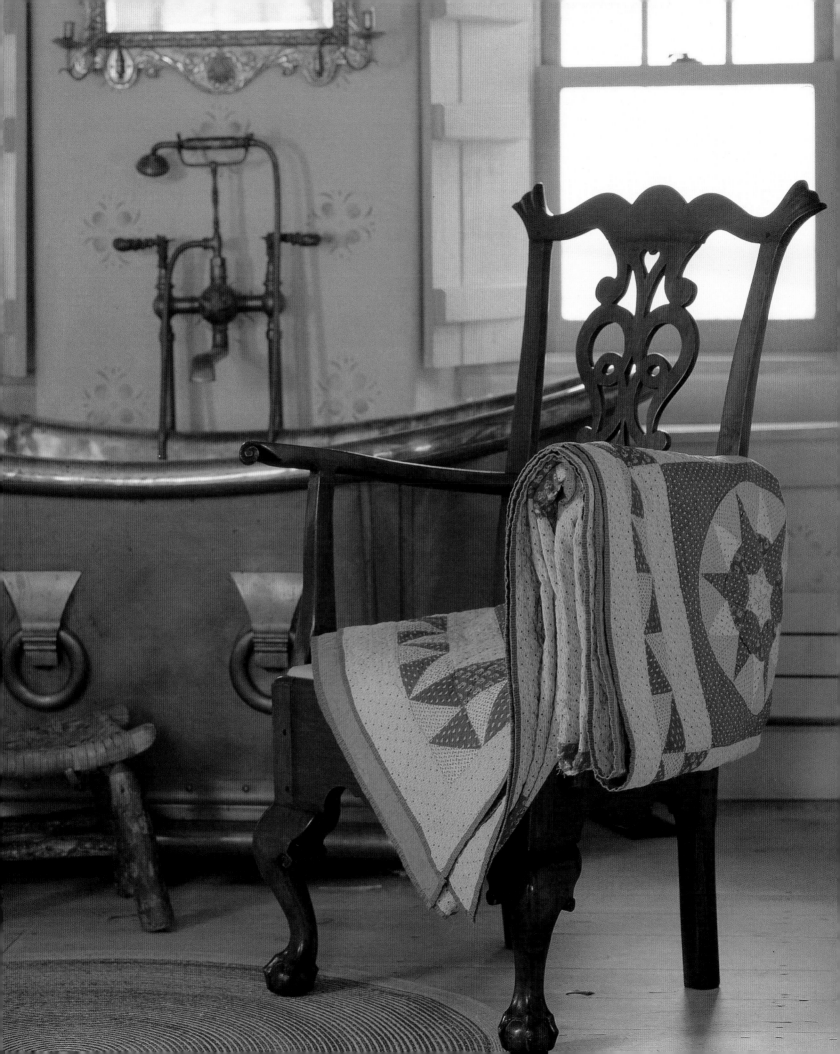

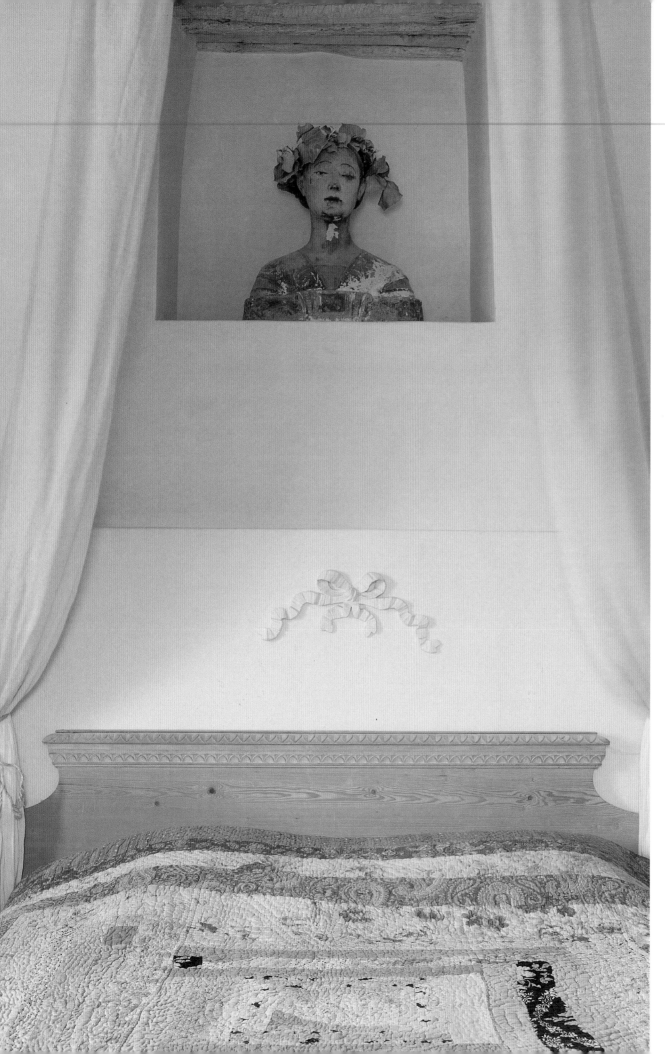

left One of the pleasures of old quilts is that in a simple modern room very little else is needed as decoration. Here a Swedish bed with a low pine headboard has a corona of draped and tied old linen and a French patchwork quilt whose faded colors echo the bleached wood of the headboard.

above right and right A combination of cultures is at work with a cotton quilt found in Bhutan and a new bedcover lined with material found in an Egyptian bazaar, together with a blanket from Finland. All this warmth is set off effectively by the contrast of light lacy sheets – masterpieces of drawn thread work, and traditional to the Canary Islands.

Decorating with quilts

One of the easiest ways to use old quilts today – particularly if they are in fairly good shape – is for the purpose for which they were made, as bed coverings. However, the majority of double beds now are larger than their nineteenth-century equivalents, and many quilts will therefore not reach to the sides or the end. You can use them instead over a plain cover in one of the colors of the quilt, or drape an old quilt folded over the end of the bed into a panel, or in a triangular shape. Or you can do both at once. Quilts are also ideal as tablecloths or covers. Over a round table, they are more interesting than a new, made-to-measure cover, and on a dining table, two or three can be used together, perhaps under a cutwork white cloth, or on their own, each one overlapping. A striking appliqué quilt can be displayed either on the wall, perhaps hung from a pole, or, if you have a tall staircase, over the banister.

The stitching on a quilt gives it a body that makes it very easy to work with if you are going to remake it. Most stitched quilts make excellent pillow covers, perhaps cut like a pillow with buttons at one end. Again, in the bedroom, a quilt makes an instant headboard, comfortable to sit up against. There is often not even a need to cut and shape it; simply draping it behind the bed will suffice. Many people also hang quilts on the wall behind the bed – perhaps with the addition of a lining of batting – to create a striking, almost canopied effect. In the same vein, a tester bed can be hung with quilts at the head as an alternative to more conventional curtains.

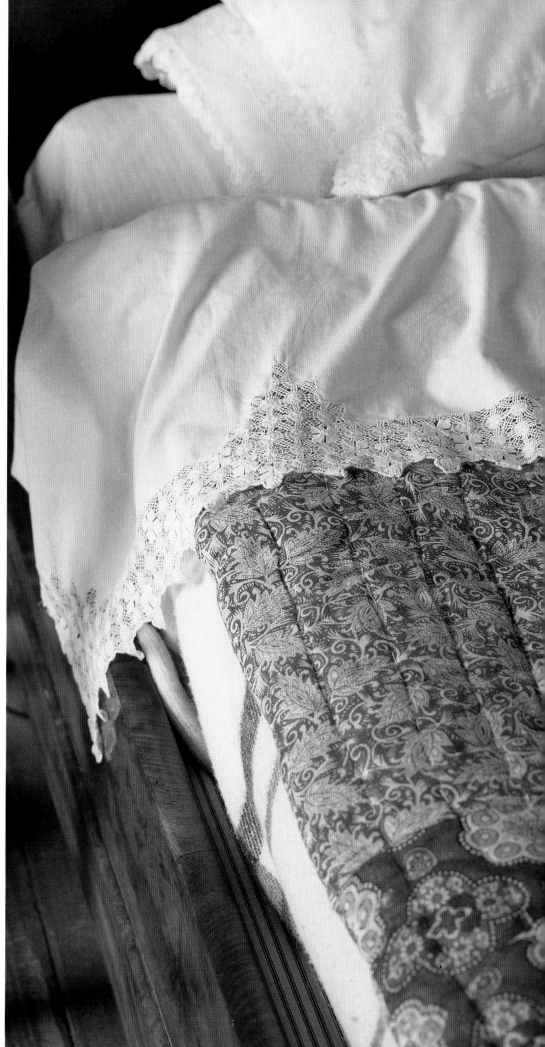

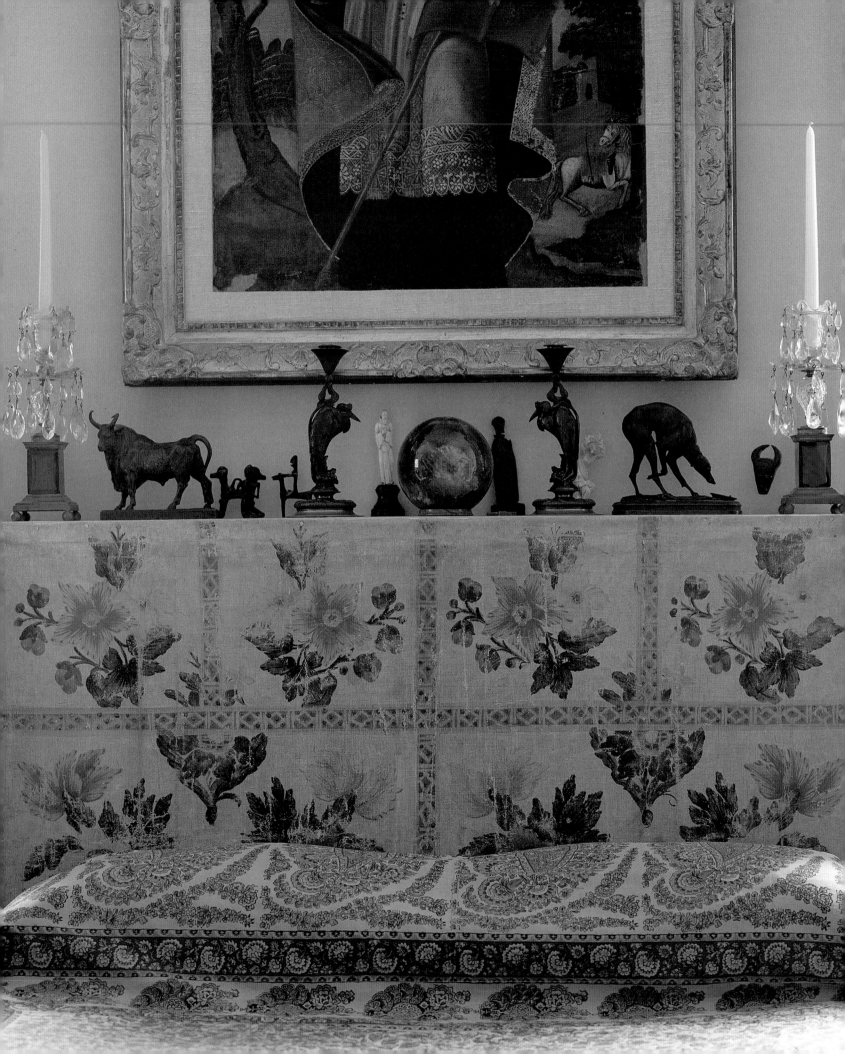

painted fabrics

The prevalence of handpainted textiles has as much to do with the quality and sophistication of available dye colors as it does with any other technicality. The countries of the East, particularly India and China, were far more advanced in the creation of dyes than the countries of the West. By the fifteenth century, for instance, there was already a flourishing trade in painted textiles between India and Persia. India had long before mastered the technicalities of resistant dyes, perfecting a method of painting textiles in bright and vivid colors that allowed them to be washed.

Interior high fashion

Western trading companies were shipping home as many desirable Eastern painted textiles as they could by the seventeenth century. English women's diaries, such as those of the indefatigable Mrs. Libby Powys in the eighteenth century, are full of descriptions of rooms of mouth-watering painted hangings.

Indian painted muslin, known as palampore, was a popular choice for bed hangings instead of the more usual woven or embroidered textiles, and were also used as curtains or wall hangings. Although the buyers of these hangings thought the designs incorporated traditional Eastern motifs, in fact Indian artists, encouraged by their traders, were adapting their traditional designs to appeal to the developing Western market. The flowering tree or vase and flowers designs owe as much to Western perceptions of the East as they do to actual Eastern tradition.

Painted panels, usually on canvas but sometimes on paper or even satin, came from China as well as India and were much in demand in the West as backgrounds in drawing and dining rooms. By the mid-eighteenth century, in part as a response to this influx of Eastern painting and in part because of a new interest in pattern and design prompted by the wealth of printed cottons now available, European painted textiles began to appear. Italy, France, and England all produced designs. Lighter in appearance than brocade, but certainly no less expensive, these painted confections caught the decorative mood of the moment, and those done on silk were thought to be particularly sophisticated.

Painted textiles were also often used for window shades. They were best in silk, which diffused the light and accentuated the painted design, but they were also made in other weights, such as muslin, chintz, and linen. A simpler form of shade was made of painted panels of material stretched across the lower part of the window. These were decorated with idealized landscapes, birds, flowers, and leaves. The fashion for all things pastoral in the late eighteenth century – that time of pretty cottages and queens playing at being milkmaids – gave rise to a country house craze for *toiles peintes*. Indian painted cottons or English printed imitations were supposed to be suitable for a country interior, but in more *rus in urbe* residences, wonderfully exotic Chinese painted silk taffeta, known in France as Pekin, was fashionable. Sophisticated and finely painted, these textiles were to be seen in such grand homes as Bellevue, the château belonging to Madame de Pompadour. So popular were the Pekins that in some schemes even the chairs were upholstered to match. In the mid-nineteenth century, rolled-up window shades were again fashionable and were often painted in veritable flights of fancy. Sometimes

left A wide, but not deep, strip of flower-painted canvas from Mexico is used in a most imaginative way, attached across the length of a panel behind the bed to make an original and decorative headboard. An east-Indian printed shawl picks out the tones of the canvas and combines two cultures through design.

above A small strip of painted canvas material is the unusual seat for a nineteenth-century wooden theatrical stool. The stool is painted with a stylized leaf design, echoing that of the canvas seat.

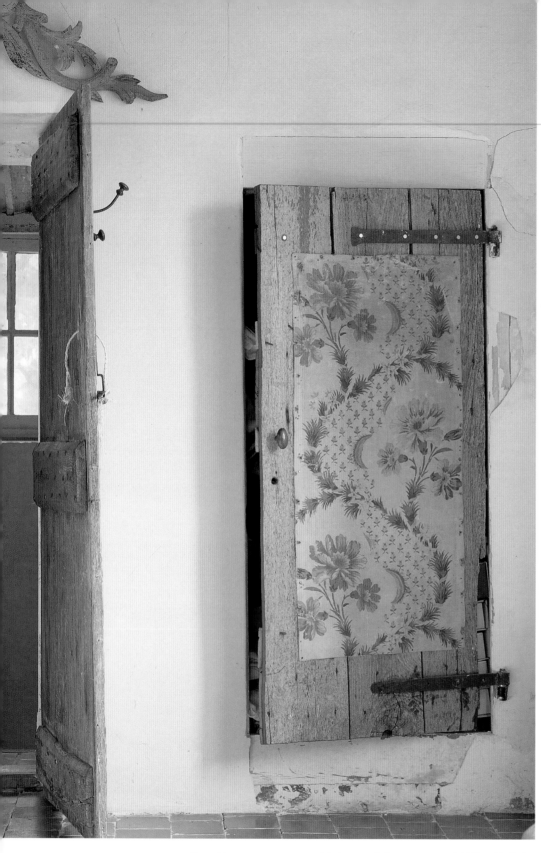

right Although this sheer, painted voile is badly faded by the sun, when it is hung with a narrow tassel down the side, the paler areas become part of the overall charm.

known as transparent blinds, they were painted on Scotch cambric or lawn and must have looked lovely, provided that they were well painted.

In the nineteenth century, oilcloths were used instead of carpet as floor covering. Made of the type of oiled canvas used for ships' sails, they were painted with patterns that were either individual or in the same design as a carpet used elsewhere in the room. In the early days of colonial America, painted floorcloths were a decorative and practical way to add texture and color over plain, sanded boards.

Textiles for display

If you are lucky enough to find old painted textiles, cherish them, for they are rare and beautiful. It is important to use them so the painting can be seen in its entirety. To that end, painted textiles are best simply displayed, affixed to a screen, perhaps, or pinned or otherwise attached to a panel behind the bed or on a door. Thinner materials benefit from being backed before they are displayed. A fragile fragment of painted textile might look best in its natural habitat, simply hung in a frame on the wall.

above How can you best display a piece of textile that is awkwardly shaped and too pretty and unusual to be cut? Anna Bonde ingeniously solves the problem by displaying a beautiful old painted canvas in the manner of an unframed picture, straight onto a cupboard door.

right Surprisingly, the roughness of the boards of the door makes the perfect contrast to the serpentine lines of the painted flowers. The canvas is simply pinned to the pale, bleached wood.

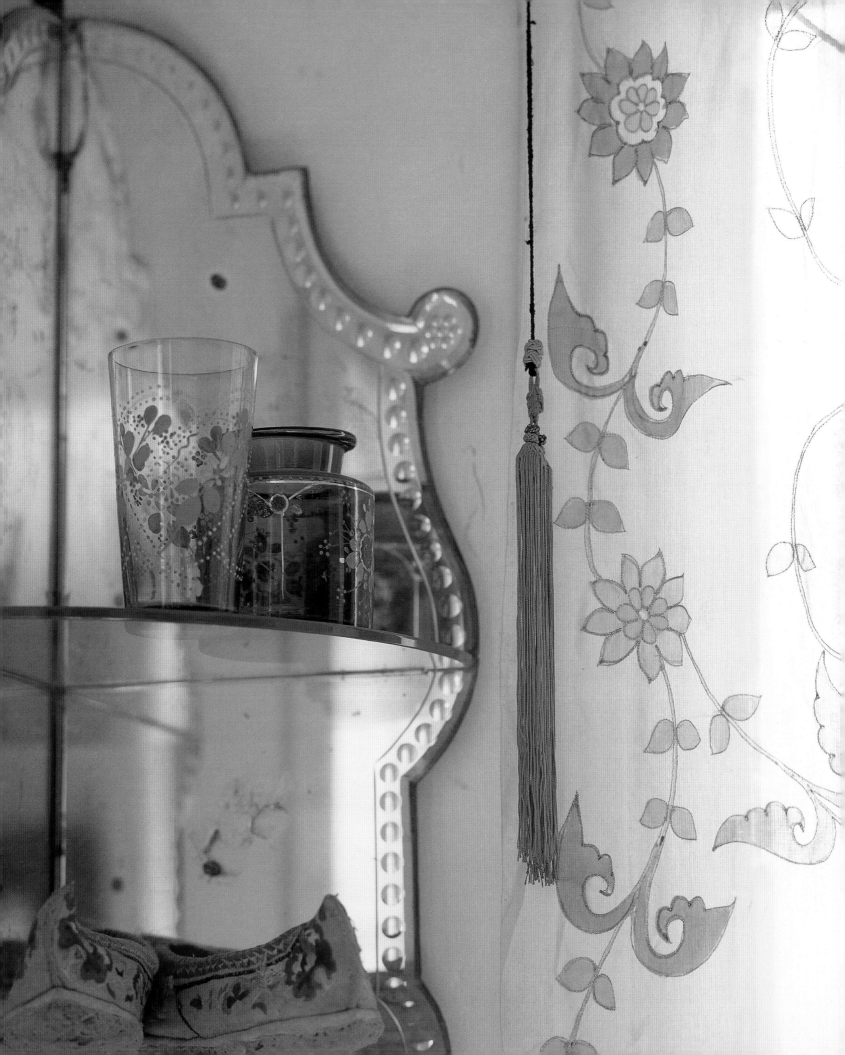

printed fabrics

Today, when every department store is awash with printed fabrics used both for clothes and for upholstery, it is not always easy to remember that for hundreds of years any patterned fabric had the design woven, rather than printed, into the cloth. There are some early examples of printing, made with a fairly primitive form of block for which a pigment was mixed with a binding agent and applied to the fabric. Most of the paint stayed on the surface of the fabric, rather than being absorbed into it, as happened when the technique was perfected.

These early printed fabrics would not have washed well, if at all, and were probably used as cheap alternatives to woven wall hangings. In seventeenth-century England, any existing printed cotton or linen was still done with wooden blocks, albeit slightly more sophisticated ones, charged by hand with a thickened dye paste and then stamped onto the cloth.

Chintz

The patterned pintados and calicoes (sometimes then called chintzes) that started to trickle from the East into Europe from the sixteenth century were quite a different matter. Superior in quality and in technique, they were colored and decorated using the wax-resist method. In this technique, areas to be left undyed were covered with wax, which was then removed with boiling water after the rest of the cloth had been dyed, leaving a design outlined in sharp relief. Chintz comes from the Hindi word *chint*, meaning a varicolored cloth. Nowadays it is used as a generic term for dyed cloth printed in a number of colors and often polished to give a glossy finish.

By the seventeenth century, as a result of the imports of trading companies such as the East India and the Dutch, the trickle of Indian patterned cloth had become a fashionable flood. As with the European craze for Eastern blue and white china at much the same time, demand outstripped supply and encouraged European manufacturers to try to imitate these prints. They successfully managed to do so by about the late seventeenth century, when the first calico printing factories were recorded. This led to a fashion for pintado or calico and

above right Bright sun can take bright colors, and an outdoor table is the perfect place to use the brightest of prints. A flower-scattered sunny print, hand-blocked onto nineteenth-century French linen, has a central panel of stripes and its original fringe.

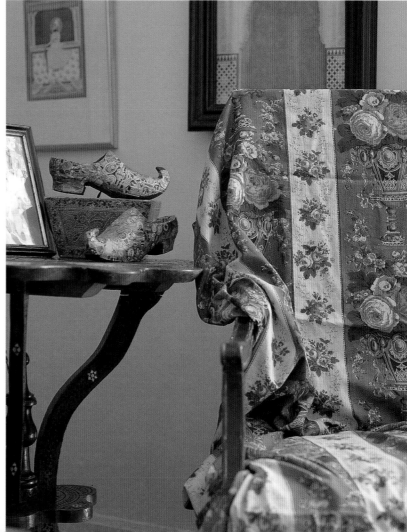

right and far right Many collectors would rather not have a permanent place for a particularly loved piece because then they can have the pleasure of moving it around to decorate different rooms and pieces of furniture. Here a fine piece of late eighteenth- or early nineteenth-century chintz from Portugal – in a column design and bright colors so typical of the period – is draped over a straight-backed antique chair. The chintz is finished with cream cotton fringe that accentuates the lively design.

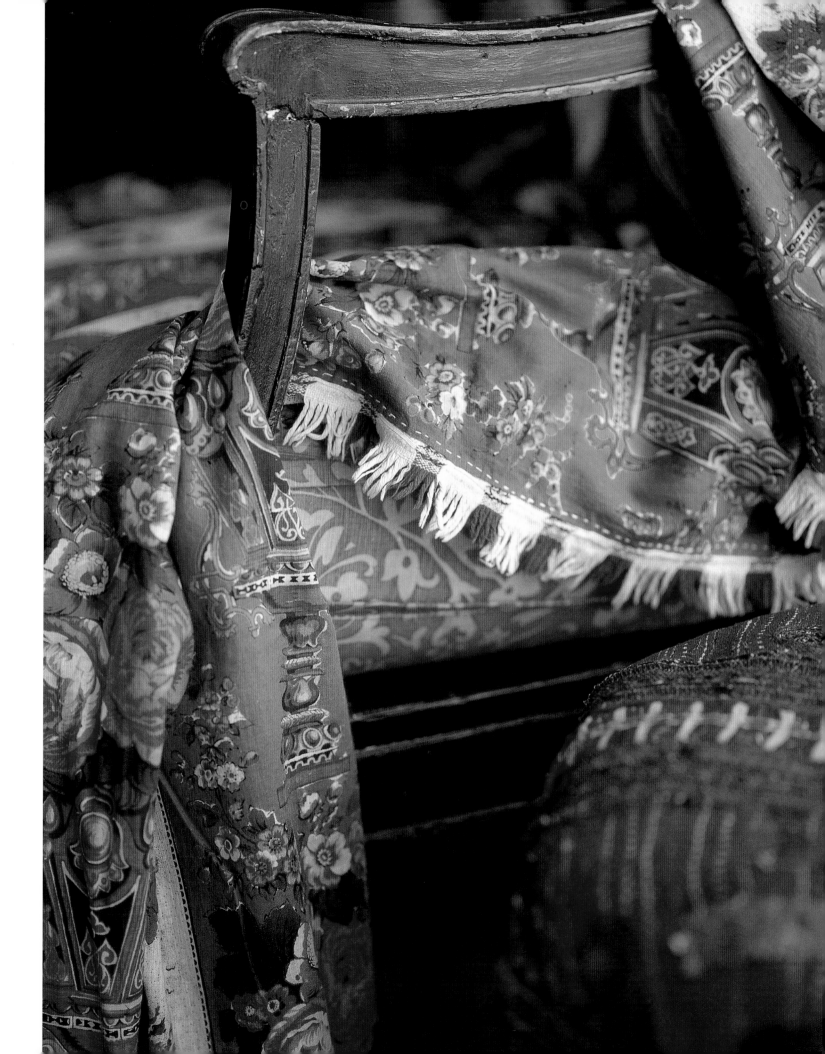

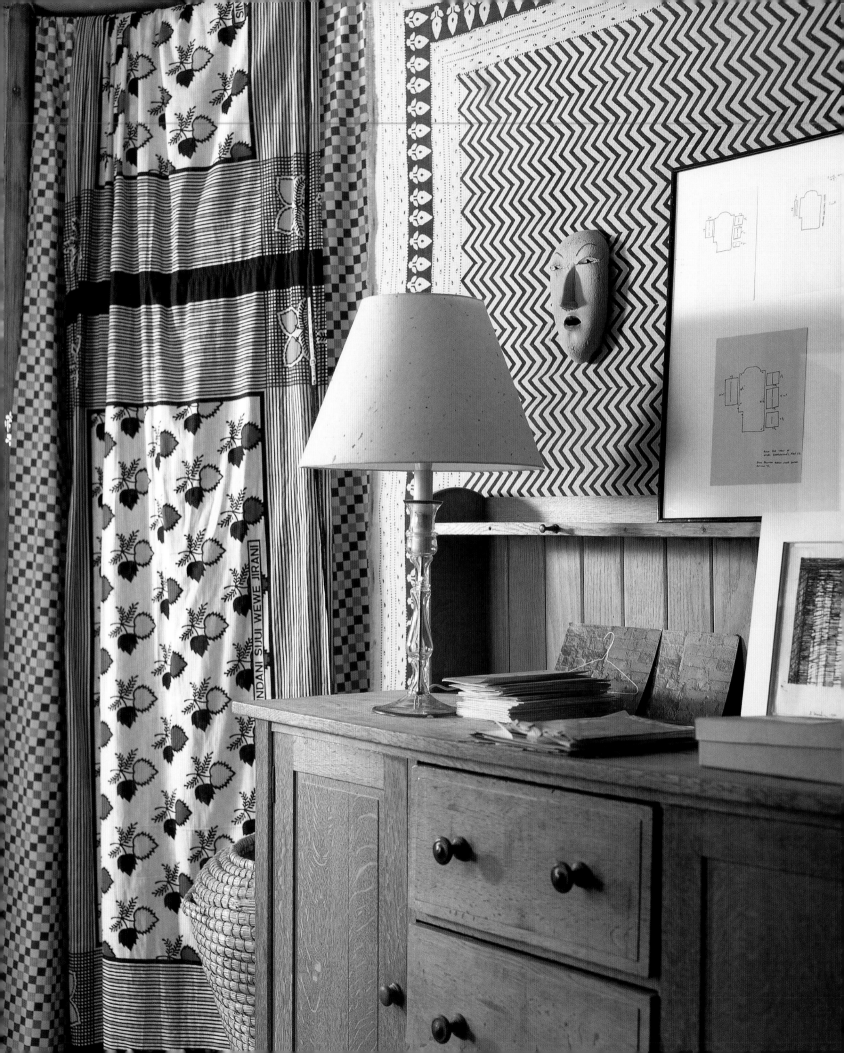

based on paintings and book illustrations that could tell a story or describe a scene on a large scale. So successful were these sometimes mythical, sometimes historical, but always lyrical designs that they were widely copied, and monochromatic prints of this nature, wherever they are made, are now collectively known as toiles de Jouy.

New printing techniques

Later in the century, roller printing was introduced, and eventually ousted plate printing altogether. The heyday of roller printing was probably 1815 to 1835, and its advantage over plate printing is that far finer detail of design can be imparted. First engraved by hand, but later by a small cylindrical "mill", the rollers were sometimes used for outline alone, with the other colors introduced into the pattern by block printing. The dimensions of the roller naturally affected the size of the print and, consequently, the style of motif.

By the late eighteenth century, the decorative possibilities of all these new cotton prints were swiftly grasped, particularly by those engaged in the design and making of decorative

quilts. Many patchwork quilt designs featured a central medallion, usually a large square or diamond, and the detailed new chintzes with large motifs such as flower baskets, cornucopia, and the like made fine central panels. The interest in patchwork lasted well into the nineteenth century, and the neverending supply of cotton prints produced went some way to satisfy the demand.

Printed textiles have always represented not only fashion, but also the interests and concerns of the day. Eighteenth-century society was fascinated by the mysterious East and all that came out of it, and those ubiquitous Indian motifs, the Tree of Life and Kashmiri feather cones, were interpreted and reinterpreted in hundreds of different ways. Printed fabric imitating the very fashionable, but equally expensive, handpainted Chinese panels was also popular. Following the excavations at Pompeii and Herculaneum, classical images, grotesques *à la* Raphael, and a forest of Corinthian columns sprouted on contemporary designs.

North America imported printed cloth from Europe until the end of the eighteenth century, but then its own burgeoning textile industry began to design prints, some based on

chintz, used both in clothing and home decoration. The success of these early printers meant that the long-established wool, linen, and silk manufacturers in England and France felt threatened. They lobbied for a ban on the printing of cotton cloths, first in France in 1686, then in England in 1700. Their protests were successful, and the prohibition against cotton printers lasted in France until 1759 and in England until 1774, setting back the development of the industry.

When the ban was lifted, cotton printers in England, Ireland, and France began production. One of the most successful and earliest of these entrepreneurs was Christophe-Philippe Oberkampf, working at Jouy near Versailles. His cottons were to become celebrated. Although he produced many designs based on the highly popular *indiennes*, he is perhaps best known for his instantly recognizable, monochrome color prints using purple, red, sepia, or China blue on a neutral background. The size of the new copperplates now used for printing meant that each design could be up to a yard in area, a far cry from the scale of design the old hand-sized wooden blocks could produce. The size of the motif gave Oberkampf scope to create designs

top left Do not spurn sophisticated interior fabrics in an outdoor context. Three different patterns on cushions and cloth are all everyday east-Indian printed cottons.

above left There is something remarkably relaxing in the sight of these faded cottons, giving a languorous air to a wooden *chaise longue*.

right An eccentric way of treating a printed fabric is to cover an upholstered seat with filmy nineteenth-century lace to give the modern, flowered cotton print below a watery, clouded look.

opposite Over a background of a mid-twentieth-century printed checked cotton, a cotton from Kenya is divided into lengths separated by stripes, each length originally cut to be wound into a headdress.

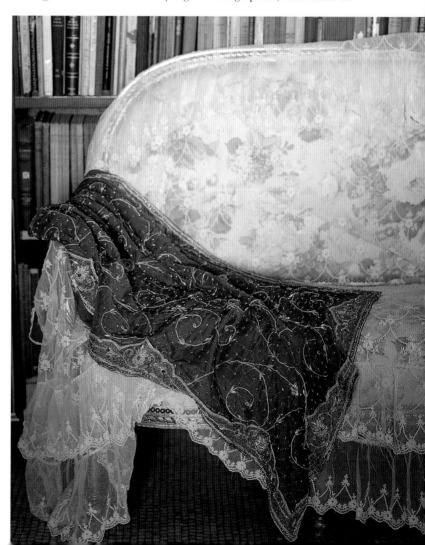

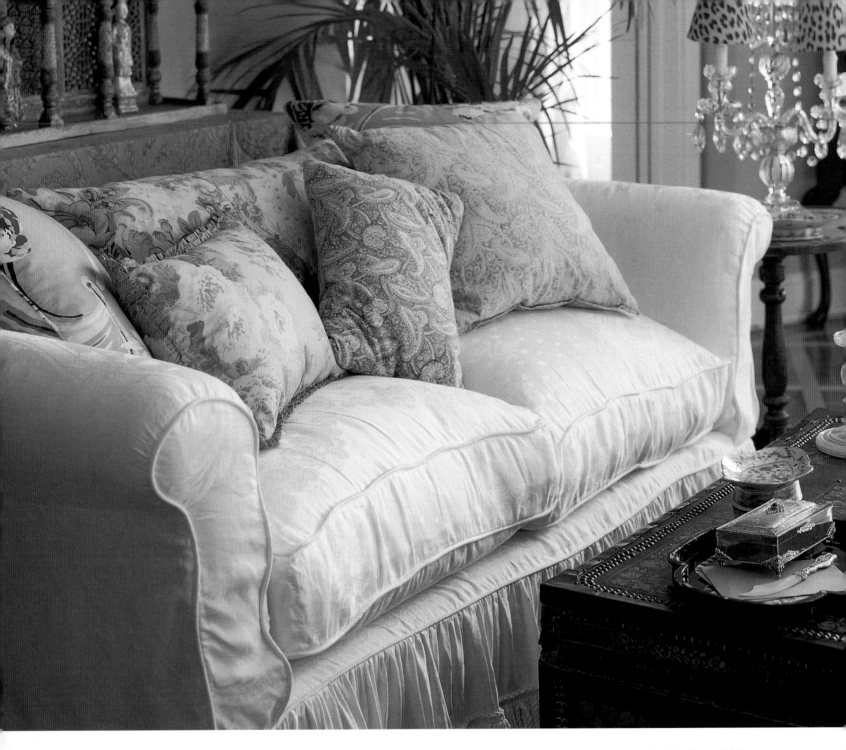

European fashions but others original American designs. They were characterized both by small all-over prints, known as calico, and by patriotic prints of medallions illustrating famous Americans and victorious battle scenes.

Combining printed textiles

Today, there is no shortage of printed fabrics, often still in the form in which they were last used, as curtains, bedcovers, and so on. If you are lucky enough to find a pair of old printed cotton curtains, their colors faded softly by the sun, don't cut them up. Even if they will not fit any window at present, put them away and wait; one day they will be right. Printed scraps can be used as the central motif in a simplified quilt or can be cut into uniform pieces to use for patchwork. If you have a large enough piece, printed cotton can be used to make an interesting headboard, perhaps trimmed with braid or ribbon in one of the colors.

And then, of course, there are scatter cushions. Nothing looks nicer and more inviting than a chair or sofa elbow deep in pillows, all uniformly faded but of different designs and shapes. If there is not enough fabric for a two-sided cover, it can be backed with a new material. Go for one that harmonizes with the old print rather than one that contrasts violently, as it will be more in keeping with the faded atmosphere. Generally, old printed cottons, however they are used, look best when mixed with other cottons, new or old, rather than with heavier fabrics such as wool, or far lighter ones such as silk. When color and pattern differ, it is important to keep the weight and texture the same.

right There is something appealing and subtle about the idea of covering this grand gilded armchair in a pale, deliberately understated cotton print. To emphasize the design, a similar but not identical – and much brighter – print is used for the large squashy cushion.

left One of the best ways to use small pieces of printed cottons, even if they are of different designs, is to make them into pillows and then mix them all together to transform a plainly upholstered seat. The decorator's touch that unifies this scheme is a throw made from the same printed design as one of the pillow covers. The color scheme is consolidated by the deep tones of the tablecloth immediately behind the sofa.

below Nathalie Hambro takes scatter cushions made of printed cotton from French manufacturer Braquenié and stacks them up into vertical piles that have more significance than pillows used singly.

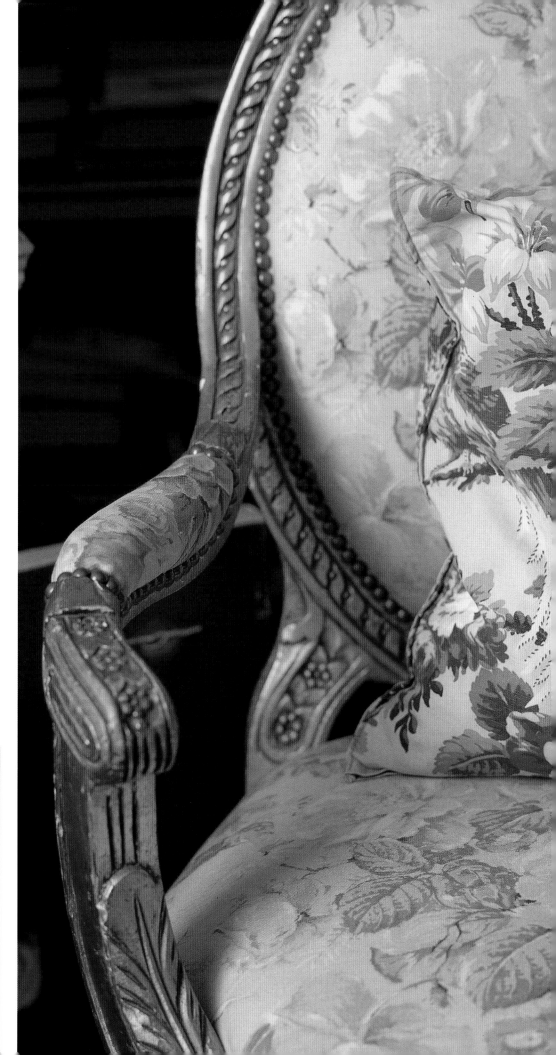

woven textiles

There was once a popular child's toy that is identical to the most primitive loom. It consisted of a huge needle that wove strands of yarn or thread through some upright sticks in a basketwork form. From such a humble structure, a piece of wooly material started to emerge: welcome to the almost magical process of weaving cloth!

Loom-woven textiles have an ancient and honorable history. It is generally accepted that woolen textiles have been woven in the Middle East from between 10,000 and 4,000 B.C. New research even suggests that during the Paleolithic period between 27,000 and 20,000 B.C., female cave dwellers in central Europe may have worn short dresses of woven linen or string. Certainly, fragments have been excavated from burial chambers across the ancient world, proving that weaving was practiced at least two thousand years ago – not just for utilitarian purposes, but also for adornment and to maintain dignity. Originally, thread was woven on hand looms, as it still is in many parts of the world today.

Worldwide weaves

Native Americans have long woven blankets, bags, and other garments using various ingenious methods, such as braiding, plaiting, and using the fingers to guide the yarn. Their choice of materials is even more ingenious, and depends on the location of the tribe. The materials include hair from buffalo, moose, opossum, and mountain goat, cat-tail fluff, and, in the case of the Salish from the northwest coast, the fine hair of a small white dog specifically bred for the purpose. Other materials include cornhusks, bear grass, Indian hemp, and cedar and mulberry bark.

The weaving of the Pueblos in the southwest is famous throughout America. Different tribes practice distinctive weaving techniques and utilize different decorative devices, such as the diamond twill designed to decorate the borders of Hopi dresses. All-purpose blankets are the most widely produced items, and those made by the Navajos are perhaps the best known of all, with their distinctive, strong harmony of color and design. The first colors to be exploited in the cloths were the tonal variations found in sheep's wool, cream to beige and back again. During the late nineteenth century, commercial dyes became available, and Navajo weavers swiftly took up the bright aniline colors. They used them in bold, geometric patterns that are now immediately recognizable as Navajo work.

In Guatemala in Central America, the Maya wove cotton textiles for their priests and the noble class in the grand civilization that flourished between the fourth and tenth centuries. The designs are distinctive and

right The strength of the design of African textiles is extraordinary. In this narrow hall are fine examples of cloths that use different weaving techniques. On the left is a piece of tie-dyed cloth, a technique used all over Africa; in the center is a magnificent Kente cloth, woven by the Ewe of Ghana; and on the right is a Kuba cloth from Zaire. No other decoration is needed, although the colors of the nineteenth-century encaustic floor tiles do go particularly well with those of the various textiles.

left It is the wonderful earth tones of Eastern textiles that make them so warm and welcoming, and so useful in interior decoration. Here, hung the length of the door, a silken African Kente cloth, with its warm ocher tones and unusual woven inserts, is complemented perfectly by a small piece of an Indian woven hanging that perfectly fills the dead space between the door and its frame.

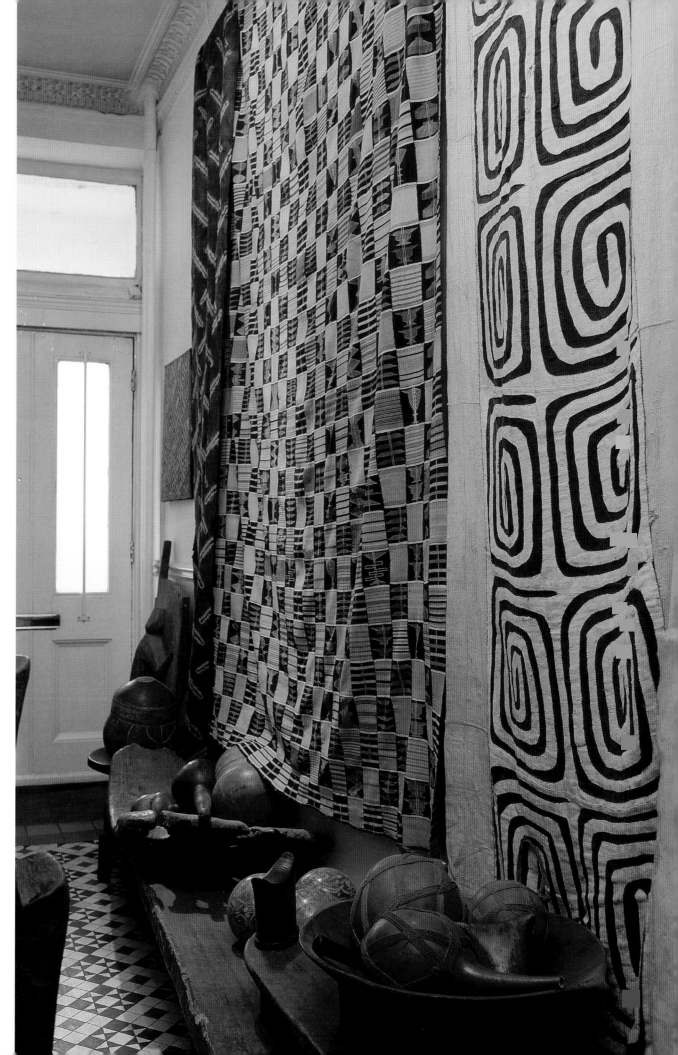

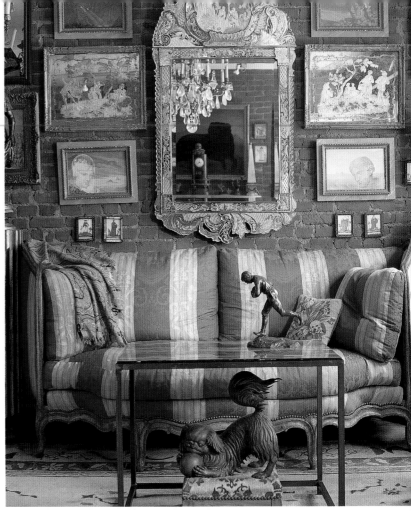

right This grouping of eighteenth-century Italian sofa, casually draped French shawl, and a Venetian mirror is eye-catching because it is arranged against contrasting bare brick.

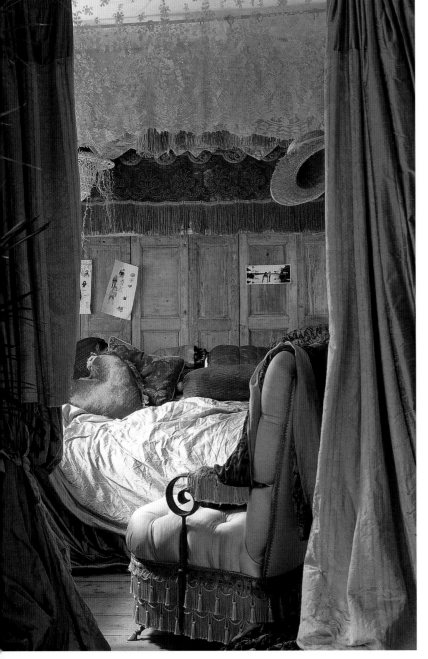

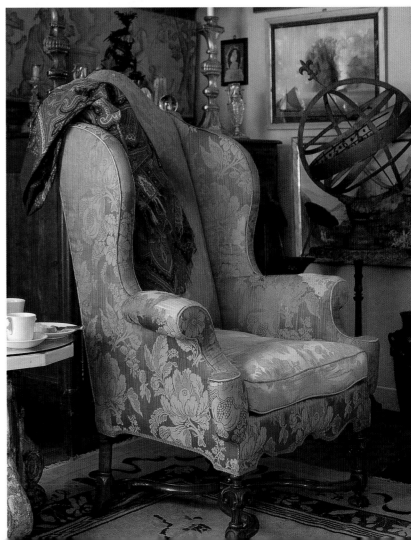

above Dark and moody, a plethora of woven textiles of all types makes this a hidden sanctuary. But all is not as it seems: the faded old damask curtains open to reveal that behind the small curtain above the daybed are books, files, and other reminders of daily life.

right A fine eighteenth-century armchair should be covered in an equally fine fabric – here silk damask – and then the pair just left to grow old quietly and gracefully.

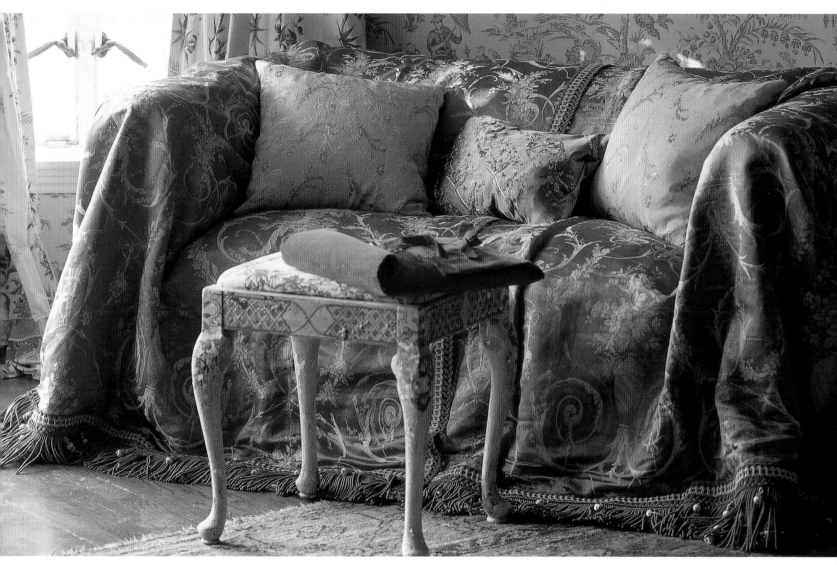

bright, depicting birds and beasts or people and flowers scattered over the field of the textiles. In South America, Ecuador, Peru, and Bolivia are renowned for the long history and wonderful qualities of their textiles. From well before the birth of Christ, different tribes and cultures wove, decorated, and embellished their textiles. In Peru, the earliest textiles found are cotton and are at least 4,500 years old, although cultivated cotton was not introduced here until some time between the eighth and eleventh centuries. The Peruvians wove some of the finest yarns ever known, often on a backstrap loom. The Incas, who reigned between the thirteenth and fifteenth centuries, made sure that their priests and the nobility were dressed in the finest weaves and tapestries, unlike the peasants who worked for them. The Inca emperor owned, controlled, and distributed all wool, and demanded woven cloth as tribute in return. In Peru today, their Quecha-speaking descendants weave colonial and precolonial garments such as belts, ceremonial wraps or mantels, ponchos, and ponchitos. These last are usually rectangular pieces from which many garments can be fashioned: they are sewn together in lengths, the width determining the shape of the garment.

Traditional weaving from llama wool and cotton continued in South America until the arrival of the Spanish conquerors in the sixteenth century. The introduction by the Spaniards of a hardy breed of Andalusian sheep, together with flax crops and silk farms, changed forever the tradition of domestic weaving. By 1650, wool and cotton blankets were being produced on vertical looms, and much of the indigenous breadth and exuberance of design was gone.

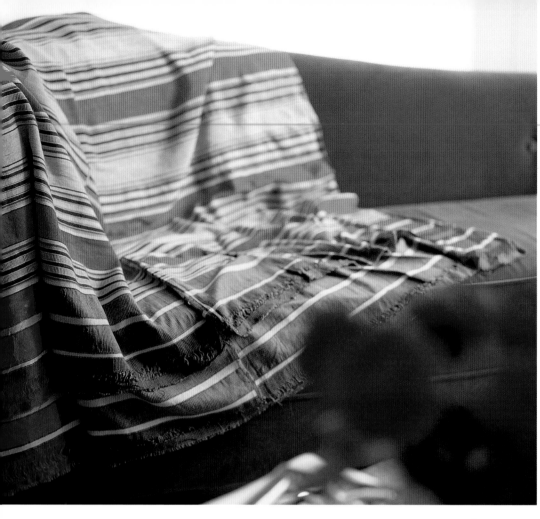

right At first sight, this combination may seem a jumble, but the beautiful nineteenth-century Venetian woven ocher cushion, with its red and green motif, and the black silk Franco-Chinese cushion with jolly pink embroidered lanterns work together because of the conciliatory background of ready-distressed contemporary linen upholstery.

above With its wonderful combination of rich colors, this striped wrap of Syrian silk is the sort of piece that will work anywhere to give the plainest of backgrounds new life and vitality.

above right Pillows made in *petit point* were routinely embroidered by Victorian ladies and remain as popular now as they were a hundred years ago. Many fine examples can still be found today, such as this unusual geometric pattern edged with fringe in the same tones.

below right Combining textures successfully is what decoration is all about, and this cushion is a modern patchwork by Italian company Etro of a checked tweed with velvet and a tweed backing. It sits on a "Wallabee Pocket Rug" – a buggy blanket with a pocket.

In North Africa, the Berber people weave kilim-type tapestries, blankets, clothing, tent cloths, and bags. The wool comes mainly from their flocks of sheep, but also from goats and, occasionally, from camels. Cloth is even woven from the raffia palm in parts of West and Central Africa. South of the Sahara Desert, the traditional tribal societies of West Africa have been weaving textiles for ceremonial and household purposes for at least a thousand years. Weaving has been a highly developed craft there since at least the sixteenth century. Weavers used whatever yarn was available, from highly prized (but rare) imported silk to raffia and cotton, which is widely cultivated in West Africa. Weavers employ narrow looms to produce strips of cloth three to ten inches wide. Between twenty and a hundred of these narrow strips are then joined selvage to selvage to make up a variety of garments and furnishings – togalike men's robes, pants, and hats, women's clothes and headscarves, blankets, wall hangings, and floor covers.

Matching the pattern from strip to strip is tricky, requiring experience and skill. The long-standing design tradition of these weaves is characterized by complex compositions and

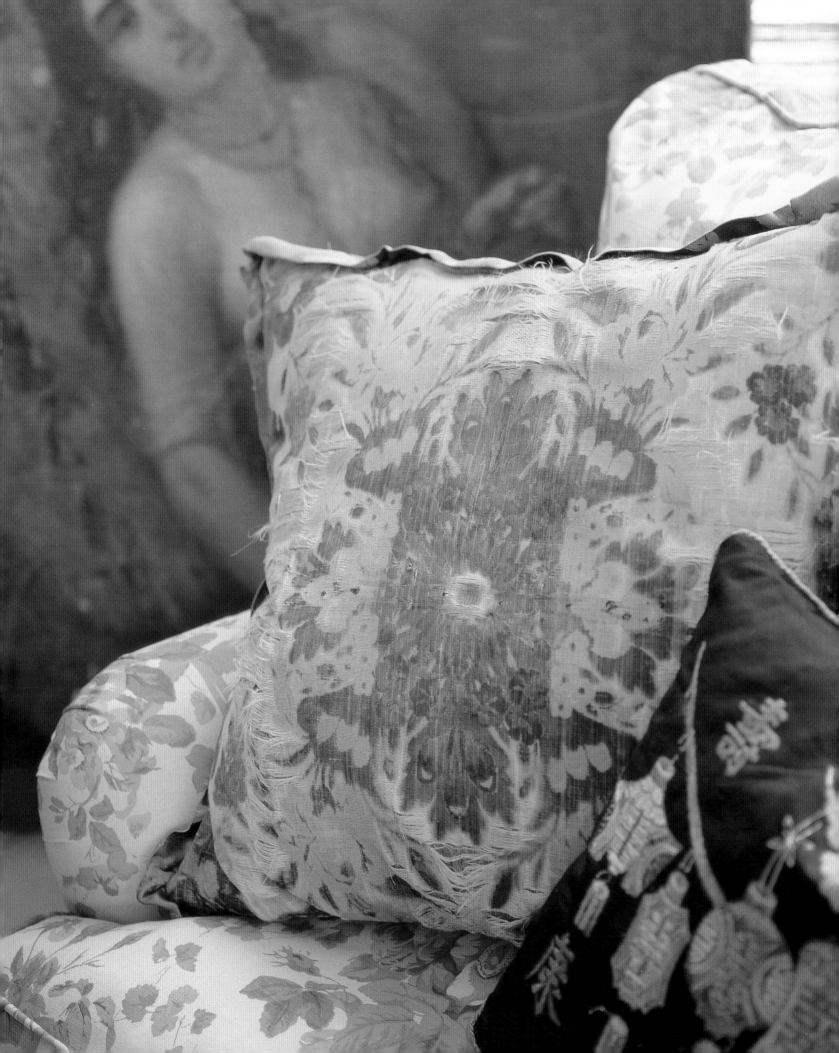

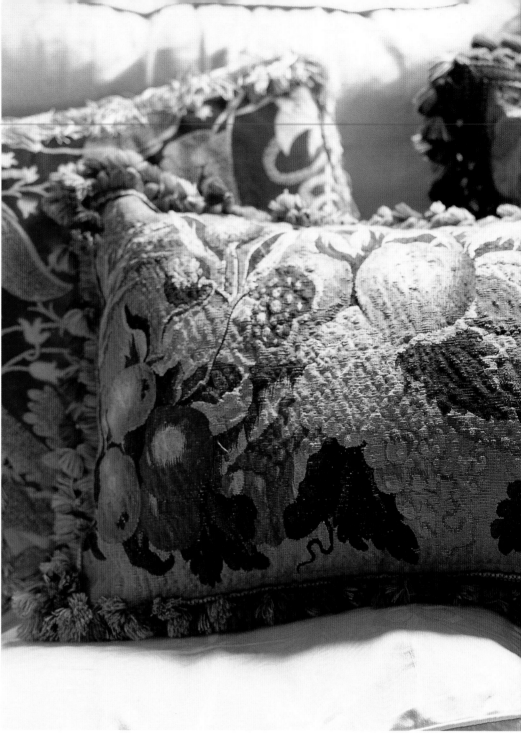

above left A collection of shawls and blankets, including a nineteenth-century British paisley printed shawl, are kept for practical purposes on a chair. It just so happens that their colors and textures make them a decorative pleasure as well.

left An interesting use for a nineteenth-century tapestry is as a coffee-table top, covered with a sheet of glass. Behind the table, on a sofa upholstered in modern cream twill, is an antique cushion of printed cotton trimmed with a thick cream fringe.

wonderful geometrical designs, and by symbolical and stylized shapes that are the result of many generations' creativity.

During the time of the wealthy Ashanti kingdom of the seventeenth century, woven cloth of an exceptional fineness was commissioned. Waste silk from French and Italian processing mills arrived across the Sahara by way of Morocco and was woven by itself or combined with hand-spun cotton to make *kente* cloths, as well as the even finer *asasia* cloths reserved for royalty and courtiers. Kente is now a common term for Asante silk

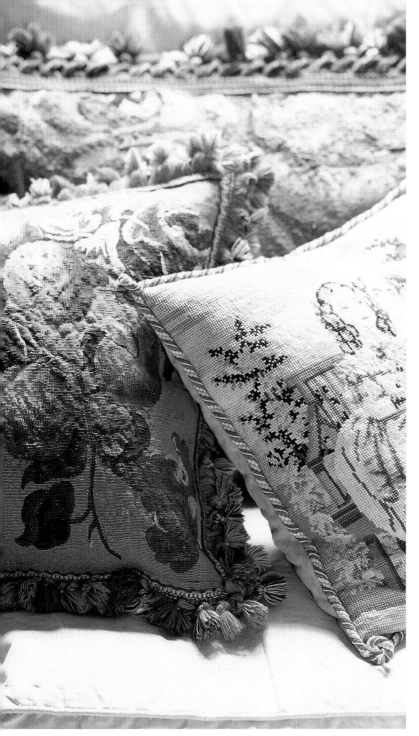

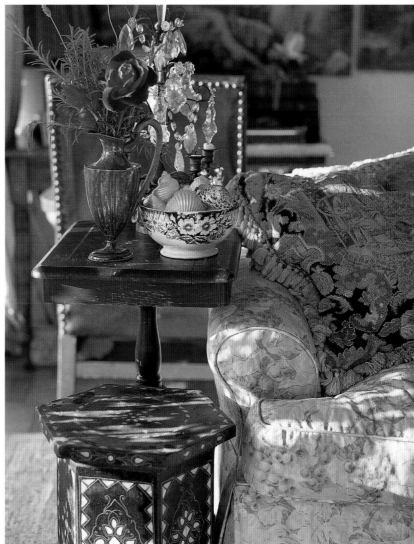

left Although all the pillows on this sofa are made from different antique textiles, including strongly patterned eighteenth-century tapestry and delicate Victorian *petit point*, they all work together because they are boldly trimmed and because they share elements of the same colors, red and blue.

below Woven textiles need not be confined to their own kind. A large tapestry cushion picks out the colors of the upholstery fabric and of the inlaid side table.

cloth, and some of the most fabulously colorful and highly patterned African textiles come from this region.

Tapestry

The apotheosis of the weaving technique is often considered to be tapestry, an art that could be defined as a woven textile that paints a picture. Almost every culture has woven tapestries at some time in its history, from the ancient Chinese, who developed silk tapestries, to northern and central Native Americans and ancient South American peoples. But it was in medieval Europe that the art of tapestry first flourished to produce the majestic woven works we know today.

At that time, members of the nobility still traveled between their various properties, and tapestries were among the most useful of all furnishings under these circumstances. They could be rolled up, packed into a baggage cart, and easily taken on to the next dwelling; there they could be hung to provide immediate warmth and decoration, and to demonstrate status due to the owner.

From the thirteenth to fifteenth centuries in Germany, France, and later in Flanders, wonderfully detailed and colored hangings were produced. They depicted in fine detail the interests of the day, such as religious subjects, courtly love, and allegory. Fascinated as they were with what can only be described as the joys of nature around them, the tapestry makers took delight in reproducing the natural world through the medium of the loom. Tapestries made during this period are crammed with animals, birds, flowers, and trees, all observed in great detail. The images

below left A wonderfully elaborate gothic chair is covered here with a close-woven tapestry of a contemporaneous pattern that reflects the eccentric design of the chair itself. A simpler upholstery treatment would spoil the fun of the piece.

below right A rounded-back Victorian chair is still in its original, now faded and worn, covering of *petit point* embroidery work The depth of character that real life gives to the honorably aged textile of this chair should not be lightly dismissed.

right A bedroom combines diverse cultures with contemporary design in the striped valance. The tassels are Turkish, the rugs oriental, and the cushions are English church kneelers.

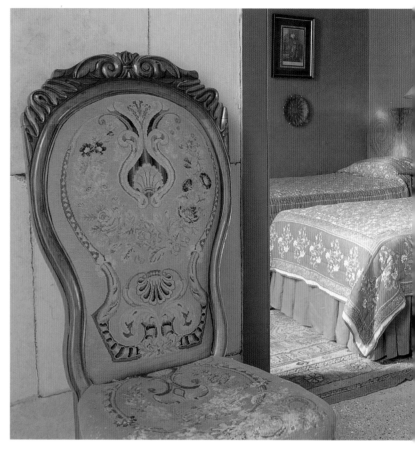

were scattered across the field of the work, finely perceived and subtly colored, although at this date there were only about fifteen to twenty dye colors available – as opposed to the choice of between four and five hundred by the end of the eighteenth century. Yet there is nothing primitive about these medieval tapestries; even today, the fineness of their thread and the subtlety and intricacy of their design have the power to astonish.

Throughout the sixteenth and seventeenth centuries, the art flourished, becoming ever more sophisticated both in design and execution. The demand was higher than ever: the new, prosperous bourgeoisie now bought tapestries. Pictorial tapestries were usually designed as a series, with a number of different scenes, one per hanging. The drawn designs, known as cartoons, were either copied from paintings of the day or were produced as originals by some of the great artists of the time, including, famously, Raphael and Rubens. Cartoons were often painted in gouache on paper or in oils on canvas and were supposed to be used as exact models. Tapestry quality depended directly on the quality of the cartoons, and thread followed brushstroke to create a woven replica. From these original cartoons, numerous series of tapestries might be executed, a popular subject possibly being in demand for as much as a decade or so. To some extent as a result of this interaction with fine art, the style of tapestries changed over the centuries. Gothic abundance gave way to a simpler, more refined style of work in Renaissance Europe.

The popularity of the woven tapestry continued across Europe, and by the eighteenth century, the tapestry makers of France were held in as high regard as those of Flanders had been before them. The Gobelins manufactory was founded by the Minister of Finance, Colbert, in 1663, and the center of Aubusson, which had been weaving for the nobility since the fifteenth century, was granted the title of Royal Manufactory in 1665. Large tapestries required large looms; the thread used was usually wool, but occasionally areas were worked in brightly colored silk or even in gold or silver metallic thread. Unsurprisingly, these large tapestries were expensive to commission, taking up to two years to complete and involving a large number of highly skilled weavers.

Tapestries were classified into various types. Pictorial scenes were almost three-dimensional and either commemorated a battle (successful, of course) or a mythical or religious subject, one that usually reflected favorably on the life and exploits of its commissioner. The other main

type was named *verdure*, comprising a never-ending variety of wooded landscapes that had developed from the early, popular hunting scenes. *Verdures* were cheaper than pictorial tapestries, as it was easier to weave a succession of glades and forests than it was to design and make specific compositions. They were also easier to incorporate into the average decorative scheme, since woodlands could be cut where necessary to fit the room without too many disturbances to the continuity of the design.

Really expensive tapestries were commissioned and designed as a set with a particular room in mind and woven to its exact measurements. Not quite as exclusive, but still expensive, was a set commissioned from an already well-established set of designs, but woven to the new buyer's required measurements. And cheapest of all was a ready-made set, which the buyer would then himself arrange to have cut to fit the room, or perhaps just folded to make the right shape. The borders were often woven separately so they could be cut to order to edge a re-shaped tapestry. For all their initial cost, once they were up on the walls, tapestries could be treated quite casually. Many seventeenth-century paintings and drawings of interiors show pictures nailed through tapestry-hung walls with scarcely a thought for the work that had gone into the background textiles.

Seventeenth-century tapestries could also be employed as status symbols: for example, kings and nobles commissioned large imposing tapestry sets commemorating their own, usually military, achievements. A trade even grew up in recycling these military sets to make them suit their new owners. One well-known set of designs from the Gobelins factory, "The Art of War", commissioned first by England's King William III, was subsequently adopted by several other European leaders. Later the Duke of Marlborough had two copies made for himself and six more sets for his generals. Twelve further sets were made for other European nobles, customized to order, in some cases partially reusing the old subjects with the main fields changed, and sometimes with faces within the tapestry altered.

At this time, woven tapestry was used for the furnishings as well as for decorative wall hangings. It was employed in suites of furniture, often designed to match the wall hangings, and separately for bed hangings. In Holland, a band of tapestry was sometimes

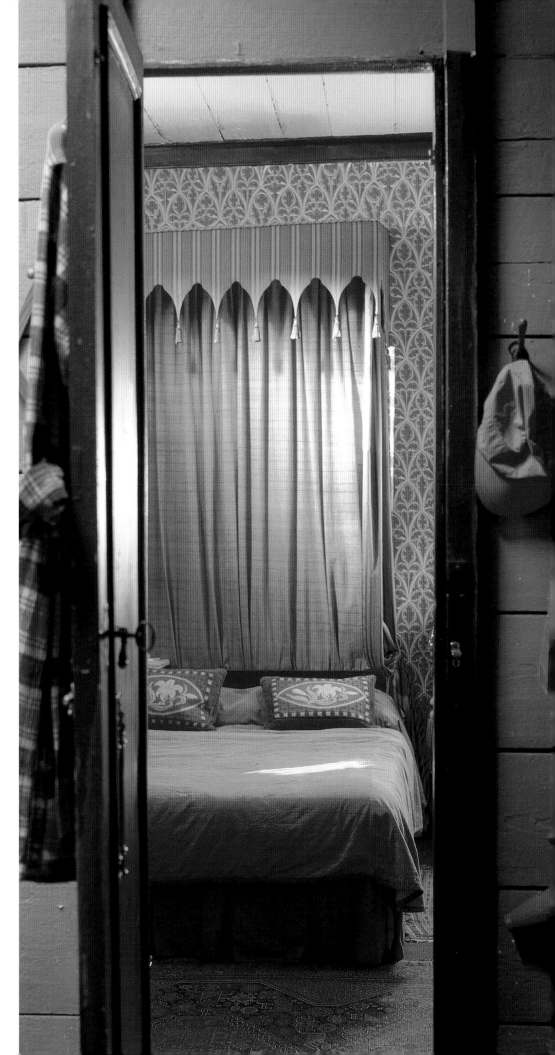

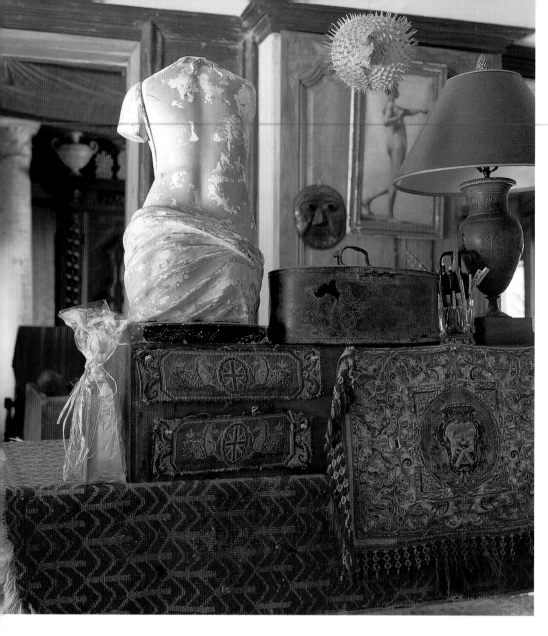

sophisticated, subtle, but expensive, alternative to tapestry. Silk damask is supposed to derive from Damascus, although it was woven in China over two thousand years ago. Later, it was very successfully woven in Lyons. Although pure silk was considered the finest thread for damask, in a less expensive fabric, the silk could be mixed with linen or cotton or even with both at once. The subtlety of damask is that the designs are woven into the fabric and are not always apparent at first glance. This made the material a fine background for oil paintings, which guaranteed its popularity in the eighteenth century.

The busier brocade is also associated with the rich hangings of the seventeenth and eighteenth centuries. Brocade is a decorative overlay that looks a bit like embroidery, but in fact entails thread, often gold or silver, woven into the original fabric to raise the pattern above the cloth.

Textured interiors

Using tapestry and woven textiles today in a decorative context is rewarding and easy to do. It is, however, important to think about the weight of the fabric you use. Obviously, if it is a very heavy weave, it will not hang well as a curtain, although a lighter weave, of shawl weight, say, can look very striking at a window. Heavier pieces can make an attractive border for a curtain (as long as the curtain material is not too flimsy), either just run across the bottom or taken down the edge as well.

If a tapestry weight cannot be used as a window curtain, it certainly can be used as a *portière*, or door curtain, which may well have been its original purpose. Woven pieces can also be well displayed on the door itself: if it has panels, they can be mounted inside them using the panels as frames; and if the door is plain, any textile additions will probably look best framed with light molding, or edged with braid and then hung like a picture. Displaying small pieces on furniture is another way of appreciating woven textiles. In his Connecticut house, interior decorator Michael Trapp pins small, interesting pieces on the back of a desk that sits at the top of an open staircase, so as you climb the stairs you see the intricacies of the weaves in detail. And formal pillows are a good way to use structured, woven textiles, since they will hold their shape and form with ease.

above Two small strips of English needlework from the nineteenth century and a heavily fringed, larger Italian appliquéd fragment from the early seventeenth are tacked to the back of an old desk. The desk itself is covered with a woven textile as a background for the display.

right Sometimes a textile is too good to be cut up. Here a fine piece of green woven fabric from Fez is simply folded over a cane seat. It can be clearly seen and appreciated without being damaged, and the lines of the design are echoed in those of the chair back.

attached decoratively around the sides of a fireplace. But by the end of the eighteenth century, tapestry was replaced in the popular taste by lighter hangings and by newly invented wallpapers. The golden age of tapestry was over.

Damasks and brocades

The term *tapisseries* was not exclusive to woven hangings, but included all those made by a tapissier or upholsterer; perhaps some of the wall coverings listed in inventories as tapestries were, in fact, hangings of another type. Many other woven textiles were employed decoratively on the wall, including velvet. Heavy tapestry and velvet hangings were replaced during the summer with lighter-weight alternatives made from fabrics such as taffeta or damask; the latter was considered a

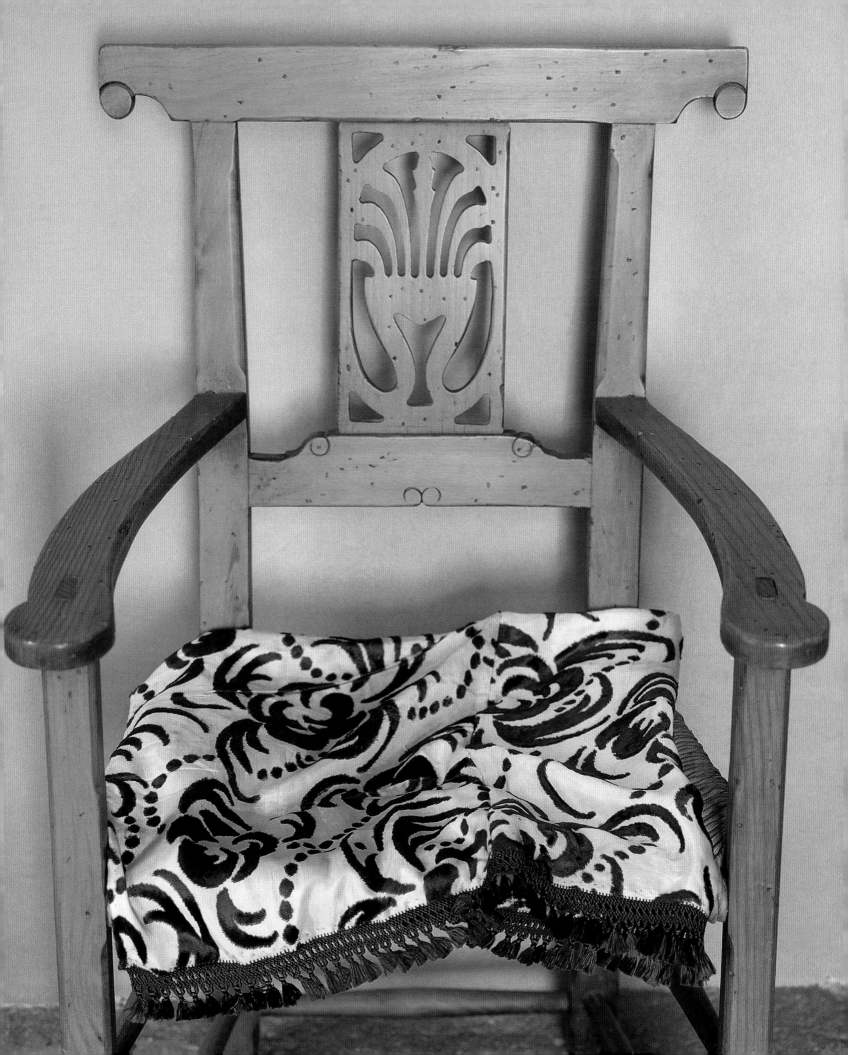

paisley

The shawls of Kashmir have been famous for hundreds of years for the softness and fine quality of their cloth. They were worn in the conventional way and also as shoulder mantles, waistbands, turbans, and scarves. Woven in a manner similar to that of tapestry and taking up to a year and a half to complete, the shawls incorporated various traditional and regional motifs, including the *boteh*, a curled, featherlike plume. This pattern has since become synonymous in most people's minds with the paisley pattern, and could be said to be one of the most important and recognizable textile motifs ever.

above The soft texture of paisley patterned shawls means that they can be folded to almost any shape – here as a cloth for a low stool with a skirt that sweeps the floor.

right Because many shawls have quite large central fields in plain colors, they can look very good as cloths draped over large tables, where the full impact of the design can be appreciated.

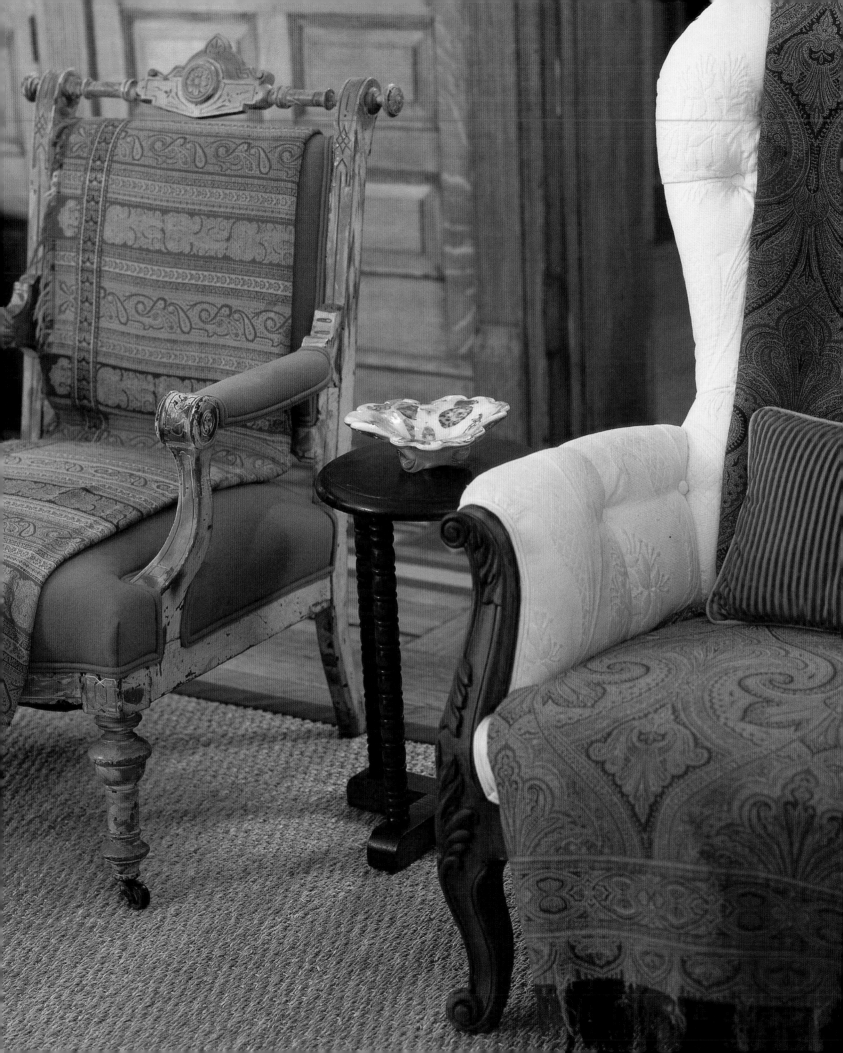

Paisley from East and West

Kashmiri shawls did not represent a folk art in the way that, say, kilims woven by Indian nomads did, but were made rather for an expanding commercial market. Increased communication between East and West in the eighteenth and early nineteenth centuries, through trade and immigration and the fact that Kashmir came under British rule in 1846, meant that these exotic, fine pieces were seen and admired in the West. Shawls from Kashmir began to be fashionable from about the middle of the eighteenth century and were highly coveted. By the early 1800s, they were essential fashion accessories both in London and Paris. As many as could be made were exported, but inevitably, as demand exceeded supply, European, and in particular British and French, manufacturers began to make their own versions of the Kashmir originals. These are what we now recognize under the generic name of paisleys.

The first cashmere-type shawls to be made in Britain were manufactured in Norwich and Edinburgh during the late eighteenth century. A little later, weavers in the neighboring Scottish town of Paisley began to follow the Edinburgh example in an effort to capture part of this ever-expanding market. Through the latter part of the eighteenth century and well into the nineteenth, all three centers specialized in weaving – Norwich focusing on silks and dress materials, Edinburgh on damask and Paisley on

voile and silk. Thousands and thousands of shawls were sold, such that even today the figures are surprising. In Norwich in 1800, for example, some twenty shawl manufacturers were registered; nearly fifty years later, twenty-nine different types of shawl were listed from one factory alone, and in just one year, 1847-8, the factory sold 27,000 shawls.

The output of many of these factories was further increased by the invention of the automated loom: one Joseph-Marie Jacquard perfected the technique and presented his eponymous loom at the Paris Exhibition of 1801. Utilized then in France, the loom appears to have reached England some fifteen to twenty years later, and the weavers of Paisley in particular turned this new invention to sound commercial use. The production and sale of shawls in Paisley grew very quickly, and by the 1820s the factories were even producing reproductions of the original Indian shawl, known as the Paisley Kashmir, and selling them to such countries as Persia, Turkey, and India. The loom had come full circle.

French fashion dictates

French fashions at the end of the eighteenth century, at the time of the Directoire style, owed much to ideas about glamour and beauty, but very little to practicality. A reaction to the rigid brocade court dresses of the *ancien régime* and all they stood for, the new fashionable dresses were made of chilly, pale voile or silk with short

above An exercise in color tones: a damask pillow on a velvet-covered bench is chosen to harmonize with an exceptionally fine Kashmiri shawl.

far left The tradition and continuity of design in antique Kashmiri shawls mean that they work wonderfully well when used to unite two very different styles of furniture.

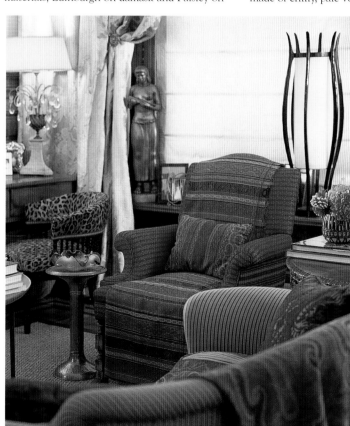

left Instead of informal throws, Kashmiri and paisley shawls are used in very formal fashion as an integral part of this seating group in Jacqueline Couman's New York apartment. And instead of a contrast in the cushion, it too is made from a fragment of shawl.

sleeves and deep décolletage. The shawl became an essential requirement for ladies of fashion. The Empress Josephine, who was responsible for launching so many fashions of the period (and who changed her dress ten times a day) was said to own hundreds of Kashmiri design shawls, both those imported from India and those designed and made nearer to home.

French shawls that were at first woven strictly to the Kashmiri tradition soon became subtly altered, as the inventive Parisians, ever in the forefront of fashion, began to create looser, freer designs. The superiority of these styles was recognized by British manufacturers, and by the nineteenth century, enterprising English and Scottish manufacturers were visiting Paris at least once a year to buy new shawl designs and patterns. When the fashion for shawls was at its height (and many people owned a dozen or more), there was a demand

left A wool paisley shawl goes over a headboard, teamed with a modern cotton quilt from Jaipur. Care must be taken with the actual design of the paisley: it would not do to cut the central motif.

below The variation in the designs of paisley shawls means that they can be used in many different ways – such as a cushion with an exuberant fringe.

not only for the conventional woven woolen shawl, but also for designs that were lighter in design and weight, suitable for wear in summer or over evening attire.

From Norwich and Paisley came some delightful printed shawls, using motifs based on traditional Indian designs, but interpreted in a light, airy manner. Printed on finely woven silk or gauze, they were beautiful, ethereal things. Other variations on the square shawl also developed: there were long, almost scarf shapes; and the turnover, on which the pattern consisted of a combination of borders, so the

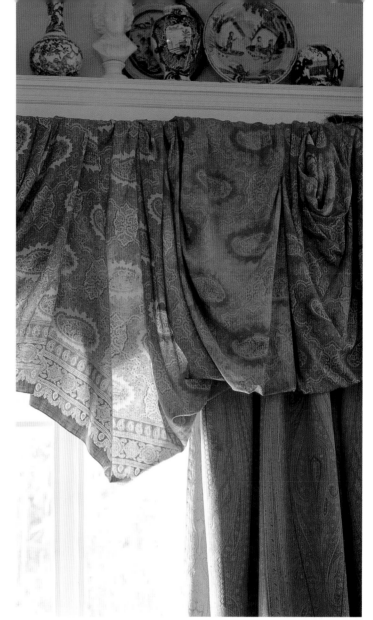

shawl could be turned and worn on the diagonal if preferred.

The changing shifts of fashion continued: the crinoline became popular toward the middle of the nineteenth century, and shawls became larger to match. But by the 1870s, the crinoline was out and in its place came the bustle. This tortured piece of fashion mechanics did not allow for the soft draping of a shawl around it. As swiftly as it appeared, the shawl as a fashionable garment was gone, and by 1870 shawl weaving had degenerated into a popular but unfashionable industry.

Dressing interiors

The shawls that remain today, over a hundred years later, are therefore either Kashmiri originals or of French or English manufacture. Kashmiri shawls are collectors' items, as are

above Many paisley-patterned shawls are woven in very fine wool or wool and silk and drape marvelously. This nineteenth-century Kashmiri shawl is used as an informal valance over the curtain pole. The way the daylight highlights the shawl is particularly pretty.

left Even the smallest scraps of damaged paisley shawls can be used; here they are brought into decorative play to cover a collection of notebooks and sketchbooks.

below left The subtlety and warm colors of Kashmiri or paisley shawls are such that they go with scores of other textiles and designs, and also enhance any color they are put with, such as this warm pink and white cotton print used for the upholstery.

below right Although old paisley shawls are, by their nature and age, not as tough as specially designed upholstery fabrics, they do look marvelous as upholstery. Just be prepared for them to enjoy a short but happy life.

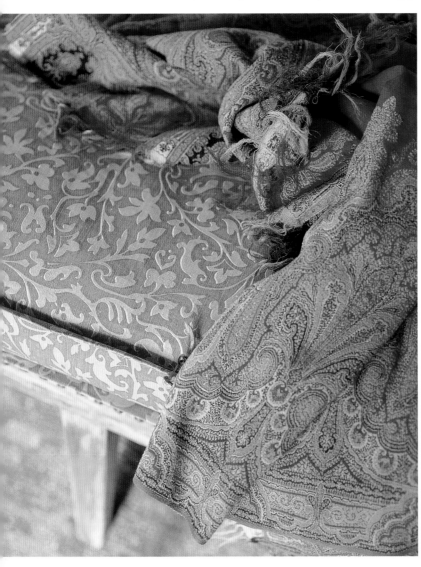

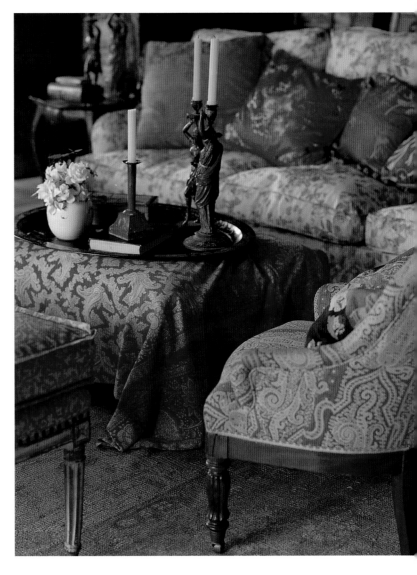

far right A single paisley shawl is used as part of a pair of decorative and practical wall-length curtains. It is lined with a free-falling golden silk that is not attached on either side, so the paisley can one day take on another guise.

some French designs, particularly those that were signed. English shawls, too, vary enormously, from the very fine – in design, weight, and quality of weaving – to the fairly workaday. They can still be found, quite often damaged or torn, and can be put to good use.

The designs, colors and texture of these paisleys, which range from the subtle through the complex to the relatively mundane, have a strong appeal to us today. There is a softness and a charm in the combinations of colors. It is for this reason that they are so popular in interior decoration. They are used for pillow covers, as throws or wraps, as slipovers or slipcovers for headboards, or on the bed itself as counterpanes. A rectangular panel may be appliquéd to the center of a quilt; a damaged length draped across the back of a sofa and tucked in; more intact shawls used as single curtains and valances. The shawls can provide the lining of open cabinets or bookshelves, or they can be made into a screen or panels. All these years later, the paisley still goes everywhere, and one of its great virtues is that a scrap can be just as usefully and decoratively employed as a large unblemished piece.

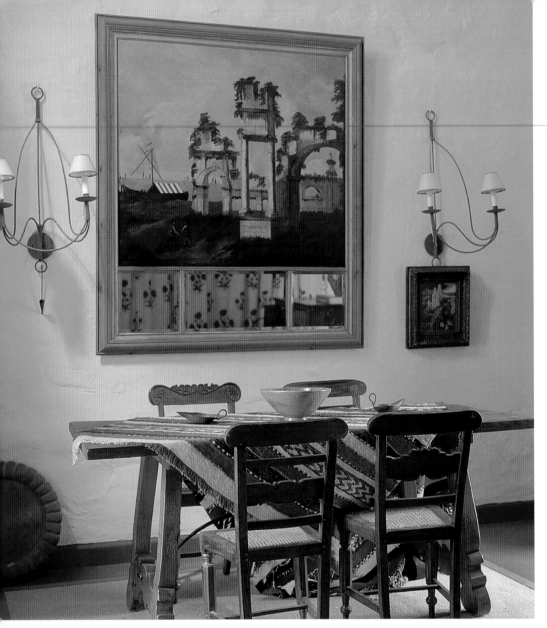

carpets

A few centuries ago, the word carpet didn't necessarily mean a sturdy pile surface, but just anything that lay flat either on the floor or on a table, both for decoration and for protection. The method that most people today probably associate with carpetmaking is the knotted pile, which involves knotting yarn around a warp to make a tough surface.

Rugs have been woven in this way since at least the fourteenth century in Asia Minor, India, Turkey, and Persia. Carpets from Turkey and Persia reached their most splendid between the sixteenth and early eighteenth centuries. The first pile carpets to arrive in the West were considered rare and valuable, and were draped over tables rather than put on the floor. By the end of the eighteenth century, oriental rugs were so widely imported, mainly from Anatolia, that they were soon also used on the floor.

In addition to being home furnishings, carpets were often used purely for decoration, employed almost as a type of banner. In Europe in particular, carpets were routinely hung from balconies and windows on feast days and holidays, perhaps along the route of a parade.

For those who did not want or could not afford the still-expensive pile rugs from the East, "Turkey work" was a satisfactory alternative, used between the sixteenth and eighteenth centuries to make carpets and chair backs and seats. In England, the work was formed using a hand-knotted pile, while in America, the needle formed a pile on a foundation that was pre-woven. The result was a carpet that, if not exactly like a Turkish rug, was a fair substitute.

Flat weaves

Tapestry weave, or flat weave, carpets have long been made in both the East and West. The Eastern version, the kilim, is woven using the hair of sheep, goats, and camels and used to make carpets, tent cloths, awnings, and trappings such as saddle bags. The Western version of the flat weave is exemplified by the tapestry carpets woven during the vintage years of the Aubusson factory in the second half of

above Christophe Gollut likes to use carpets on the table, and in an interesting lateral take on the idea, he sets this Moroccan kilim rug in a diamond shape over the table, rather than using a less interesting rectangle.

right An antique French metal bench, covered in a cotton/linen print, has a central panel of Navajo textile especially woven for Jacqueline Couman. The wall is covered with a modern French fabric used back to front.

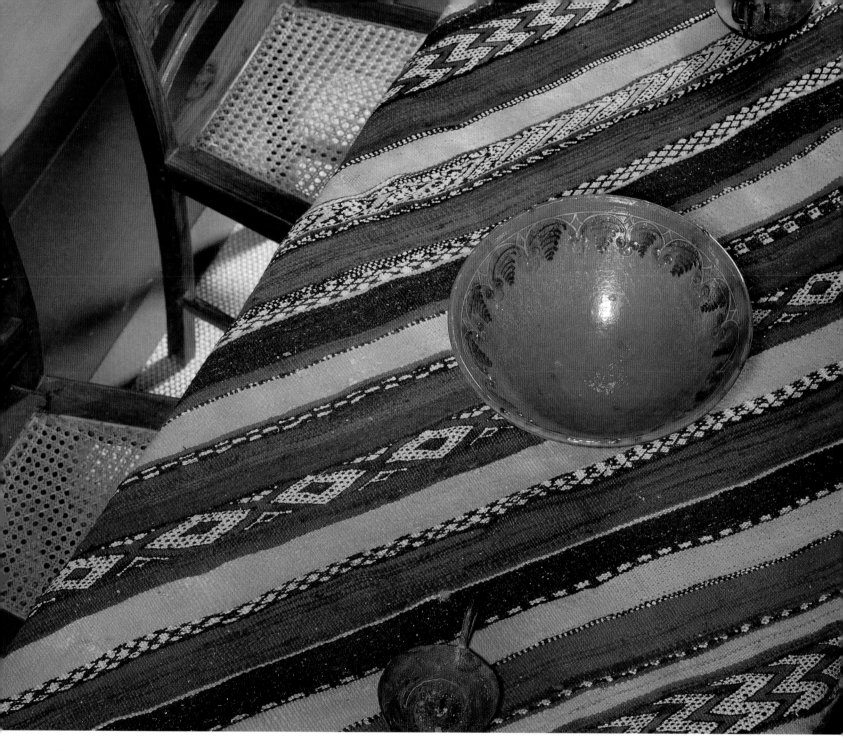

the eighteenth century. At this time, some of the best designers and artists worked for the French factory, luminaries such as Christophe Huet and that personification of the rococo style, François Boucher, whose beribboned, flower-filled designs still charm us today.

Since about the sixteenth century, needlework carpets have been made in the West, both at home and professionally, using coarse or rather finer canvas. The needlework techniques employed were *gros point* or *petit point*, and both were very popular: many a small rug was made to go in front of a fireplace

or in a bedroom. In the seventeenth century, too, a type of velvet with a worsted pile that made it robust was also used for floor carpets. The design historian Peter Thornton reports that Cardinal Mazarin had a carpet made of three widths of velvet moquette, an area wide enough for it to be used on the floor.

In their early days in America, rugs were made in the most ingenious ways – everything was used, nothing was thrown away. The first rugs were of rags cut into strips and then sewn and woven together. Other rugs were made by sewing scraps of old clothing and other

above The characteristic earth tones of the Moroccan kilim used as a tablecloth are accentuated by the ocher of the walls and terracotta of the floor.

household textiles in patchwork form onto a base made from old sacks. The American settlers also braided rugs, using worn material cut into narrow strips and sewn together and then twisted into a fat braid, which was wound from the center in a circular or oval shape.

Most famous – and the most sought today – were hooked rugs, an ancient technique that was developed by the early Americans into an art form. Worn-out material was cut into narrow strips and then colored with homemade dye made from whatever was on hand – vegetables such as beets and onions, fruits such as cranberries and blueberries. The different colored strips were then hooked with a sort of large crochet hook into a backing of wide mesh burlap or woven flax. Their designers encompassed every possible pattern, from seascapes to intricate patterns of flowers and pets and imaginary animals.

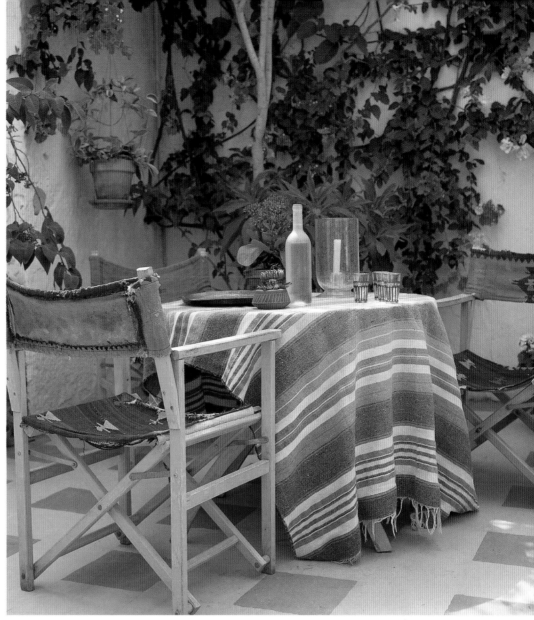

Furnishing with carpets

Although at first glance carpets might not seem the easiest textiles to use in a decorative way, a little lateral thinking will open up ideas. Either whole or damaged and in fragments, carpets can be used instead of other upholstery materials, for example. Take a leaf from Christophe Gollut's portfolio. In the courtyard of his Spanish house, an old kilim carpet has been cut into rectangular pieces, which have then been sewn on top of the canvas back rests and seats of director's chairs. And a whole rug, brought back from Morocco, has been used to cover a dining table, but draped diagonally instead of as a rectangle, prompting a new way of looking at the accepted dimensions of an angular table. Less unusually, but equally strikingly, rugs can be used behind beds, either attached to the wall, or draping an existing headboard.

far left Old Indian kilims can be used in many practical and good-looking ways. This one is cut to upholster the seat and back of a gentleman's chair, where it looks both masculine and comfortable.

left It is interesting to see carpets returning to their original position in the room – on the table. Outside there are additional advantages: this Greek rug is more breeze resistant than a light cotton cloth might be.

above Never throw away worn or torn carpet! Here directors' chairs – easy and cheap to buy – are cleverly covered with strips of old Moroccan kilim. The process is simplicity itself, and for ease and added strength the kilim strips are attached directly to the existing canvas.

embroidery

More than any other textile work, embroidery is a witness of its own time, and of the taste and style of its maker. The closer you look at an embroidered piece of cloth, old or new, the more astonishing it appears. Whether it is a humble piece of domestic stitching or a unique *tour de force* worked with precious stones and gold, each element used, from the thread to the design and the technique, is a source of wonder.

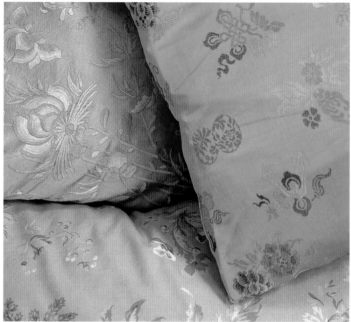

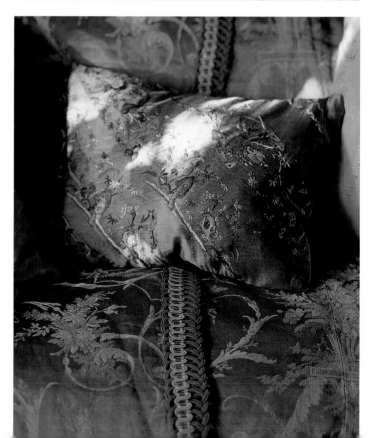

above This flamboyant crewelwork on a pillow was made in nineteenth-century Russia.

above right When using several different patterns of embroidery on scatter cushions, try to group them by color.

below right Pieces involving one or two different embroidery stitches look particularly good as pillows.

far right The dragon is an important ancient Chinese symbol, and great care was taken in its design and execution – as in this intricately embroidered, fire-breathing example.

Defined as "the ornamentation of textiles with decorative stitchery", embroidery is also one of the most fragile and evanescent of needlework techniques, as well as one of the most personal, and one that says as much about human determination as artistry. An embroidered piece can be rough and ready or highly sophisticated. It can be a tribal textile depicting figurative representations in bright, colored yarn or a farmworker's unbleached linen smock; or it can be a piece of fine lawn or silk worked in a variety of complex stitches to create a subtle, intricate design. But wherever or however it was made, each piece displays a universality of technique and understanding.

The art of embroidery has been pursued in almost every country and culture in the world since antiquity. Embroidery threads have been found on ancient Egyptian mummy cloths, and the art was employed in both ancient Greece

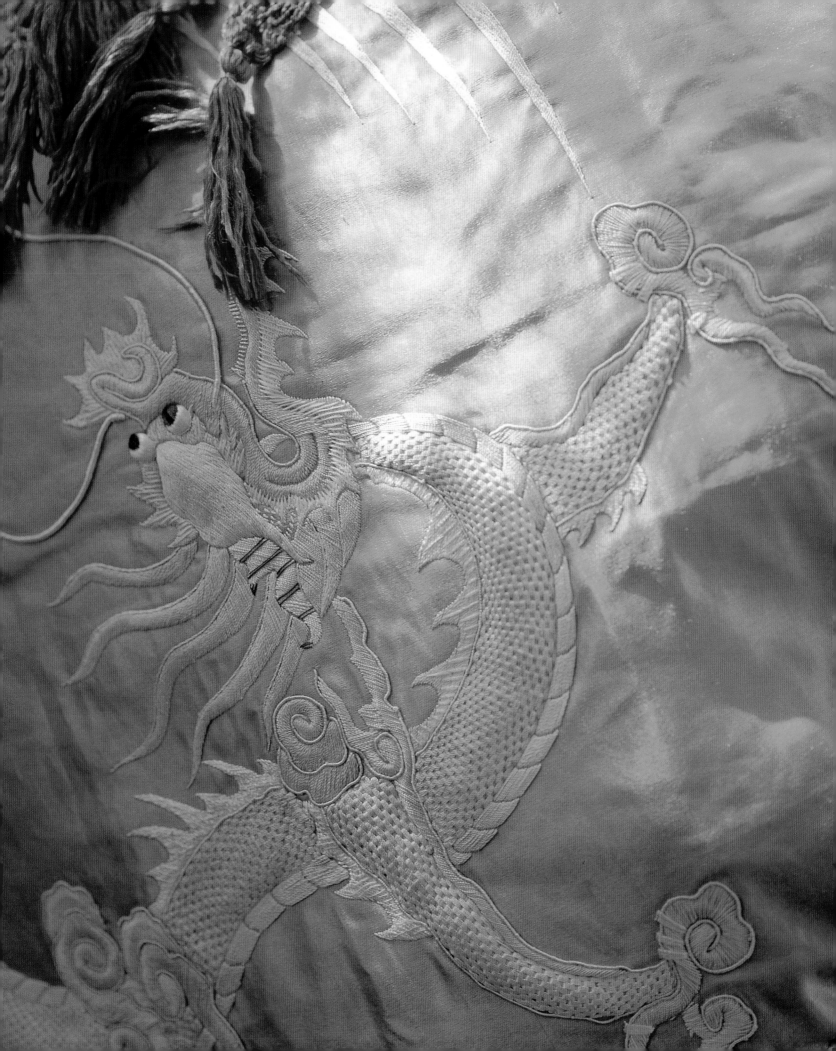

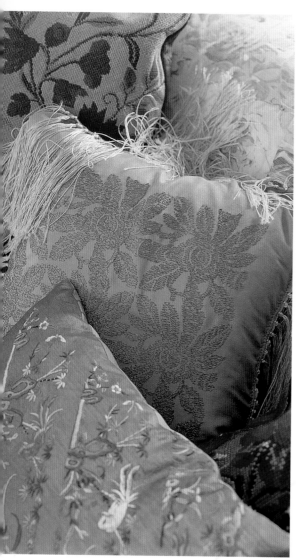

and ancient Rome. Silk embroidery is perhaps the finest early example. Silk has probably been produced in China since 2000 B.C. Once woven, this precious, luxurious textile was embellished with fine and complex thread work to create ornate hangings and embroidered garments, usually ceremonial robes. On the Indian sub-continent, embroidery was undertaken as early as the fifth century, and Indian motifs and techniques, like those of the Chinese, were to have a great influence on Western taste, albeit a thousand years later.

The early art

European embroidery also has a long and honorable history, with identified work dating, in England at least, to the fifth century. In the Middle Ages, England was particularly known for its ecclesiastical embroidery, which became famous throughout the Western world by the thirteenth century. This early embroidery, generally known as Opus Anglicanum, was appreciated everywhere and widely commissioned for export. The demand was so great that the Church employed bands of men and women to make huge quantities of hangings and ecclesiastical vestments using an abundance of gold, silver, precious stones, and enamels. Because of the high value of gold and silver metal thread, it was not actually sewn through a textile but instead laid along the surface and attached with small, almost invisible stitches.

By the fifteenth century, although ecclesiastical embroidery was still undertaken, household embroidery began to take on a new importance, and for the next two hundred years was pursued in some measure by many. Economic wealth meant that more people, from

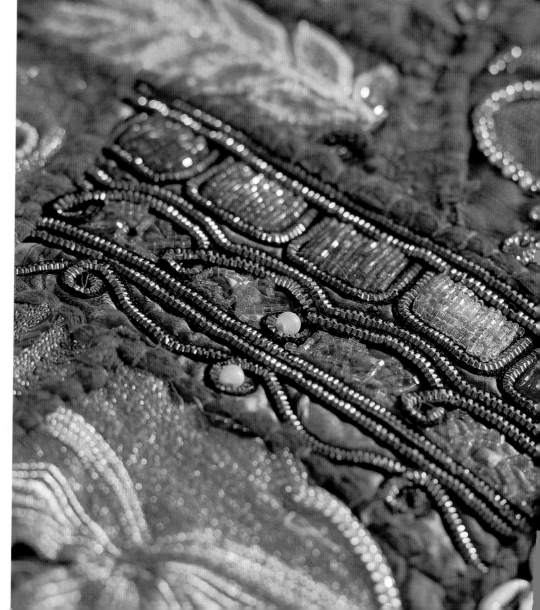

above and below left
One of the best ways to use small pieces with fine detail, particularly if they are old and unusual, is to make them into pillows to show each impressive stitch. Here two pieces of worn but intricate silk with embroidery, appliqué, and crewelwork can be enjoyed.

below The like of this unique piece is rarely seen. It is a camel blanket from Rajasthan. Quilted and appliquéd on hand-dyed cotton, the maker employed everything that glitters, including couched metal thread, beads, cowrie shells, and tiny mirrors.

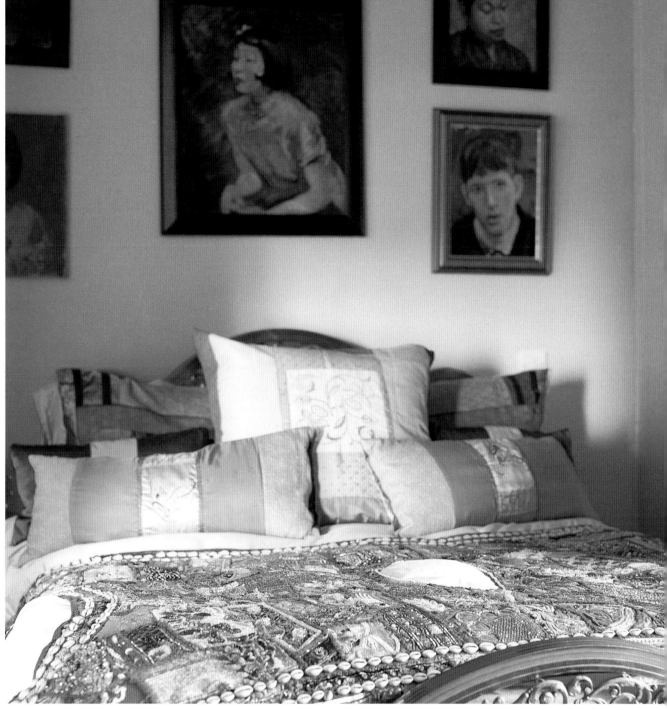

members of a royal household down to those of the new bourgeoisie, could enjoy leisure pursuits, particularly those that had practical applications. Queens Catherine of Aragon, Elizabeth I, Mary Tudor, and Mary Stuart (taught by Catherine de Medici) were all fine embroiderers. Needlewomen produced both the grand – velvet hangings and silk embroidered cloths to be hung in drafty, large rooms – and the mundane – household necessities such as table and floor carpets, cushions, coverlets and valances, as well as the ubiquitous bed hangings and all manner of clothing, from slippers to doublets and petticoats. Alongside these talented amateurs were professional embroiderers. In 1561, Queen Elizabeth I refounded the ancient Broderers' Company, a band of about a hundred professional embroiderers, all of whom were men – not as unusual then as it might be considered today – usually working from city ateliers.

Sixteenth-century embroiderers characteristically used flowers as motifs, and as printed books became more commonplace, they added other, more intricate botanical and herbal themes. Later in the sixteenth century,

above The Rajasthani camel blanket seen in all its glittering, beaded, and embroidered glory as a cover for a double bed, with the camel's head hole neatly in the center. It is flanked by quieter cushions made by Kirsten Hechterman from a mixture of antique textiles and new hand-dyed silks.

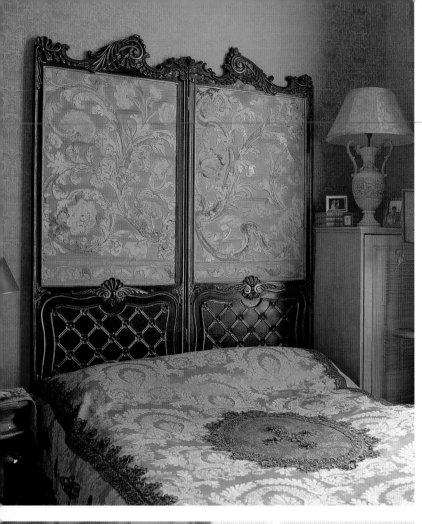

the production of specific pattern books extended the available choice of designs. Many embroidered bed-hanging sets were executed in exuberant crewelwork. Crewel is a name for worsted thread, a wool blend that is thicker than silk or cotton thread. Crewelwork is defined as embroidery in colored yarn, generally in dark, strong colors and done on wool cloth or white sheeting. First introduced in England and later extensively employed in North America, it was popular in the seventeenth and eighteenth centuries and often incorporated trees, leaves and flowers, all climbing sinuously from bedpost to canopy.

Embroidery in the seventeenth century was beautiful and extensive in the techniques it employed. Elizabethans and Stuarts embellished both themselves and their furnishings with every kind of stitchwork, a fashion made easier by the newly developed sharp, efficient scissors and metal needles. Worked pieces were rarely embroidered all over, but were more frequently made up as bands or panels of decoration, used for all manner of ornamentation. With the exception of ambitious sets of bed curtains and some wall hangings that were made professionally, embroidered pieces were usually quite small. They were particularly suitable for firescreen panels, stools, coverlets, chair seats and backs; and for pillows, which wore out relatively quickly and had to be constantly replaced.

Household embroideries of the time reflect the concerns and interests of contemporary society. They illustrate brightly colored scenes set in gardens and fields, and they are filled with flowers, fruit, and vegetables, every aspect of contemporary horticulture. Birds, beasts, and flowers were all embroidered onto sleeves, skirts, stomachers and jackets.

Embroidery remained just as popular over the next hundred years, to adorn both clothing and furnishings; by the 1700s, enterprising printmakers and booksellers were even issuing sheets and engravings of designs and patterns – flowers, fruits, birds, and animals specifically designed for the home embroiderer.

By this time, Chinese embroidery and finely worked Chinese needle paintings were much sought in the West. Embroidery from India was also exported to the West through the East India Company from about 1650, and by the late seventeenth century, Indian chintz and embroideries were highly prized enough to be recorded in household inventories. Later in

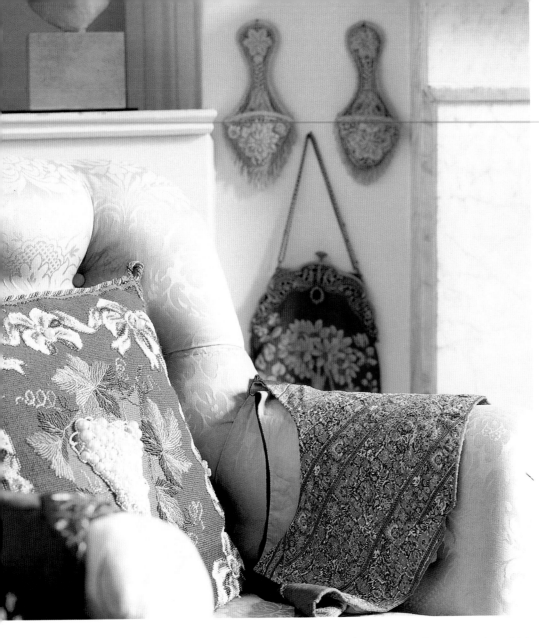

Embroidery was as popular on the European continent as it was in Britain. Every country had a specialty for which it was renowned. Switzerland had a reputation for white embroidery on handkerchiefs and underclothes; Poland for gold and pearl embroidery; France for the artistic use of the silk, gold, and silver thread imported from Italy and Cyprus.

In the late seventeenth and early eighteenth centuries in France, embroidery became as fashionable as it was in England, particularly to embellish clothing – so much so that Henri IV issued edicts against the wearing of extravagant costume. It obviously had little effect, because in 1629 Louis XIII issued a further edict forbidding men, or women, to wear either embroidery or imitations of embroidery on their clothes at all. Tambour work, in which chain stitch is embroidered while the cloth is stretched tightly over a drum, was particularly popular. Madame de Pompadour even had herself painted working at her tambour. Italian embroidery, too, particularly the Florentine work of the Renaissance, also called bargello, was highly regarded during the period and in later years.

The Americas and Africa

The story of American embroidery is similar to that of European work, but is characterized by the pared-down, simplified charm typical of early American arts and crafts. During the first

the eighteenth century, the first ladies' magazines were produced, aimed at the leisured classes, and some incorporated ready-to-use, pull-out patterns providing new embroidery delights.

As the nineteenth century advanced, embroidery maintained its popularity, but in the process lost some of its subtlety. Techniques such as Berlin woolwork became very popular across Europe and North America from about 1810 to 1880, reaching a peak between 1840 and 1850. Bright and cheerful, but distinctly not low key, this needlework was done using colored yarns on a canvas. Its surface was divided up by a chart ruled in squares, each square representing a stitch. Both the charts and the embroidery threads were originally produced in Germany. The new aniline dyes produced in the nineteenth century gave contemporary embroidery a brightness and

naivety that was certainly energetic, but which lacked the elegance of stitchwork done in earlier times.

European variations

Much of the history of European embroidery is on view for us today in many surviving samplers from different countries. To our eyes, perhaps, old samplers sometimes look rather dull, with their faded colors and rigid geometry, almost like pages from exercise books executed in stitches. But when they were originally worked, early samplers were not just demonstrations of skill, but also personal pattern books, there to give the (usually) young embroiderer ideas and inspiration for future works. Today they are a clue, a signpost of changing styles in embroidery and fashions in the sixteenth and seventeenth centuries.

above This is a very elaborate piece of early twentieth-century English cotton cutwork embroidery of a type that is rarely made now. It is backed with panels of velvet, whose colors complement the design. The feminine colors suggest that it may have been originally intended as a runner or cloth for a dresser table or chest in a lady's bedroom.

left A way of displaying a particularly elaborate piece of work is to sew it over another piece that emphasizes its pattern and colors without drowning its fine points.

opposite left This living room corner boasts a wealth of embroidered surfaces used decoratively. A pair of elaborate, nineteenth-century oriental beadwork slippers and a beaded bag hang on the wall. An eighteenth-century embroidered vest is permanently draped across the arm of the chair, which itself features an ornate embroidered cushion.

opposite right A small pillow such as this could easily be lost if it were grouped with many others. Here it is the sole incumbent, allowing its pale colors and small motif to be appreciated.

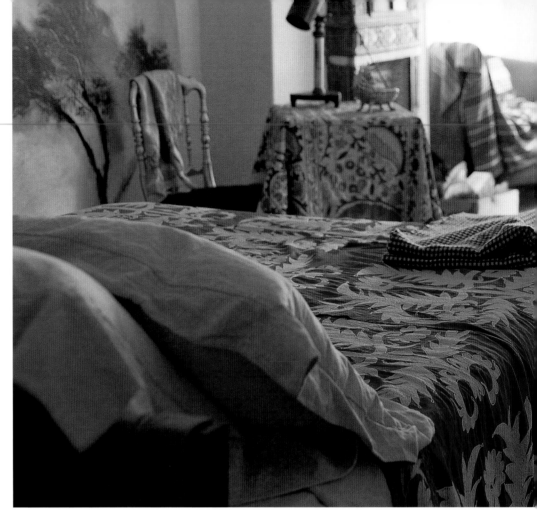

below left and right
Embroidery is the pastime of a few today, but at one time it was considered an essential skill, as well as one that provided much enjoyment. Here are two examples, the first on a background of dark red silk on which sinuous flowers have been ornately worked in metal thread. Beside it is a piece of gold and cream damask appliquéd with dark red satin ribbon and over-sewn with fine cording.

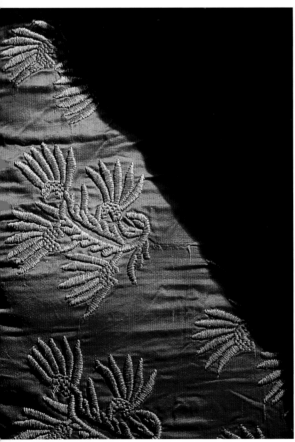

part of the eighteenth century, early American settlers imported many of the techniques and fashions that had been popular in their various European homelands, particularly England, Holland, Sweden, and Germany. Gradually, though, a style evolved that owed more to the new nation than it ever did to any of the old. Although some base cloths were imported, homespun was increasingly used, along with local cotton embroidery thread, which was thicker than imported yarn. Self-sufficiency was an important concept, and sewing was a necessity, not merely a pastime. It was important to be economical with thread, and early designs were therefore often simpler than their European counterparts. Early motifs included many species of flower, as well as the local household items surrounding the embroiderer, such as baskets and simple bowls.

There has been a native embroidery tradition for many centuries across the continent of the Americas and throughout the countries of Africa. In North America, Native Americans decorated garments with beadwork, using beads they had traded with the new settlers for fur and stitching them onto buck, deer, and buffalo skins. They strung the beads

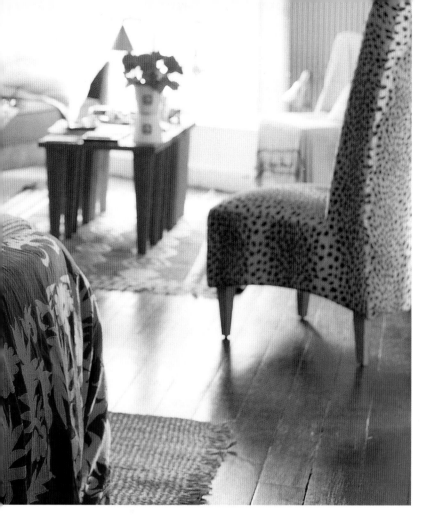

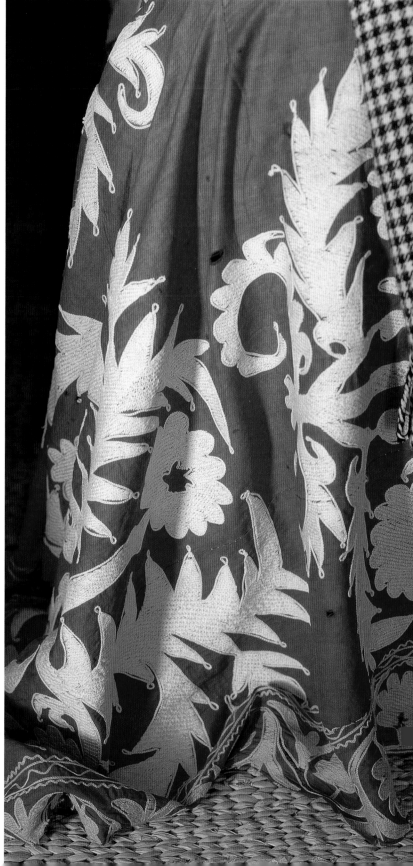

on short threads in evenly spaced rows, sometimes also embroidering the outline. They also employed a form of fur appliqué and quillwork, in which porcupine quills, chewed to make them pliable, were formed into a long thread that was sewn on or partially threaded or woven into bark or skin, including that used to make leggings and moccasins. Across the continent, this work was done on both ceremonial and ordinary clothing.

The native peoples of South America have long had a tradition of embroidery. In Peru, for example, embroidery has been practiced for thousands of years; two hundred years before the birth of Christ, the Paraxas were embroidering clothing and had more than a hundred and ninety natural dyes at their disposal. Between the fourteenth and sixteenth centuries, the Incas used tropical bird feathers attached to plain, woven cotton bases to make ceremonial vestments of shirt or mantle. Regional differences have always been very marked in the South American countries. The Kuna Indians of Panama are famous for their appliqué panels, for example, while Mexican embroidery is characterized by a riot of colorful local and topographical scenes.

above This fine crewelwork cover is used on the bed of a room filled with interesting and unlikely textiles – all completely different, but working with each other in an unusual way. There seems to be little attempt to coordinate colors or design, and yet everything is harmonious, maybe because of the shock addition of the leopard-print chair.

right Almost a sampler of the stitcher's fine skills, this detail of the crewelwork bedspread above shows the complexity and finesse of the work.

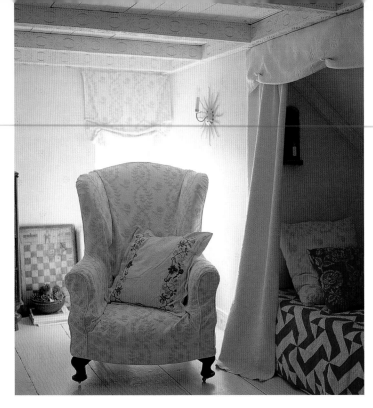

right In a low-ceilinged bedroom, a boxed-in bed is covered with a fine early twentieth-century appliquéd American quilt. An antique armchair covered in modern crewelwork is embellished with a pillow sporting two wide embroidered bands that unite chair and bed.

below An elaborately embroidered Turkish velvet valance is draped across the top and sides of a cupboard, giving it new importance and allowing the embroidery to be appreciated at close quarters.

Embroidery also figures in the daily lives of many African tribes, for example, the Yoruba, the Ibo, the Nupe, and the Hausa. The Hausa are particularly known for their embroidering skills, the men often doing the embroidery while the women do the weaving. The most typical style is a broad-sleeved gown embroidered with elaborate designs, some interlacing and some more angular. Many of the designs will have first been drawn by a scholar of the Koran as talismanic devices, giving them significance beyond mere attractiveness.

It is thought that by the fifteenth century, Hausan traders had moved out from Nigeria, selling these embroidered goods and encouraging the development of local embroidery. Another characteristic style of African embroidery was that of rich ornamentation on hooded cloaks, sometimes combining silver or gold thread and sequins. The Yoruba also wear gowns enriched with intricate embroidery.

Embroidered embellishment

Using any form of embroidered piece in interior decoration today involves thinking laterally as well as straightforwardly. Embroidery can be used for the purposes for which it was originally designed or in quite another, new way. Mirrors, for example, were rare curiosities in the seventeenth century and often had embroidered bands framing the glass. Workboxes and writing cases once had pieces of embroidery mounted on them, edged in braid. These same ideas can be imitated today.

The decorative possibilities are endless. Embroidered textiles can be used on pillow covers, of course, but they can also be mounted as panels down chair seats, or as framed medallions on chair backs. A panel could be used behind a bed, either in its entirety or as a part of a larger whole; and a broad band could hang beneath a low window to hide a dead space beneath and draw attention to the window above. As with so many decorative textiles, embroidery is seen to great advantage when used to decorate a window – perhaps as a panel making a soft valance, or a wider, longer piece used as single small curtain, caught back. Narrow strips of embroidery can look lovely as borders on curtains or shades, or as edgings applied to each side of the fabric.

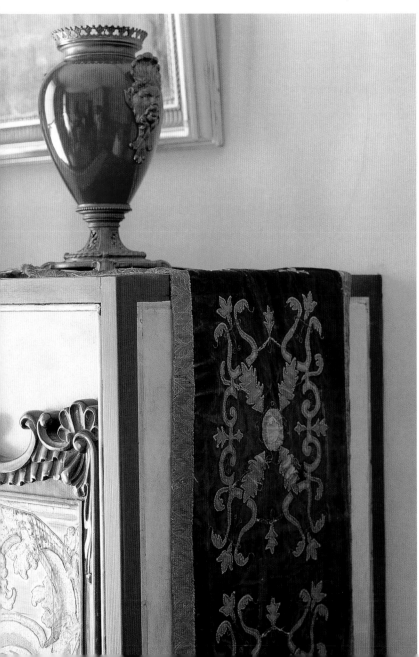

right Crewelwork is an almost free-form embroidery done with colored yarn on a linen base. It was popular in the seventeenth and eighteenth centuries, and was often used to make bed hangings, presumably for warmth as well as for decoration. Here a crewelwork hanging is used as a chair throw.

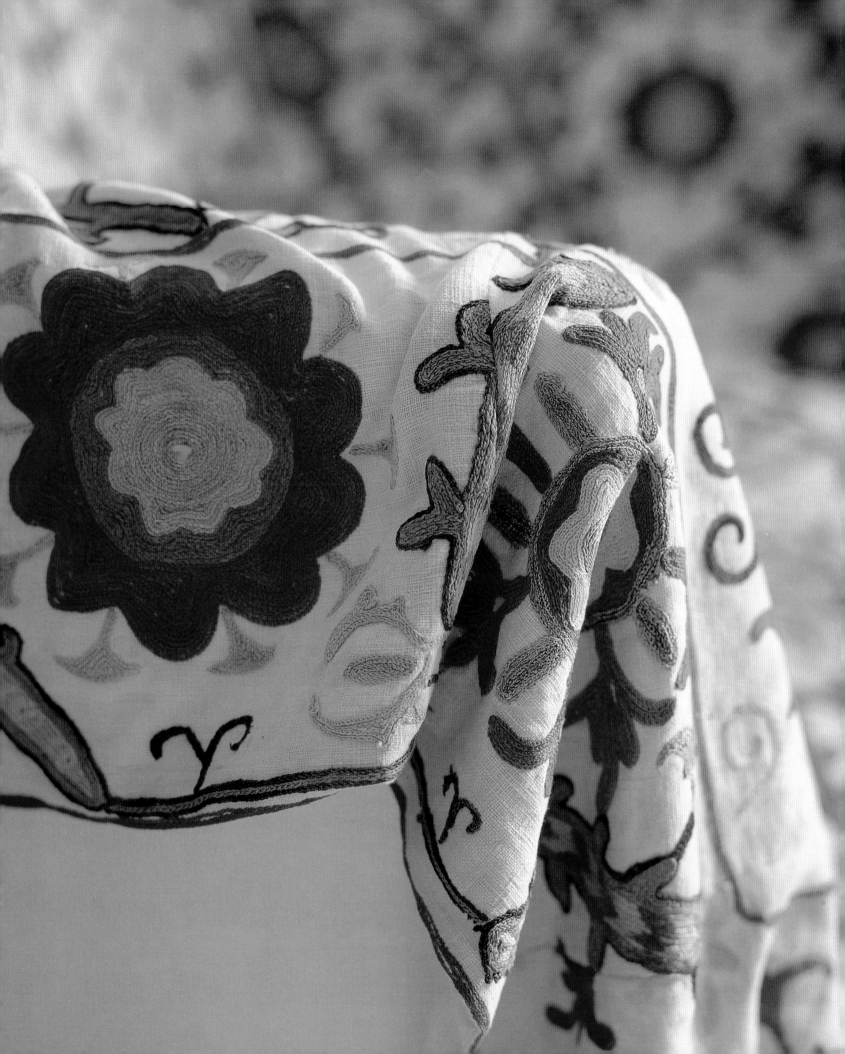

fabric furnishings

The interesting thing about collecting textiles to use in interior design is that when you think about their application, you realize there is nowhere in the house that you could not use them, there is no aspect of living that they would not enhance. In every room, from the bathroom to the kitchen, and on almost every piece of furniture, there is a place where decorative textiles can make a difference. And it is not just upholstered furniture that can benefit – every piece, from dining tables to headboards to lampshades and mantelpieces, has room for the judicious use of a textile or two.

In these relaxed times, interior decoration does not suffer from the same sets of so-called rules and strictures as it once did. Every element of a scheme does not have to match and conform; sofas and chairs, for example, no longer need to look like a regiment in the parade ground with each looking exactly the same and every tentative variation frowned on. What matters now is what always really mattered – using things together that work well, please the eye, and do not jar. The only rules

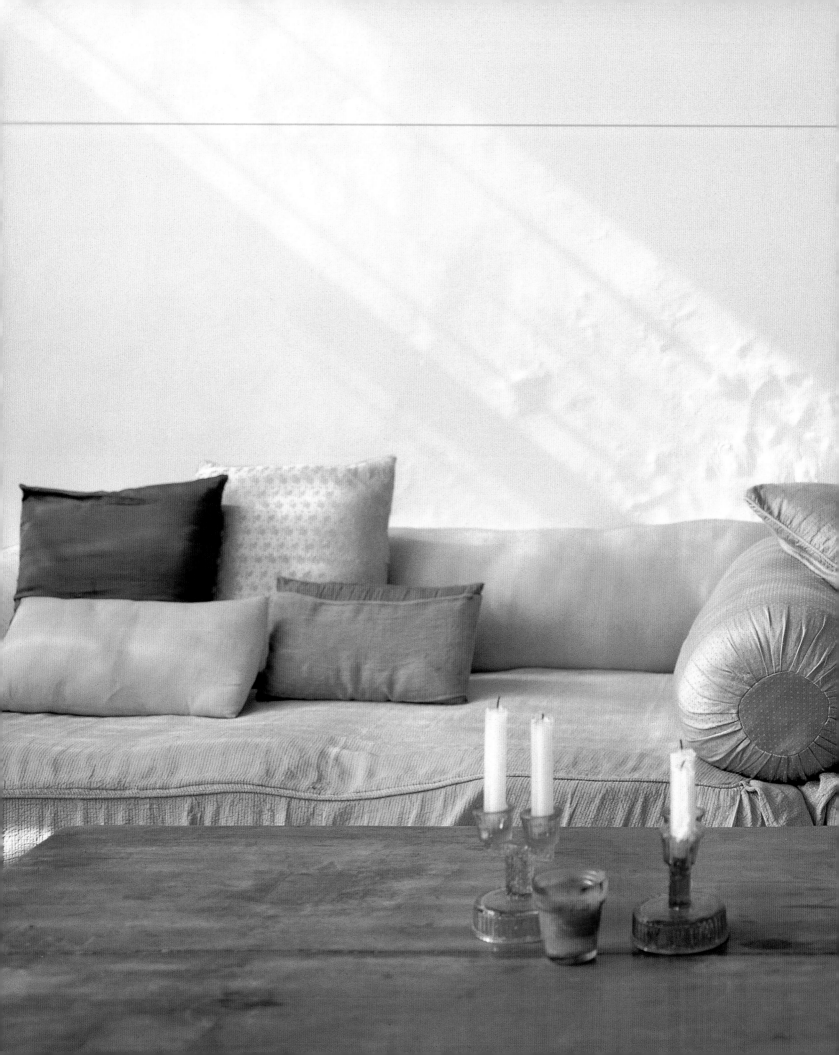

that apply are the best and original ones of taste and proportion, harmony and scale. When upholstering, for instance, the scale of the design on a fabric should be in proportion to the size of the piece of furniture. Equally, the pattern and colors of a chosen material for curtains must work with the size and design of the particular window for which it is intended.

The aim in matching textiles to furniture or architectural elements in a room is for each to make the other look better. So what better time could there be to use some of the pieces in your lovingly acquired trove of textiles? Think laterally, and soon you will be looking for more to augment your now-depleted stash.

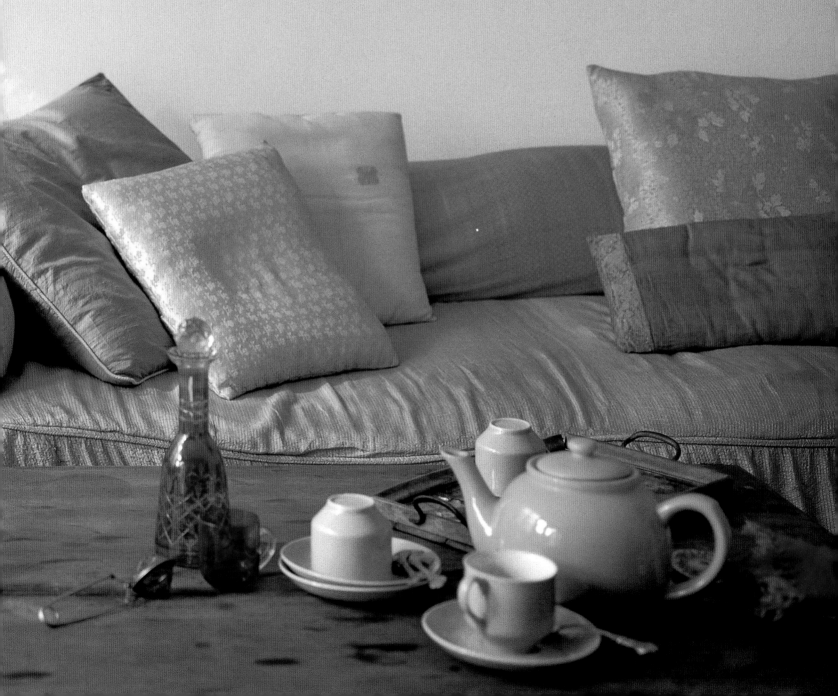

curtains

One of the most obvious ways of using decorative textiles – old or new, from East or West – must be to hang them at a window. The first curtains were so simple that they were not really worthy of the name – they were merely strips of coarse cloth hung across the glass to keep some warmth from escaping and, to some degree, to control the light. You could say that this remains their function, but since the seventeenth century, designers and decorators have also seen the window as a blank canvas ready to receive their flights of draped fantasy.

From that time, curtains evolved from objects devoted to pure practicality to important elements of a decorative scheme. The first curtains to be recognizable as such were single panels, giving way to pairs of panels by the end of the seventeenth century, and they were often made of wool for warmth. The Georgians introduced silk curtains, which had many advantages – they diffused the light in a particularly pretty way and hung as gracefully as the fashionable dresses of the day. During the eighteenth century, those concerned with the interior decoration of a house – usually the fabric furnishers – turned their attention to the type or color of the material used for the curtains and for the surrounding draperies. An interest in swags and tails, light or stiffened valances, passementerie, and so on began.

Some of the most charming curtain designs date from this era, including the use of simple, single, asymmetric draperies caught back from a rod or pole. This is still a lovely way in which to use a single textile, such as an antique shawl or scarf, showing off its colors, patterns, and textures. There were also designs featuring a broad band attached flat across the upper frame of the window as a sort of curtainless valance. This remains a good use for a band of lace or embroidery – by itself if it is deep enough, mounted onto a broader band of fabric if it is not. Kept flat this way, the intricate designs of such textiles are well displayed. One of the most important rules when using old textiles at

left and below An effective way of incorporating color and interest is to add a separate band of fabric across a plain curtain to balance the fringe above and on the floor. Half a length of an Indian silk sari has been added to the curtains seen on the far left, with the sari border becoming a decorative horizontal band on the curtain. The 1930s folding chair is dressed with an intricate nineteenth-century embroidered hanging in different shades of gold silk from Rabat, originally made as a bolster cover. The red and white cushion is made from traditional nineteenth-century Fez embroidery.

left The best curtains are often the simplest. In this tall bay window, Nigel Greenwood has ingeniously made the curtains from two very long Moroccan shawls woven from silk and cotton and with hand-knotted fringed ends. At the top of the window, they have been turned back on themselves so the fringed base appears as a deep valance.

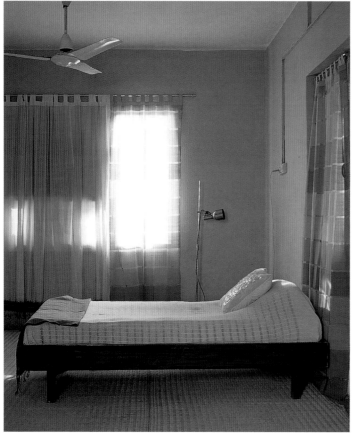

above It is not only the fan that makes David Abraham's guest bedroom in Delhi feel so cool. Windows hung with his silk and cotton scarves, inspired by saris, are light and airy.

top In a dining area, a small table is covered with a *khadi* throw of crinkle cotton embroidered with nylon pompoms. The curtains are gold-bordered cotton sarongs.

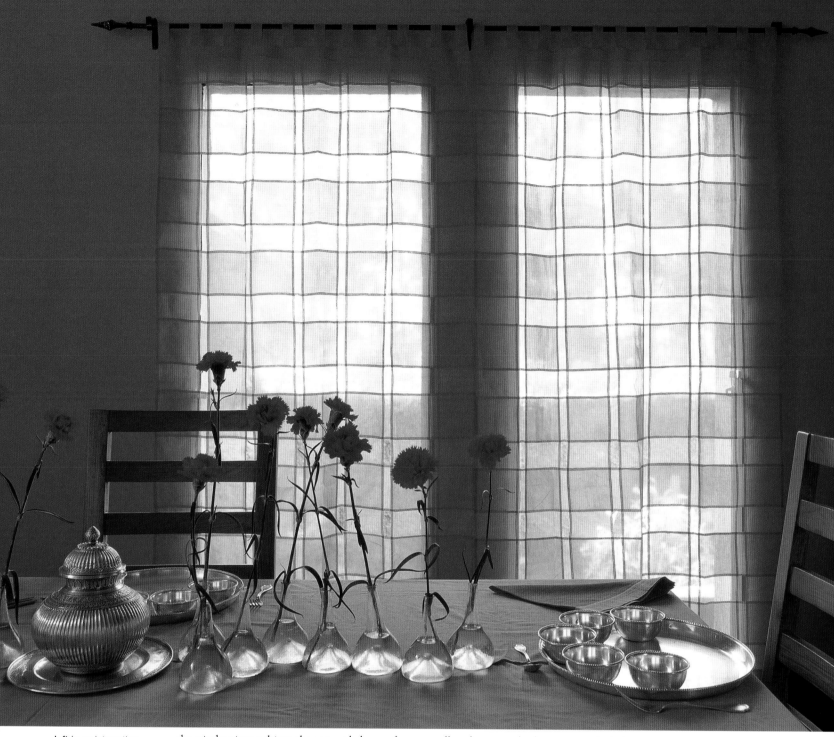

left In an interesting juxtaposition of textures and fabrics, the pillows here are cotton velvet with bright nylon pompoms stitched on. The translucent curtain is made of a group of silk and cotton hand-loomed sarongs that are hung individually and then bunched together to create a soft, full finished effect.

the window is to achieve the correct balance of scale and of pattern and color. If the piece you have is particularly rich in design or pattern, or strong in color, you should use it either alone or combined with another fabric of the simplest style. And take into account the features of the textile you are using. There is a certain sense of like-with-like that has nothing to do with period or coloring, but which is based on more basic design rules and instincts. A highly patterned Indian cotton, for example, would really not look good teamed with pale and faded floral chintz, although it might go very well with an

equally pale cotton check – a geometric design that would complement the complexity of the Indian fabric.

It was usual in many periods to have door curtains, *portières*, in front of drafty doors, sometimes matched to the other hangings, sometimes a single piece of material that tied in with the rest of the room's furnishings. Today, although the treatment might be simpler, door curtains are a good way to frame a door – for example, one that leads from a bedroom to a bathroom. The curtains soften the transition from one room to the other, and

above When using sheer textiles at the window, two completely different looks can be achieved, depending on whether you gather the material or stretch it tight. Here a woven check cotton is used in a spare, contemporary way. Compare its almost severe lines with the fullness of the sheer curtain on the left.

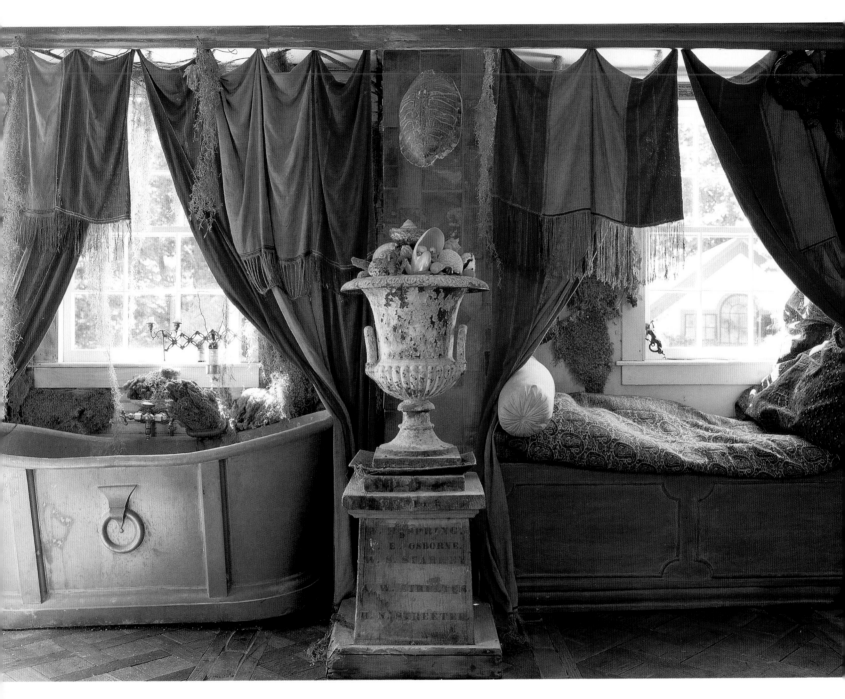

can be chosen to complement or contrast with the rest of the fabric furnishings.

The main thing to remember when planning what to do about curtains is to keep it simple – and this applies even more strongly when the piece of textile is decorative in style. Ornate headings or added embellishments in the shape of heavy tassels, deep fringing, and the like need to be used with flair and in the right place. Some designers using old textiles don't even use conventional rings or hooks. Anna Bonde, for example, uses old linen under-sheets, simply starched, ironed, and

folded and then draped across a polished metal rod. The drapes are slid across when the light needs to be kept out. They are not even hemmed and just fall naturally into a fold on the floor. The key words in this description, though, are "ironed" and "starched"; simplicity never works if it is messy or dirty.

There is no reason why a pair of curtains needs to match in every respect. If you collect paisley shawls, for instance, two based on the same colors but with different designs would work, as would two based on the same design but woven in different colors. Old pieces of

non-matching but similarly colored damask or figured cloth also work well together, as do old linen sheets or cloths.

Shades are another good way to use old or exotic textiles, particularly the bold and the bright. A shade can make a statement in a way that a curtain often cannot because the fabric is usually presented flat. And if you have only a narrow piece or a border, it can be used to edge a plain shade very successfully. Neither treatment takes as much fabric as a pair of curtains does, so strong patterns and colors – say, in a printed African cotton – will not be overwhelming.

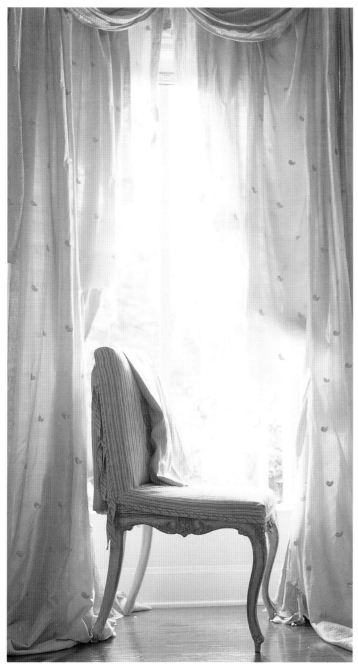

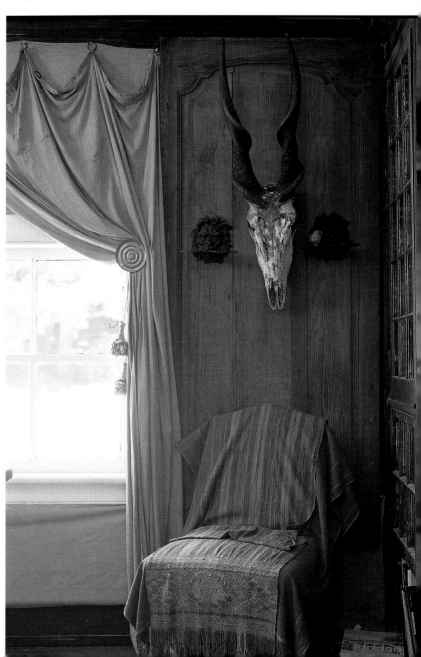

above A sunny window is hung with faded, twentieth-century Indian saris, one cream antiqued with tea, the other a curry yellow.

left A bathroom is made positively palatial by material at two windows, pinned and folded back on itself to make a valance. The textiles drape an antique bathtub and a window seat of pillows covered with carpet.

above right and right Michael Trapp illustrates an easy way to dress a window dramatically. The window wall is covered in lengths of eighteenth-century Imperial Chinese silk brocade. Dress curtains are then added in the simplest manner possible – small rings go over a row of pins that hold the wall fabric. The two curtains cross each other at a central point and fall into natural folds.

right Through sheer cream cotton, the exterior decorative iron grille makes a pattern inside the room. The curtain is edged with a band of contrasting striped cotton.

far right Coolest of all in a hot climate are bamboo blinds that allow diffused light and any breeze to wash over the room. To avoid a monotonous space, David Abraham has hung a single strip of a hand-loomed cotton sarong over one corner of the lowered blinds. The effect is textured art.

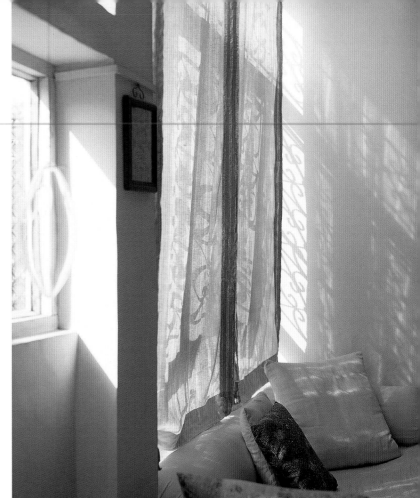

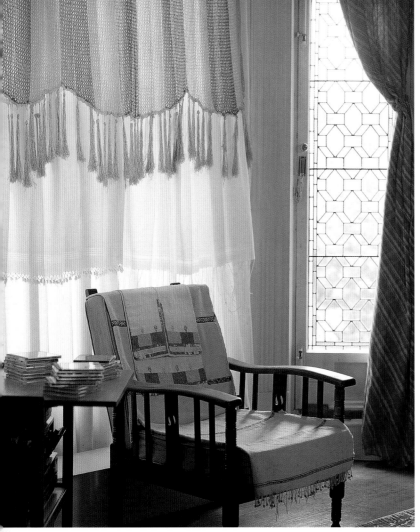

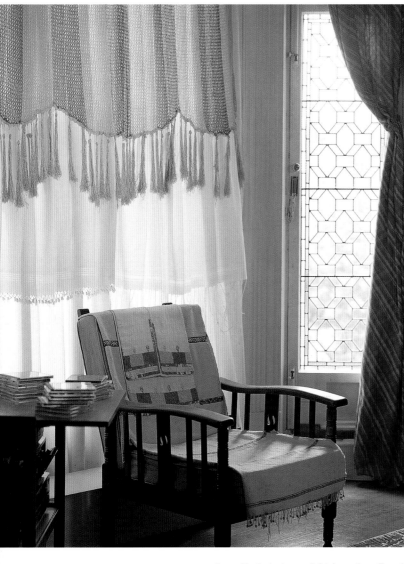

above For instant dressing, a wide window is curtained in antique silk door hangings from Fez, doubled over so the fringe hangs down, giving a depth and intricacy to the textile.

right An antique French lace panel, probably made originally to hang loosely at a window, is stretched taut over a full-length window and edged in cream linen to keep the lace straight.

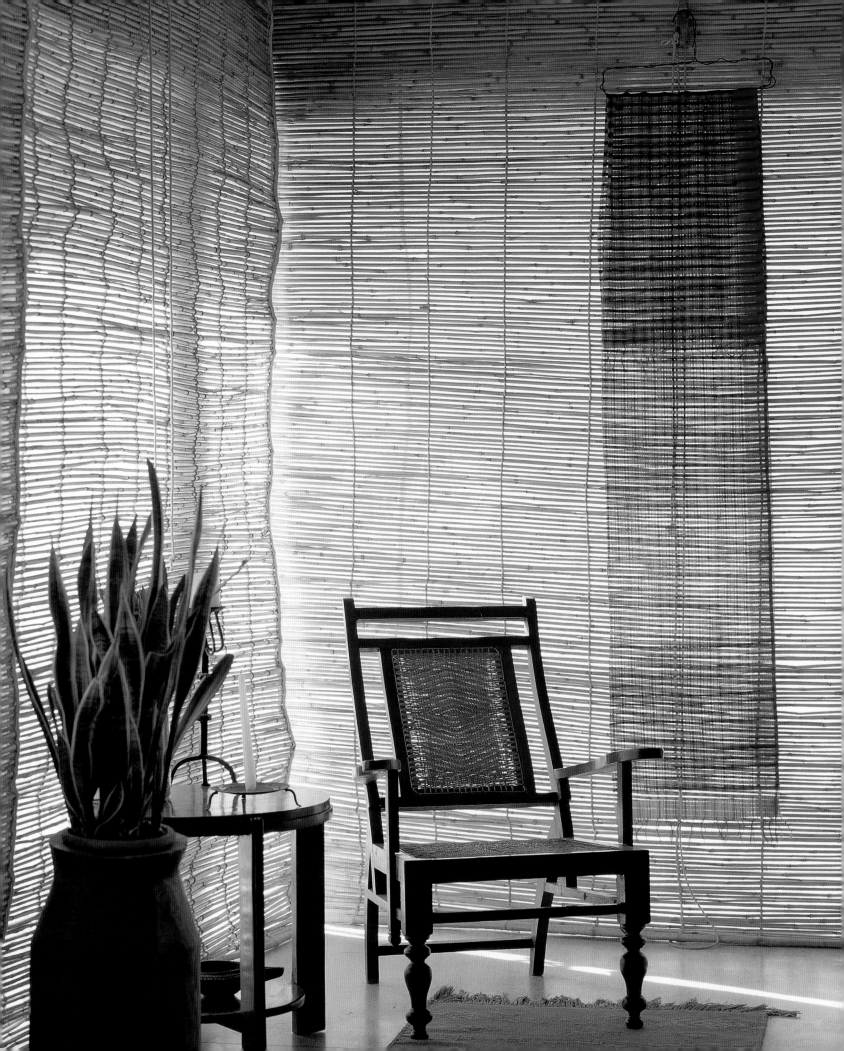

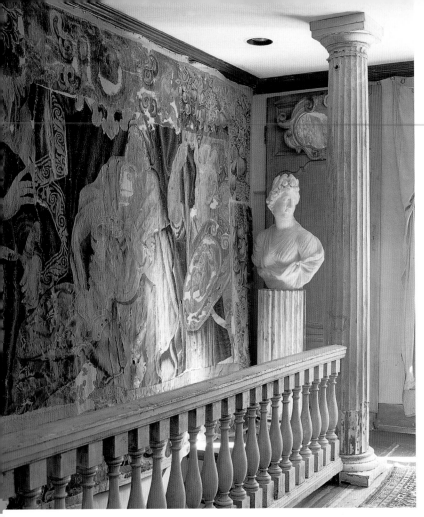
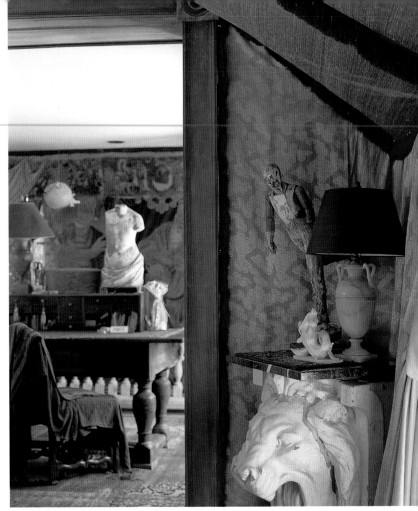

walls and ceilings

People interested in the look of their houses have always hung textiles on the walls – and sometimes on the ceiling, too. From about the fourteenth century, woven tapestries were often used in this way, and by the seventeenth, there were also hangings made of velvet and wool moquette for warmth, or silk and cotton for summer lightness. They might be printed, figured, or painted, and they all worked instant transformations on the interiors in which they were displayed.

Although today we would not want, as they did in seventeenth-century France, to have the whole room coordinated, with walls, bed, and chair covers matching, we still use fabric on the walls and ceiling almost as routinely as we decorate with wallpaper or paint. Fabric can look wonderful, with a depth that neither of the other two finishes can achieve, but it is important to stop it from looking heavy and claustrophobic.

If the textiles you want to use are antique, it is quite likely that you will not have enough to cover each wall in its entirety from ceiling to floor. In other times, rare or expensive material was used in an ingenious way that has obvious applications today. Two or three widths were sometimes framed into panels that were then bordered with a contrasting, plain fabric or by embroidered silk; alternatively, the panels might be stitched together and then finished with braid or some other trim covering the length of the seams. The ornate textiles were also often trimmed with fringe for elaborate good measure.

above left A faded and worn but beautiful eighteenth-century tapestry is hung on a staircase wall where its charms and intricacies can be closely inspected. Its colors lead the eye directly to the antique tones of the grand curtain at the end.

above right Looking back from textile-hung walls toward the large staircase, the tapestry is seen as a warm background for a collection of carefully chosen objects on a desk.

right Like it or loathe it, this minute half-bath is certainly original, draped as it is with upholsterer's muslin of two different weights, from which the sink emerges like a ship from mist.

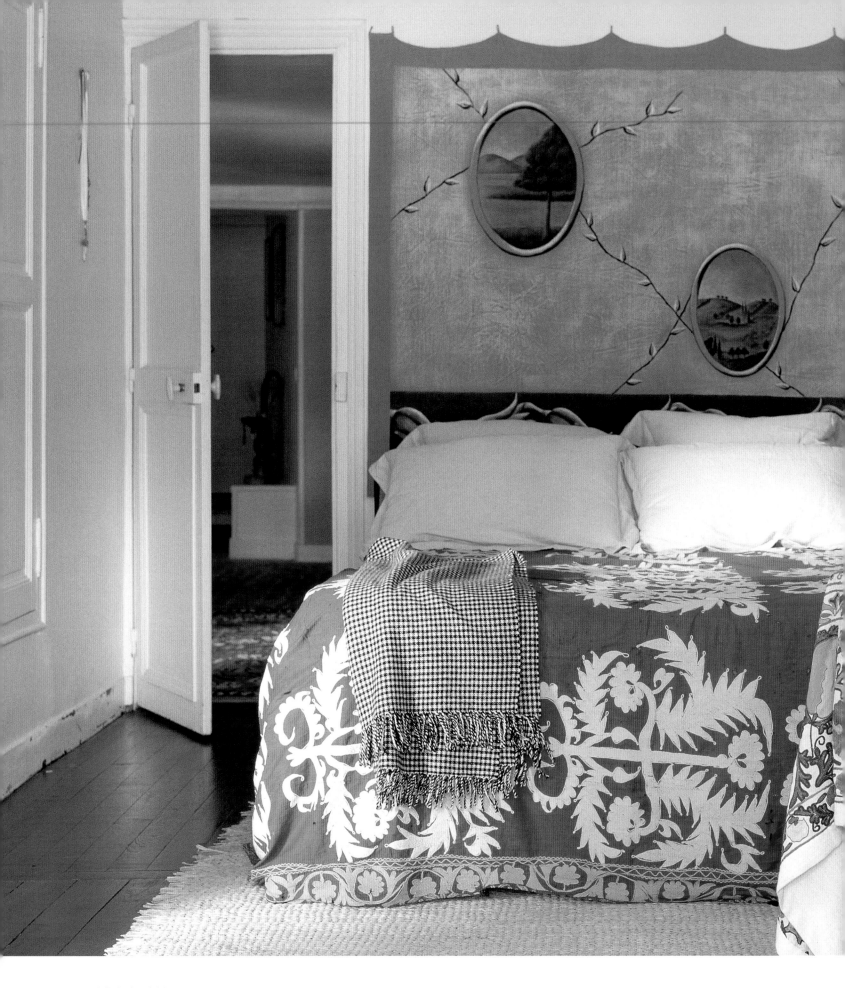

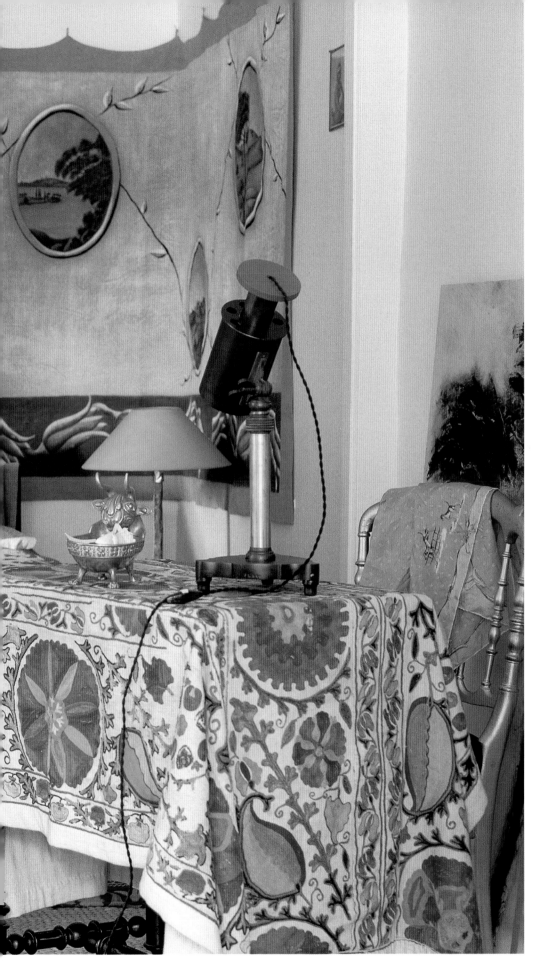

This canvas with small, oval, painted scenes has an air of *trompe l'oeil* about it. Used on the bed wall, it becomes part of the bed itself, but also plays a central part in the decorative scheme of the room. When a textile is striking enough to stand alone, it can hang in the simplest manner, as this one does, just attached at points along the wall.

Translated into a modern context, textiles can be used on a wall in panels, and there is no reason why each panel should be jammed right up against its neighbor. If you go for the option of a fabric border, it can be fairly wide, as long as it remains in proportion to the textile it surrounds. Or, instead of a material border, ready-cut molding can be placed round each panel to frame it. Gauge the width of the molding according to the strength and drama of the textile design. If the panels are set into a fairly large wall area, although the traditional solution might be to paint the wall in a contrasting color, a subtler alternative would be to use a color within the same range as the material, perhaps just one shade lighter or darker. Another, rather more esoteric scheme described in the eighteenth century (but perhaps today only suitable for the bold-hearted) was the breaking up of paneled hangings with fabric columns, presumably cut from printed cotton or silk, appliquéd the length of the wall. Plain or damasked silks were used as paneled hangings, as were chintzes – again an idea that could look very fresh and contemporary.

If you do not have enough textile for a panel, follow the lead of those designers who use single scraps of fabric – particularly stiffened materials such as canvas – on a door, either edged or just pinned to the door surface. Either paint the surrounds of the door in harmonious tones, or paint a thin piece of

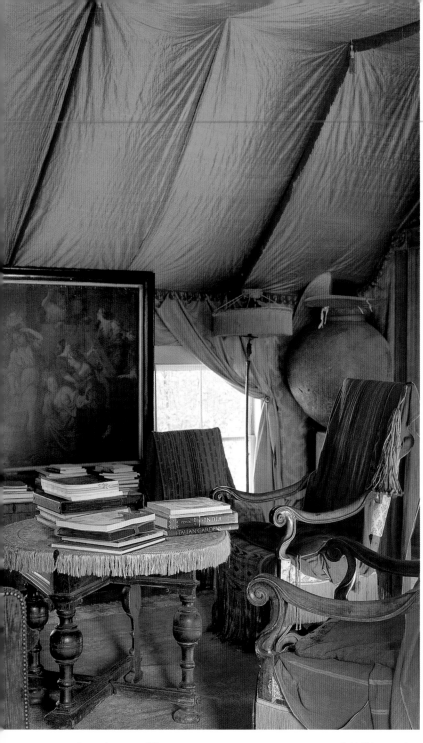

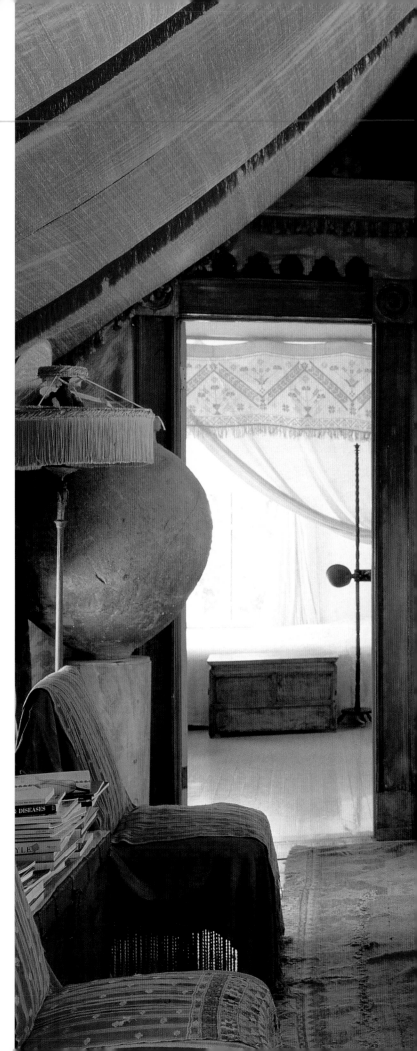

above A corner of the room on the right shows how the walls have been hung in loose panels of eighteenth-century gold Chinese brocade, barely attached but just pinned at strategic points. The ceiling of Thai silk also gives a tented, billowing look and obscures angles and hard edges. Using silk rather than heavier textiles means that the fabric flows across the room.

right This room is a hymn in praise of decorative textiles. Over the sloping walls and ceiling are wide textile panels edged with deep red fringe. The tall chairs are draped with early twentieth-century Buddhist priests' shawls, called Kabné Khiras, from Bhutan. Just seen on the table behind the sofa is a rich red and blue textile from the collection of the Nawab of Hyderabad.

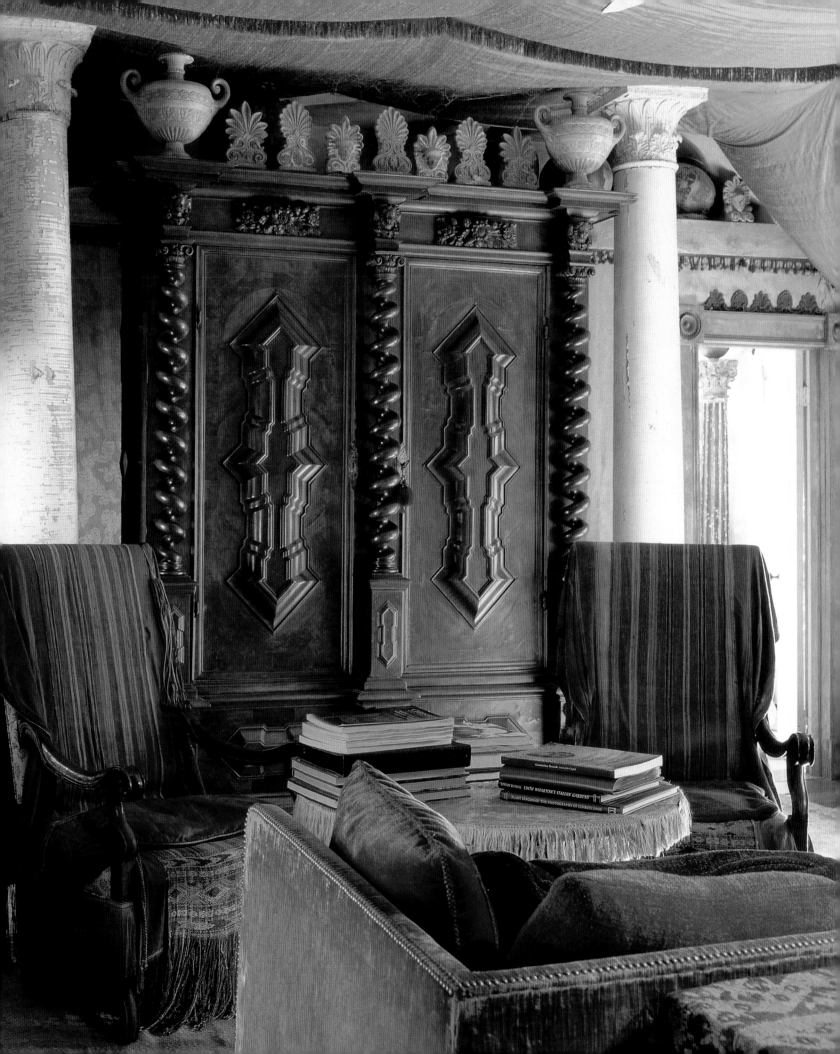

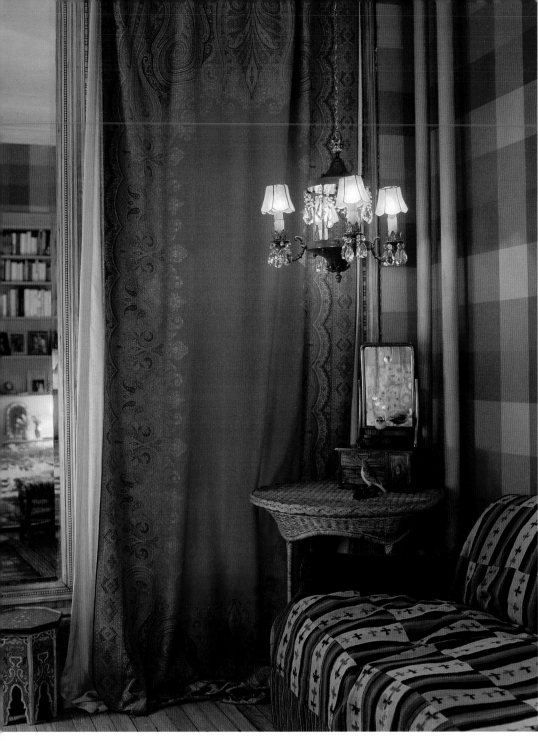

wood and attach the scrap, a method that is advisable when the fragment is valuable.

Covering an entire room with fabric, either in tent form or flush to the walls, has long been an interior decorative device. In the nineteenth century, suggested options included hanging it flat, in rectangular folds, or even in deep festoons. Deep borders in different, patterned fabrics were often used, as were carved and molded valances. Today's tastes lean more toward the simpler options. Although covering the walls with fabric produces an attractive and striking look – and one that works particularly well with decorative textiles – the usual method is to attach fabric flush to the wall on wooden strips or to hang it more informally. This is perhaps easier to achieve and can create a dramatic, billowing effect.

One of the simplest ways of doing this in a low-ceilinged room in which both walls and ceiling are to be covered is simply to catch the material at various points over ceiling and walls. The obvious contact points are where ceiling meets wall and again in the center of the ceiling. This method works only with lightweight material – sari silk or voile, for

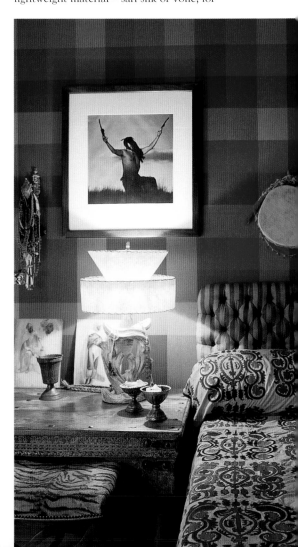

above Beside long paisley shawls used as full-length curtains, a wall is covered with contemporary bigcheck woven material that picks up some of the colors of the shawls. A Tibetan rug is used as a sofa cover.

right It takes imagination and confidence to use such a bold check in a bedroom, but it works very well, giving a warm glow to everything that is put against it, including an Indian cotton print bedspread.

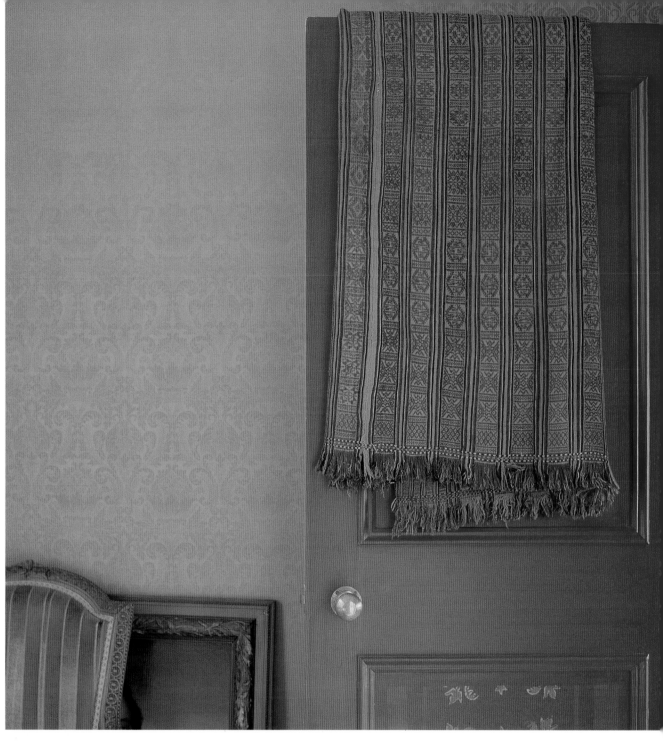

left Drawing the eye upward above a door, a narrow piece of woven and embroidered nineteenth-century silk, possibly made for liturgical use, is attached above the frame.

above Nineteenth-century French *gauffre* velvet over the door exactly echoes the rich red painted woodwork. On the wall is what appears to be a very expensive damask, but is, in fact, a printed one, probably from Nigeria and normally sold as dress material.

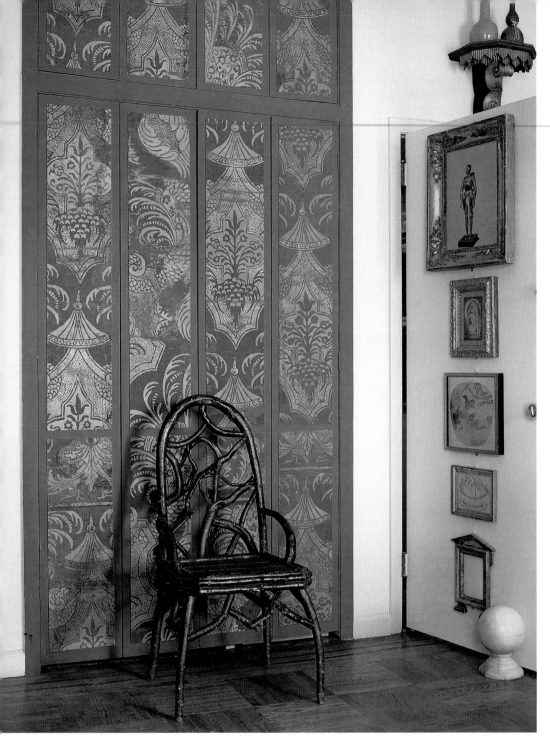

above These striking curtains are made from superfine hand-loomed cotton shawls from India. Unusual large black and white motifs are woven into the fabric using a complex double *ikat* technique.

right An original French design is now printed on cotton in new colors in Jaipur and is heavily interlined to make it drape well. This hanging becomes an inventive, practical, and very good-looking curtain that goes all the way around the walls, concealing any imperfections underneath as well as giving an air of opulence and warmth to the room. The Moroccan rug covering the table accentuates the red flowers in the curtain.

above This rare and beautiful piece of work, an eighteenth-century stenciled Venetian canvas with a distinct air of chinoiserie, was probably originally designed as a wall covering. Each length of the canvas is attached with special fabric glue to a wooden panel, the surrounds of which are softly painted to blend quietly with the background of the canvas – a more original solution than painting the edging in a contrasting color.

example. If there is a selvage on the material, there is generally no need to cover the edges, but if not, ribbon or braid affixed over the seams is advisable. There is no reason why wall and ceiling materials need to be exactly alike. They could be tones of the same color, and even of slightly different weights.

Another extremely effective way of using textiles on the walls is to make a giant curtain on poles mounted around each wall of the room. The material, when lined, falls in satisfying folds down to the floor. In addition to being relatively easy to achieve, this idea has

the dual advantages of being the ultimate quick fix for a wall that is not in perfect condition, and of being completely portable – sometimes an important consideration for textiles you have collected. To complete this look and also to define the room area, the curtain edges can be highlighted with braid or ribbon. You can use a fairly heavy material if you wish, but for a completely different look, and one just as effective in, say, a bedroom, you can try very lightweight materials such as gauze, sheer silk, or voile, in either one layer or several layers of different colors.

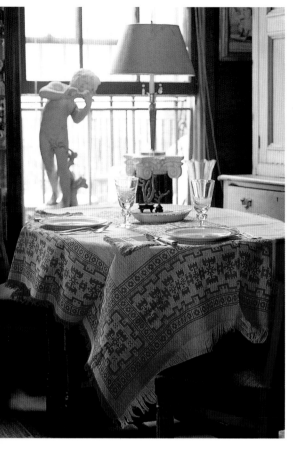

left and above
Of course, textiles look good used at the table, and many are hardier than they might at first appear, particularly those that were originally for household use. This table is set with an American cotton Turkey cloth and Turkey napkins from the late nineteenth century. Turkey refers to the dye, a particularly hardy one used extensively in both England and North America in the last century. The table is embellished with period china and glass.

above center and right
A basic table becomes interesting with two completely different textiles – a Victorian plush table carpet over twentieth-century printed cotton from French manufacturer Boussac. When using fabric on fabric, there is no rule that dictates that one should be plain.

table dressing

The flat plane of a table is, in one sense, the perfect canvas on which to display textiles. They can be viewed to advantage and in turn add depth and interest to what can otherwise be an unrelieved, blank surface. Even quite narrow strips, such as bellpulls or scarves, can work, laid down the length of the table like an Edwardian runner; and large pieces, old hangings, or woven fragments, can make a central island. Shawls – of embroidered silk and woven paisley, for example – work well, particularly if they are ornately fringed.

Early table cloths were often actually carpets, far too valuable to be used on the floor. And so they can be again; carpets small or large, floor length, or just of table dimensions can be used this way once more. It doesn't even matter if the carpet is actually smaller than the table area: one of the most ingenious ideas we found was a rug placed centrally, in a diamond pattern across the width of the table. It looked much more interesting than it would have running straight along the table.

A quilt, whether it is stitched, patchwork, or appliquéd, turns a table into an area for display, of a collection of glass or silver, or vases of flowers and books. And it can have a washable cloth laid on top at meal times.

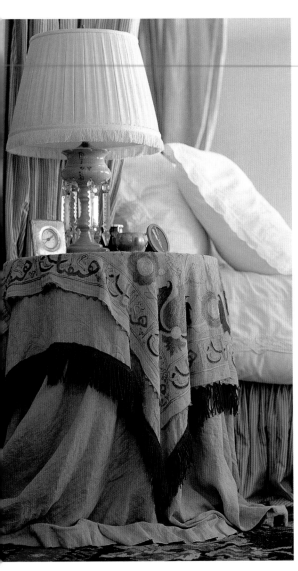

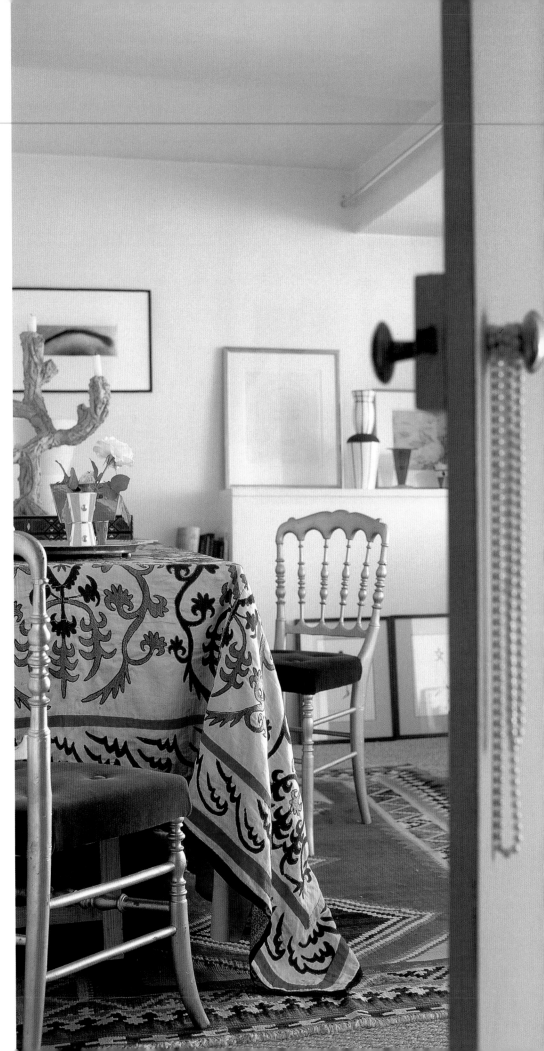

above Layering textiles gives a rich and luxurious effect, and it is a good way to combine them. Here three separate pieces are used on a round table. A generous base cloth of heavy linen is lined for weight; it is covered by a piece of damask with heavy fringe, which in turn emphasizes the colors of the Moroccan crewelwork of the decorative top cloth.

right When you use a favorite textile to cover a table, remember that it does not have to be an exact fit or of equal proportions. This piece of bright crewelwork is certainly not exactly the right shape for the small table, but the effect is perfect.

above left In this outdoor sitting area, a veranda is furnished with a permanent cement table and benches. In order to break their solidity, they are covered with an ever-changing selection of multicolored sheeting fabrics. The colors of the sheeting are accentuated by the dishes of contrasting flowers.

left Nothing looks more welcoming than a really bright cloth over a table – here an antique French printed cotton with flowers and stripes. An even brighter bowl of flowers picks out the same sunny tones.

above This corner is a study in texture and pattern. A wall-hung whatnot shelf is draped with an Eastern housecoat embroidered with flowers. On the table below is a flock-cut, nineteenth-century devore shawl with bright fringe. Even the feathers in the pitcher are of the same shades as the shawl. The whole arrangement makes something previously unremarkable interesting.

bed dressing

The bed has always been a showcase: bed hangings were usually the most expensive items in an inventory, and bed linen and bedspread were finely embroidered and decorated. Today the bed can again be the perfect place to display all those decorative textiles, whether complete hangings or scraps of crochet work. Look for odd pieces of crochet work and old lace in flea markets and antique fairs, and see the difference they make to both sheets and pillowcases – even if they are put only at one end of a pillowcase.

Adding more pillows is, in fact, the quickest way to make a bed appear inviting. They can either be covered with traditional embellished pillowcases or they can have specially made decorative covers. Large pieces of collected fabric can be used to cover square pillows to sit on top of the bed, as long as the chosen designs do not clash with the rest of the bed coverings.

Mixing different fragments looks more original than edging every element in the same pattern. The bedspread or counterpane was originally decorated as elaborately as the bed hangings. Think of the bed space as an artist's canvas waiting to be covered with an old quilt or an embroidered shawl or two, perhaps one covering the pillows, another over the bed itself. A damaged textile can be folded at the foot of the bed to show it to best advantage or cut and draped to cover the existing headboard. A tester bed can have curtains made from old linen sheets, or just have a panel made from a hanging or old tapestry mounted on the wall behind.

The tester, or four poster, has had something of a design renaissance, and in consequence there are many good-looking contemporary versions available today. Rather than reproducing the somewhat heavy lines of antique beds, modern testers are slim and spare, almost minimal in form and often made from metal rather than wood. Hangings should then be far less full than the traditional

above and right
A fine, complex twentieth-century American Indian patchwork appliqué quilt, in a pattern called Seven Sisters, is the starting point for this carefully thought-out bed dressing by Mary Drysdale. The curtains are made of unlined checked silk, and the dress pillows and bed cover are in lime green on white crewelwork. A dustruffle is made from the same checked silk and has tiny handmade bows attached to it.

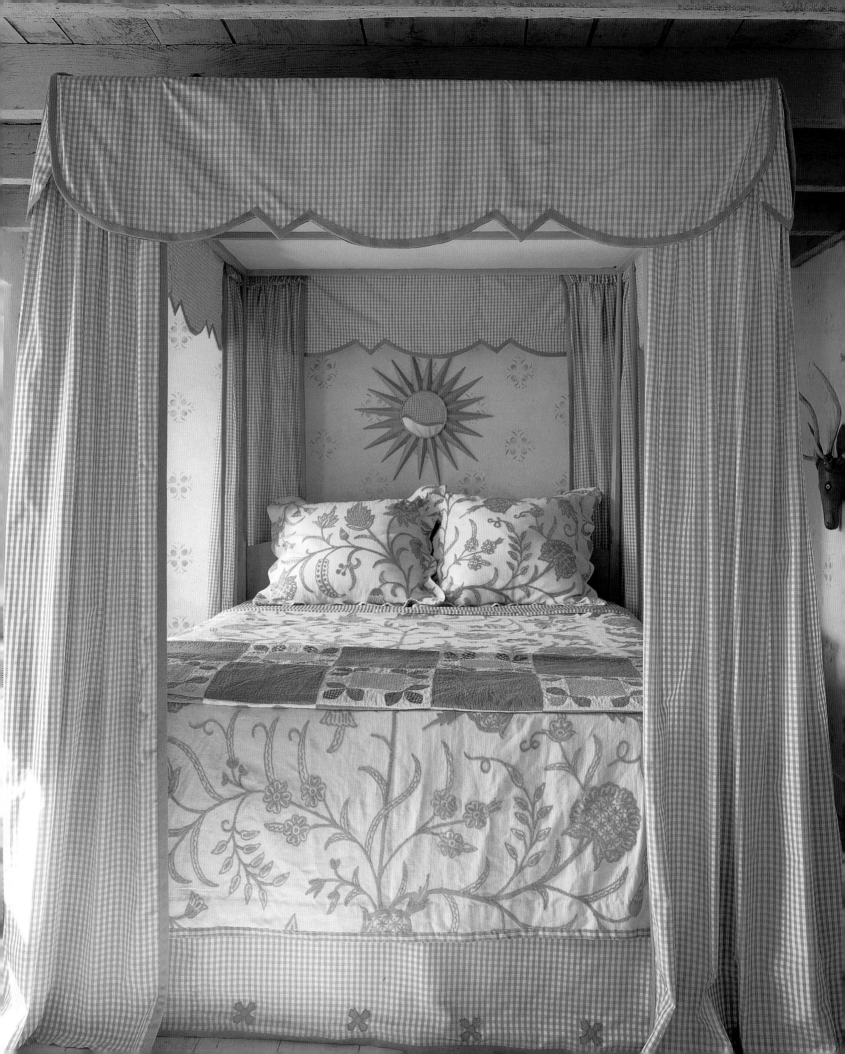

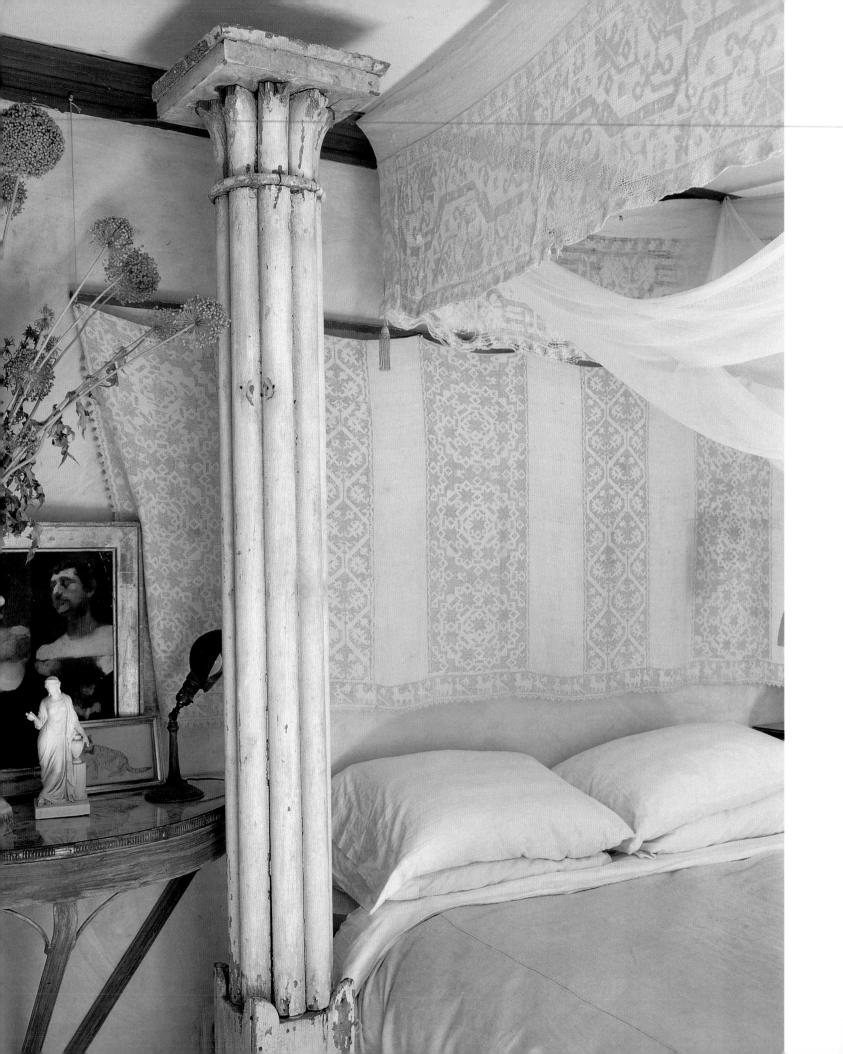

left A divan bed becomes a glamorous retreat with thick white linen draped from the wall behind the head. A wide band of nineteenth-century American crochet is attached along a length of wood above the bed.

right In a contemporary take on a traditional theme, the back rail of a four-poster is dressed with fine cotton scarves, an *ikat* throw, and another in a cotton waffle weave. Complex pillows include one of velvet appliquéd onto Dupion silk and another of patchwork cotton.

below Simplicity is a mattress on a *dhurrie* covered in *khadi*, a crinkled Indian cotton, with matching pillows. The curtains of transparent raspberry-colored cotton woven with a self-stripe induce quiet repose.

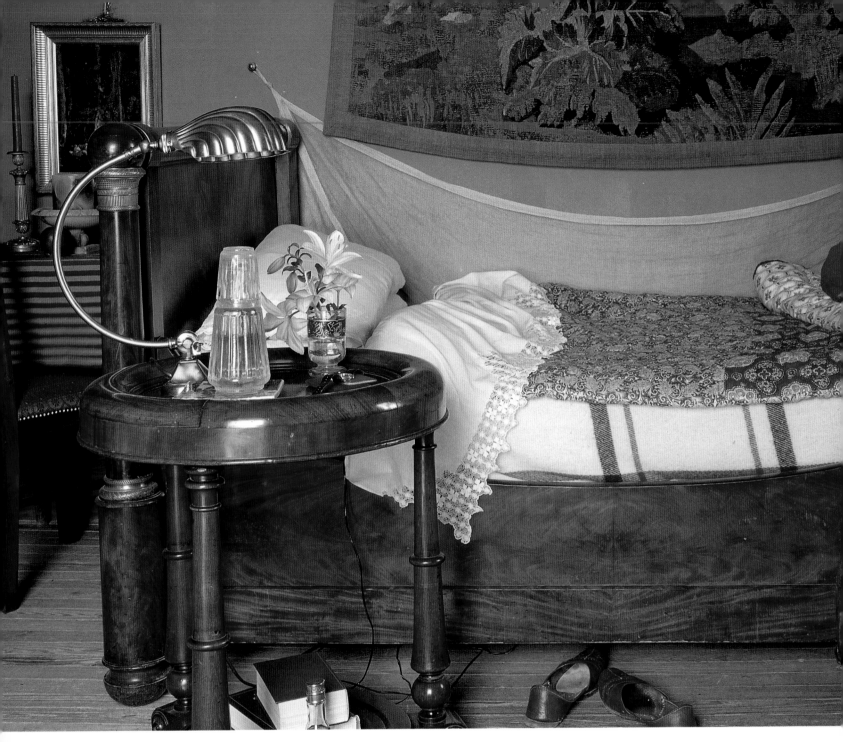

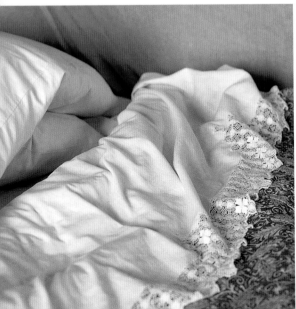

left A detail of the bed shows the elaborate drawn threadwork of the sheets and pillowcases that is typical of Canary Islands embroidery.

bed-curtain width to avoid overwhelming the design of the bed. These testers offer a perfect opportunity to use all those textiles of narrow width, such as pieces of paisley (non-matching, naturally), striped Norwich shawls, or even ethereal Eastern sari lengths. A number of sari fabrics in several designs – but at most one or two colors – would look very pretty. Little other adornment would be needed to suggest – for that is what you want to do, rather than emphasize – a bed of charm and comfort.

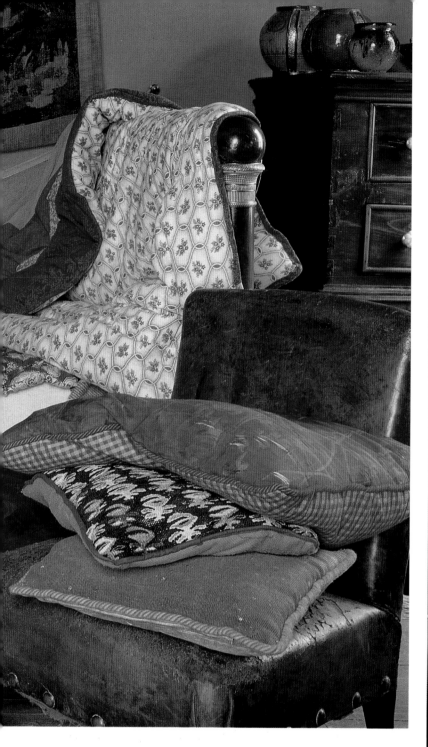

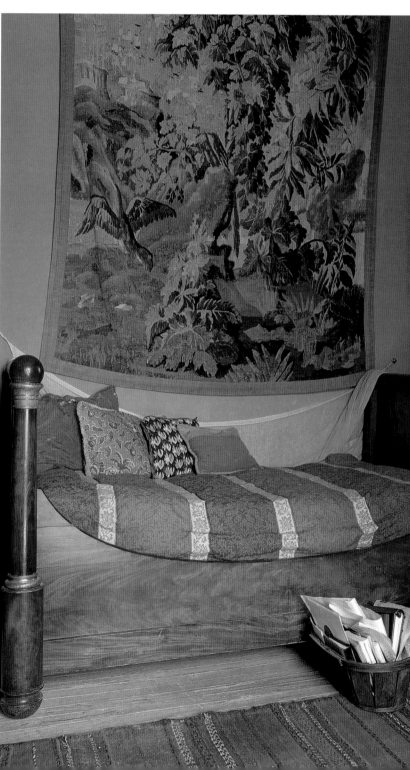

following pages On the left, a very simple bed has a pleasing but simple cover made from a piece of Swedish striped linen. It was not wide enough to make a cover on its own, so it has been sewn as a panel onto an old linen sheet. The pillows emphasize the colors of the newly constructed cover. In the bedroom on the right, the blue shutters set the scene. An antique iron bed has a dress pillow made from a piece of blue Russian country cloth; the smaller needlepoint pillow in front is new. The bed cover and tablecloth are from Jaipur.

above Ready for bed in Gran Canaria, where Christophe Gollut selects an international mixture of textiles. A blue and white piece of quilting is from Bhutan, handmade sheets are from the Canaries, and the blankets are from Finland.

right During the day, the night table is moved to one side, and the fine Empire bed doubles as a sofa, covered with a contemporary Egyptian bedcover. A fine eighteenth-century French *verdure* tapestry decorates the wall behind.

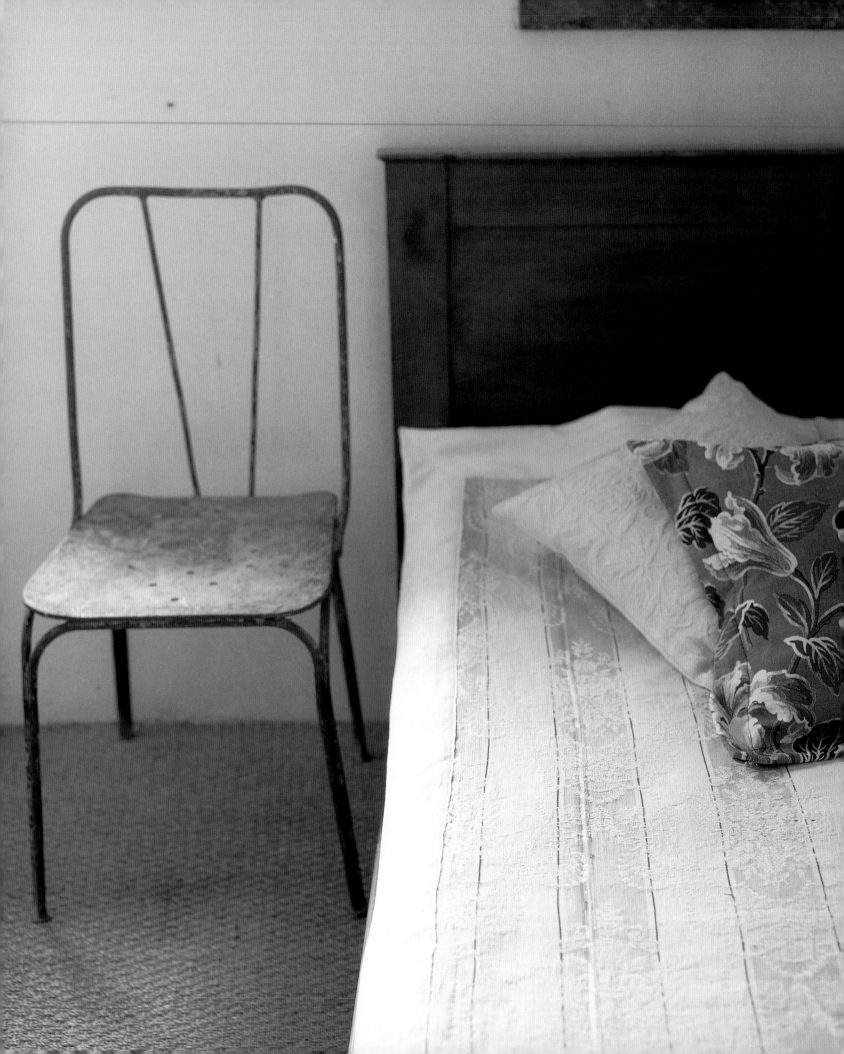

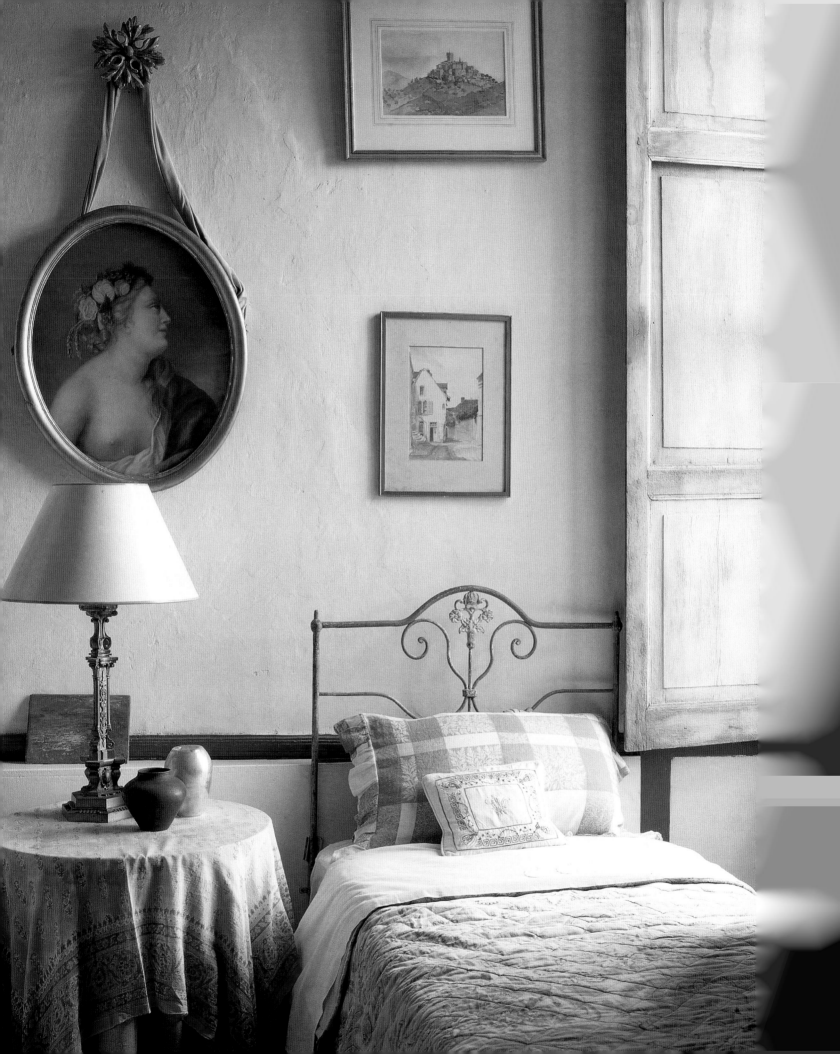

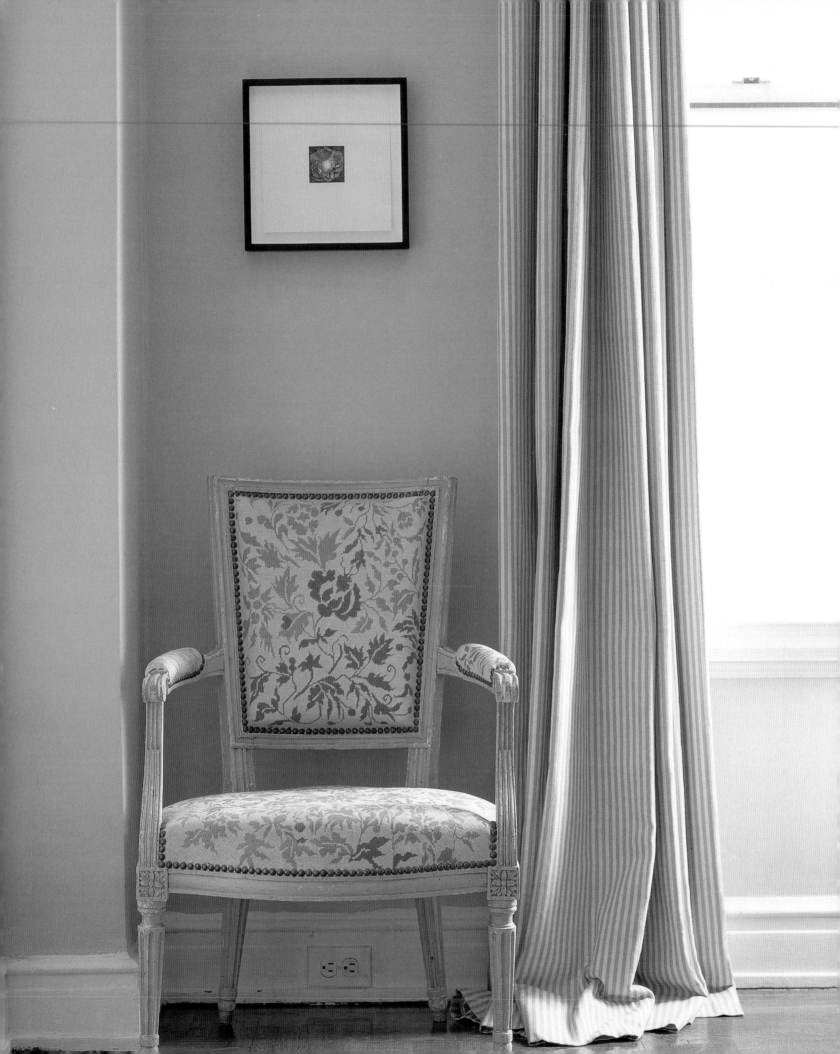

upholstery

Upholstery has really come to mean any sort of fitted cover or cushion, even those made from printed cotton or a cotton-linen mix. Although purists might catch their breath a little (and it is true that the fabric probably will not last as long as a tightly woven one), the charm of a bedroom chair or stool upholstered in faded old chintz or an embroidered linen tablecloth is not to be denied. But it is an indulgence; once, upholstery textiles were considered only to be those made to withstand tough usage – some damasks or woven horsehairs, for example, developed in the eighteenth century for use on dining and other straight-backed chairs.

below left A chair is cleverly upholstered in traditional French red and white check fabrics that at first sight look the same, but which are in fact all slightly different.

below When upholstering with similar materials of varying pattern sizes, make sure the rest of the decoration is simple, with color as the link. The eye needs restful spaces interspersed with such sophisticated decoration.

left An antique French chair is upholstered in faded, fine needlework, so fine that it looks more like damask than a stitched textile.

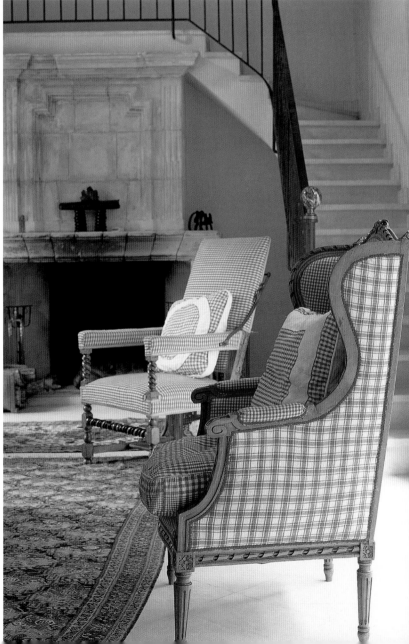

Dining chairs are a good place to start when thinking about using different textiles mixed together. Why does each of a set of dining chairs have to be covered in the same material? Does this idea date from the time when a long, wooden, extra-shiny table stood in solitary splendor in its own room, flanked by its own special set of ramrod chairs? Today, such a sight is becoming rarer and rarer, except in the largest houses. A dining table is far more likely to be an integral part of another room, a living room or kitchen, perhaps, and used for work or leisure pursuits as well as for eating. And the

above A library chair is covered with pieces of nineteenth-century Turkish kilim, made more interesting by the jolly, early twentieth-century woven Moroccan pillow.

above left Especially chosen to pick up the color of the walls, a precious piece of French silk from the 1840s covers a stone bench in this hall.

left Part of a nineteenth-century American hooked rug upholsters an old milking stool, finished with brass-headed nails of the same period.

chairs, even if they are part of a set, are far more likely to be placed where they will be useful. Perhaps two or four will be around the table, the remainder scattered around the room or the rest of the house, to be brought to the table only when needed.

In such cases, it actually makes more sense for the chairs to be upholstered differently – perhaps in colors or patterns that work together, but definitely differently. If you collect old weaves, tapestry, *petit* or *gros point*, here is the perfect opportunity to show them off. There are other decorative ideas dreamed up by earlier upholsterers that can be reinterpreted today. For example, chairs with wood legs sometimes had the legs upholstered in the same material as the seat and back. Alternatively, the legs were painted in imitation of the covering material or in the same colors as the upholstery.

right A chair with a cover made in the 1930s is beside an old camping stool, now covered in needlepoint and fit for the most stylish of rooms.

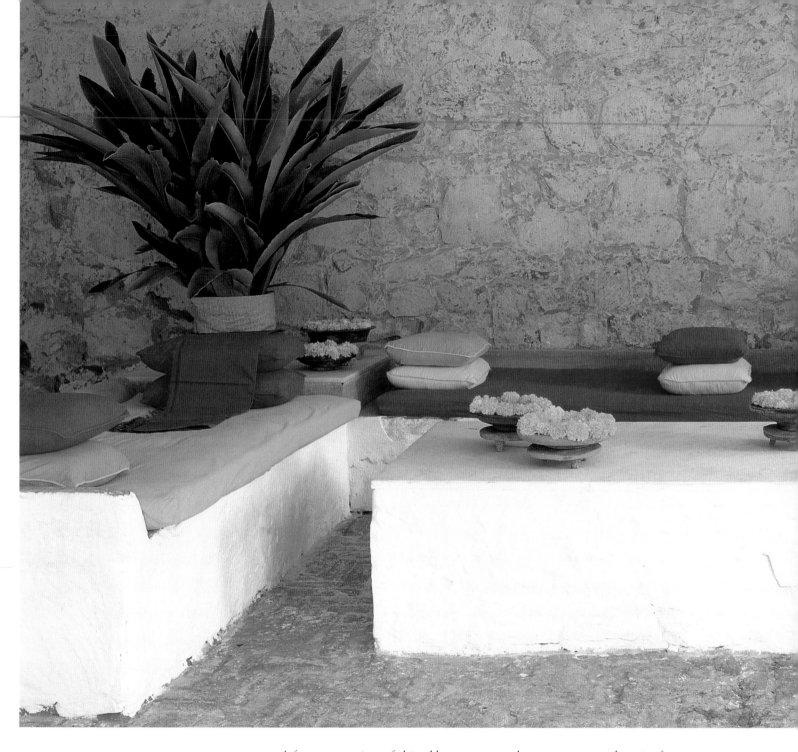

A few years ago, it was fashionable to cover sofas, chairs, and stools indiscriminately in kilim or other flat-weave rugs, but that look has been refined. Now either only part of a chair is upholstered in kilim, or different designs are used on different areas, such as seat cushion, back, and the overall structure. This fashion has the added advantage of being a way of displaying pieces that might otherwise seem too small to use for upholstery.

Another way to use carpet strips is to recreate a fashion of about eighty years ago, when sofas and chairs were upholstered in

velvet or moquette and a strip of carpet was sewn down the center from the top to the feet. The idea of a central strip or band of material has been carried into other textures by Christophe Gollut, who uses narrow strips of woven fabric or needlework on dining or hall chairs with traditional, upholstered seats. He also uses passementerie the same way – a wide piece of braid or ribbon simply tacked to the base material and, if the chair has a back, down the length of that as well. If a piece of needlework is too small to cover the entire seat, instead of making a new cover

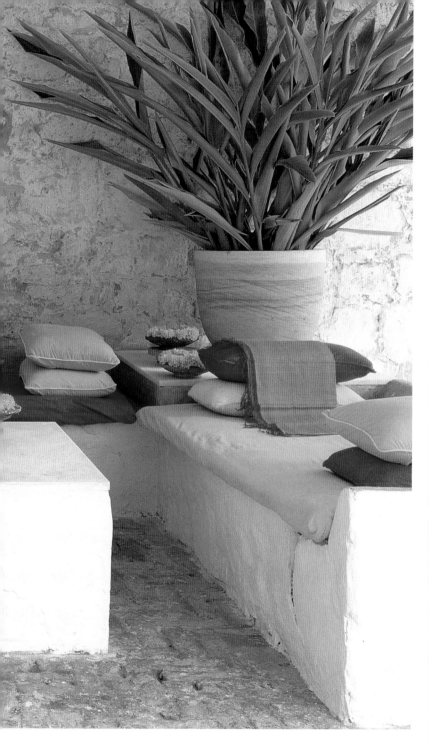

above This seating area looks so inviting, and its secret lies in the scheme's simplicity. Although there are so many pillows (inviting in itself) and seemingly so many colors, all is carefully worked out. The seat cushions are made in two of the pillow colors, the only addition occasional flashes of bright green. Lengths of woven cotton laid across some of the pillows are an interesting decorative extra.

right Instead of using a large piece of material to cover a sofa or chair, consider making an abundance of similarly sized pillows that will transform even the most basic upholstery – here a slipcover over a wicker base.

above right Deckchairs covered in an unusually heavy canvas and topped with extravagant fringe become chairs that could almost take their place inside the house.

below On a beautiful, lacquered, eighteenth-century sleigh bed, pillows from different cultures and periods all work well together. At each end, large cushions of glowing yellow nineteenth-century Empire silk, woven with neoclassical designs, contain a mixture of Chinese embroidered pieces, Moroccan needlework, and European cotton. Repeated use of bright yellow accents guarantees that the composition works. The round Victorian stool in the foreground is magnificently unreconstructed.

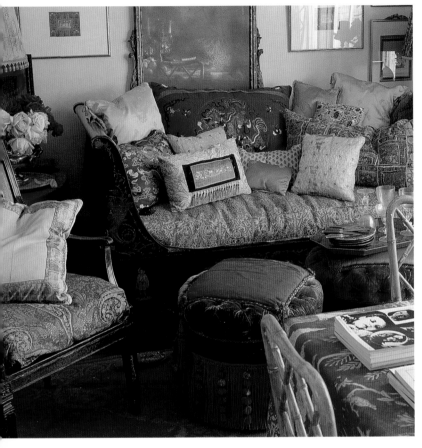

incorporating it, you can simply center it on the existing cover and sew it on securely. That way, you can always transplant it elsewhere should you want to.

If one area of a piece of upholstered furniture becomes worn or cat-torn, it can be replaced with another textile, perhaps in the same or a contrasting color range. This treatment is particularly effective when the piece of furniture is freestanding – such as a *chaise longue* or an easy chair – and the different sides can be seen from different angles. If there is a fitted seat cushion, you can consider covering this, too, in something from your collection.

Trimmings were once used extensively as much to disguise poor upholstery work as to decorate the furniture. There was fringe of many different types, as well as tassels, rosettes, cords, and ribbons. Old passementerie can be used very successfully on any upholstery; for example, fringe or braid can be affixed around the bases of sofas and chairs. Again, there is no need to have exactly the same fringe on every piece of furniture.

Exterior decoration and the creation of outside "rooms" are more and more a part of mainstream decorating, and upholstery is particularly relevant in this modern context. One of the simplest ideas we saw was the clever use of pieces of kilim over the canvas strips that go to make up a director's chair for a courtyard patio. By keeping the canvas attached to the chair, the carpet strips can simply be tacked around, without undue work, and the final result is unusual and, even better, appropriate. To make the scheme even more sympathetic, the table that sits in the courtyard is covered with another small kilim. A beautiful result is achieved for little effort.

above One of a pair of hall chairs, the seat of which is covered in a contemporary weave and a strip of nineteenth-century English woven tapestry that is cut and simply tacked down the center.

right A French Napoleon III sofa covered with its original printed moquette and fringe is a base for a variety of contemporaneous pillows. One is crochet work applied to a silk background, the others Moroccan.

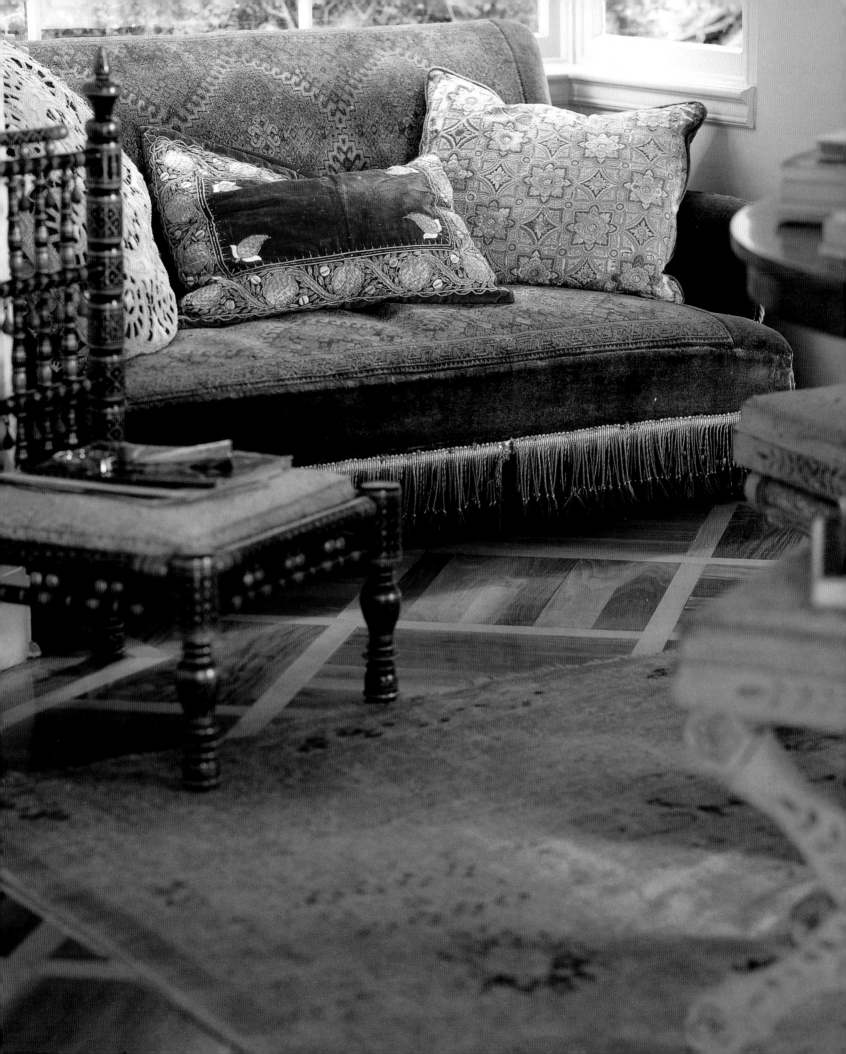

left A modern fabric in a pattern based on a traditional American basket design upholsters this antique sofa. Lifting it to a style above the merely tasteful is a very striking Welsh double-weave blanket in strong mustard and brown used as a throw.

right At one end of the sofa is a pillow made from a most unusual material – the ribbons used to wrap cigars. These exact ribbons may be difficult to find, but others could be used in the same way.

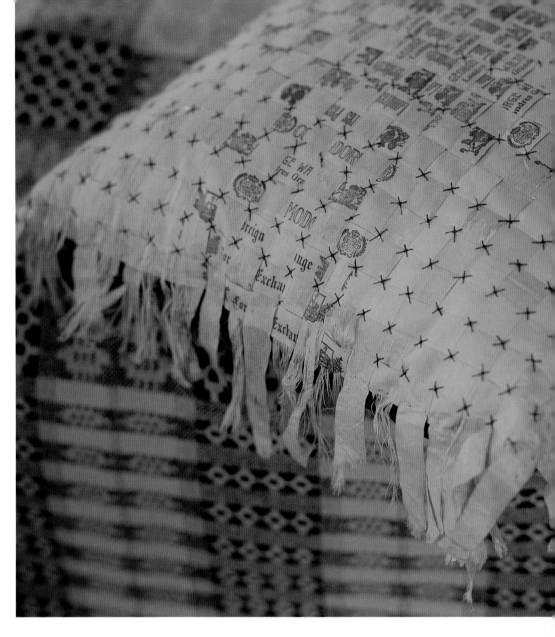

sofas

The sofa that we know today developed from a simple form of bed called a *couche* or *couchette*, early versions of which can still be seen in frescoes and vases from the Classical world. It evolved into the single-ended daybed and, later, into the double-ended ceremonial couch, a sort of backless sofa. From there it was a logical step to add a back and, presto, the modern sofa had arrived.

Like a bed, the sofa positively invites the showing off of textiles, particularly fairly large pieces. The only decision to make is whether they should be displayed in structured or casual style. Sofas and living rooms in general fall into two categories, neat and formal, or messy and informal. You must know which describes your room before you decide how to use textiles.

As the ubiquitous throw remains fashionable, usually in the form of a blanket or rug, it presents a heaven-sent opportunity to give an individual spin on a modern theme. Introducing a throw is also the simplest way

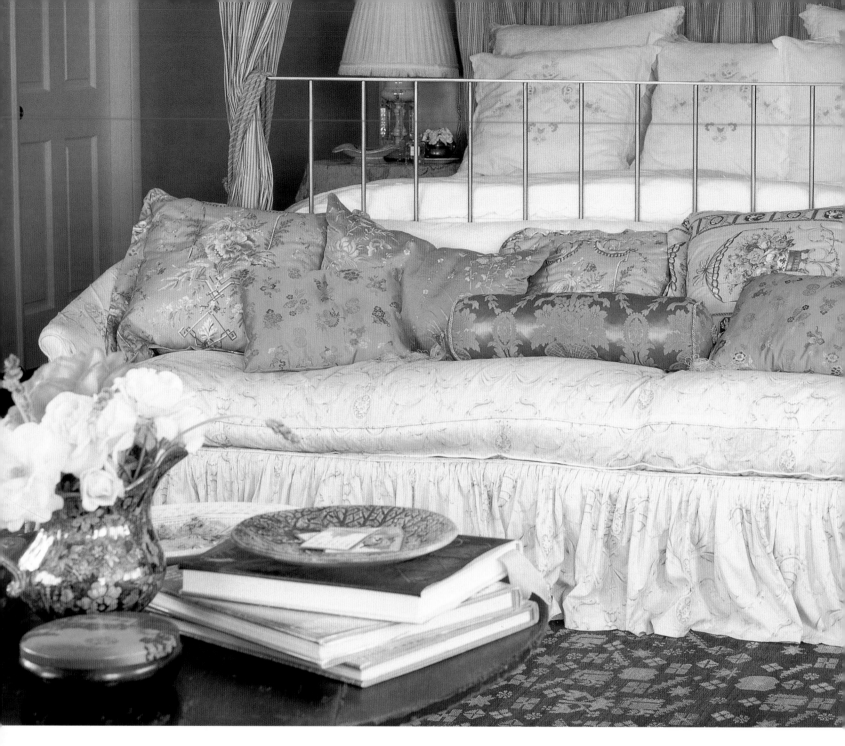

above This comfortable bedroom may seem artlessly arranged, but the scheme is actually carefully considered. The classical, feminine comfort of white on white on the bed, with its pillows three deep, is offset by the textured pillows on the white sofa at the foot. French printed cotton pillows are the backdrop for three Chinese embroidered ones and a resplendent nineteenth-century French damask bolster, all in sharp citrus tones.

speedily to change the look of a sofa. If the piece of material is a regular design, geometric or even plain, it will look best folded or hung in a straight line. If, however, it has an all-over design – floral, paisley, or scenic – it can be draped in more negligent fashion. Basically, almost everything that is possible with fitted upholstery can be approximated with loose textiles, with the advantage that when you want to change them, remove them, or move them elsewhere, it is easy to do so. Seat cushions can be covered with loose textiles with the sides tucked in, and the backrest can be covered in its

entirety with the edges tucked in or folded over in the manner of upholstery.

For an entirely different look, bring out the white stuff, the linen and lace. A crisply starched cloth – either an old tablecloth or a large sheet – draped over a sofa is unexpected but very effective. To define the look, add layer upon layer, using a heavily embroidered or monogrammed hand towel as a panel draped over the center of the sofa back. Don't hold back. If the towel has a deep, fringed edge, so much the better. Smaller, huckaback or cotton hand towels can extend the length of each arm, and the look is complete.

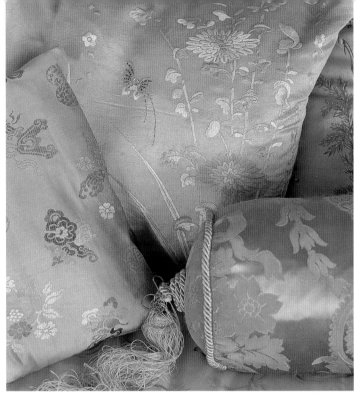

left A detail of three of the silk sofa pillows. The colors are so close, yet different enough to blend without being boring. The Eastern style of the Chinese embroidery and Western extravagance of the bolster are complementary.

right These wonderful Chinese export hangings with their inimitable, vibrant colors and close-tufted trimmings are, by their nature, quite fragile and can really only be used on a sofa that will not get a great deal of wear.

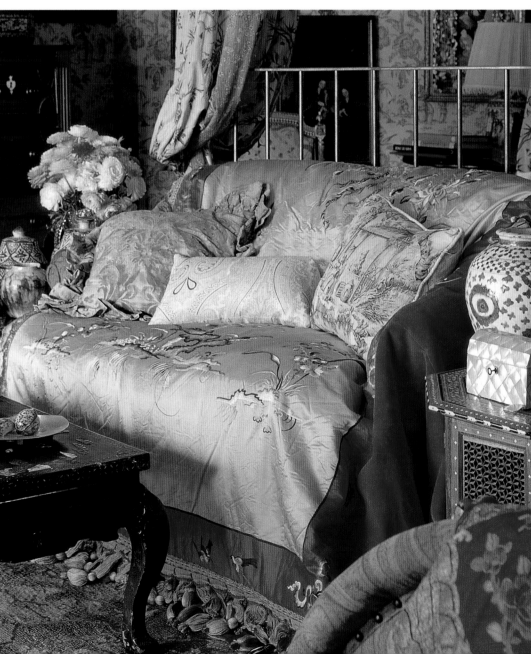

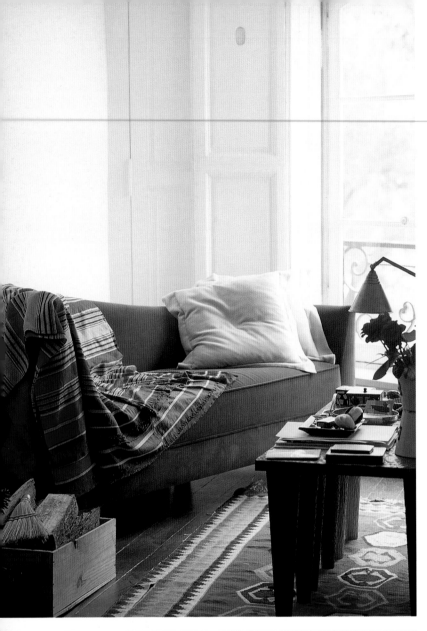

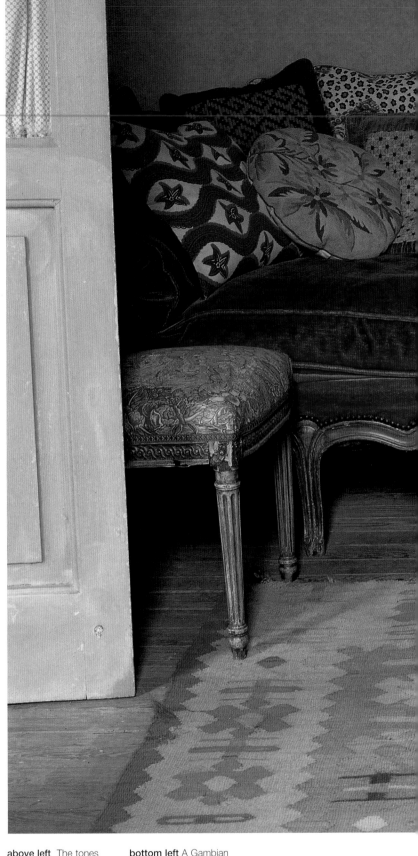

above left The tones used here are subtle and sophisticated, and the addition of a striped Syrian silk throw cleverly connects the sofa to the colors and patterns of the rug.

bottom left A Gambian car-washing rag finds new life as a cushion on Christophe Gollut's sofa.

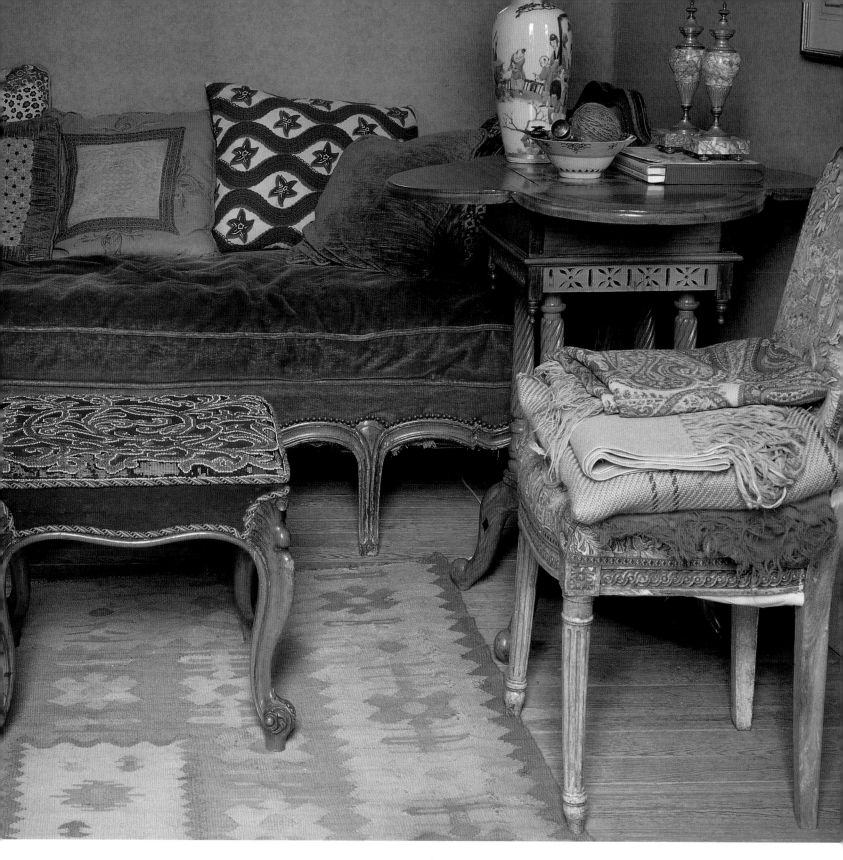

above An exercise in color coordination is in evidence here. On a daybed covered with blackberry-colored velvet is a group of pillows, each one very different. Yet the purple and white Gambian cotton, new needlepoint in blues and pinks, and old damask in pinkish mauve all work well together because they are from the same color spectrum. All purple would be too rich. In front of the sofa is a beaded Berlin woolwork stool on a deep purple background.

right Lynn von Kersting has transformed this nineteenth-century painted Italian daybed by draping an early twentieth-century Fortuny fabric over the seat and adding white pillows that belonged to her grandmother. Set in this sea of starched linen is a nineteenth-century embroidered Indian pillow and another of the same period from Turkey.

below Shawls, antique clothing, and an assortment of pillows, including this one made from a piece of old-gold velvet banded with lace, completely cover this sofa.

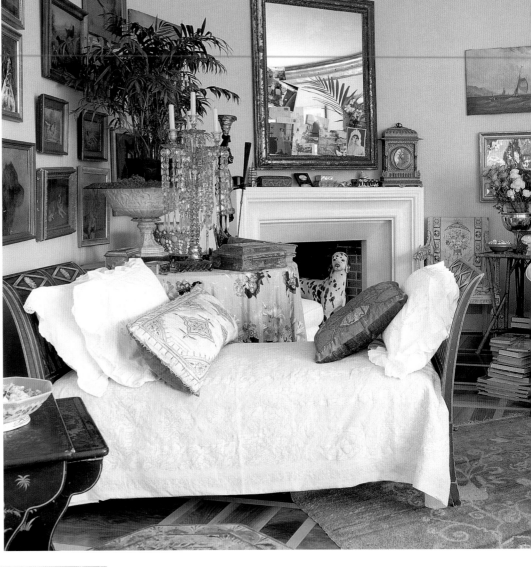

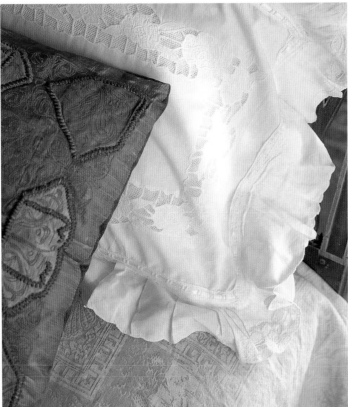

left A detail of the sofa above shows how the use of contrasting textiles – antique Turkish embroidery against the starched white of hope-chest linen – keeps the arrangement from becoming sugary.

right Culture clashes can breathe new life into a scheme. Old silk damask covers a formal, straight-sided, nineteenth-century sofa and is given an edge with a silk throw from Bhutan tucked around the seat cushion and a pair of dark bolster cushions.

A sofa can also be permanently upholstered – rather than simply loosely covered – very effectively with all manner of antique and exotic textiles. Old velvet, particularly silk velvet, behaves rather like leather when used as an upholstery fabric. Its charm increases with age, and the rubbed and faded patches that develop give it individuality. Edwardian and Victorian upholsterers sometimes adopted a style in which the facing panels of the arms or the base of the sofa were upholstered in plain velvet in a color that corresponded to the heavier weave fabric used elsewhere. The fashion can be successfully revived today. When using different weights of textiles together this way, narrow rope or cord that picks up the various colors and tones attached around each seam will tie everything together and complete the look.

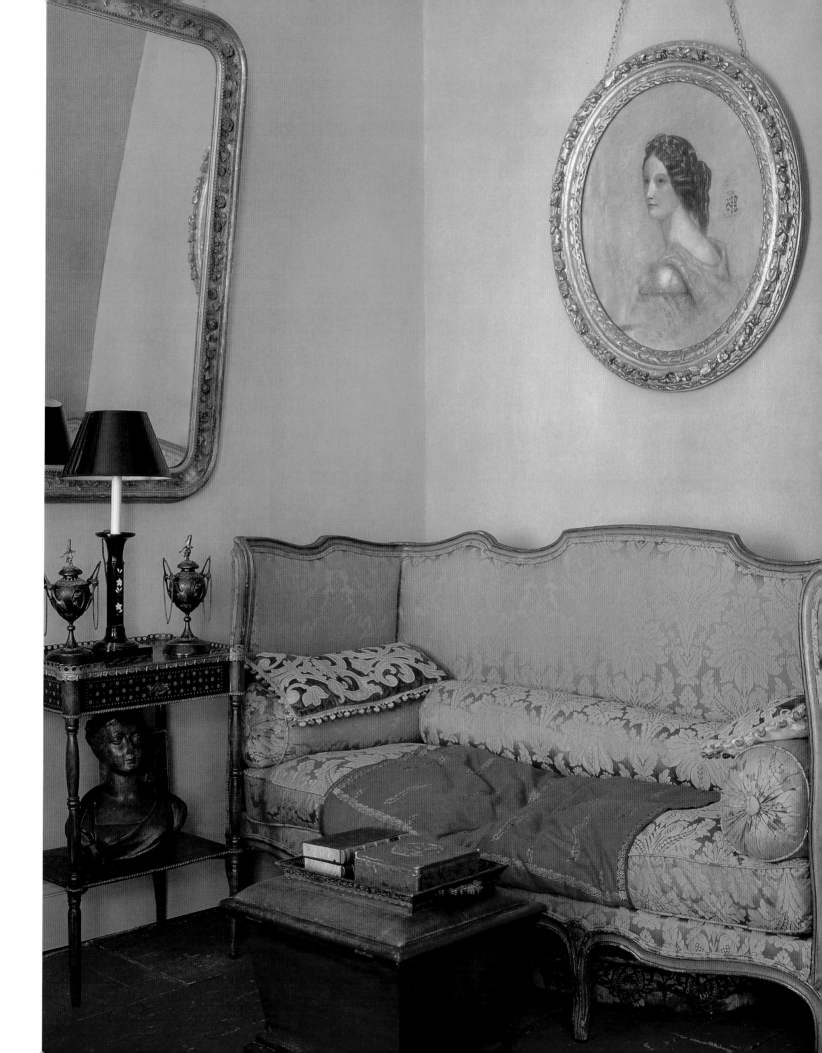

far right Rare and expensive fragments of material such as old toile can still be used for pillows. These are made in graded sizes so they can be displayed together without further ornamentation.

right Pillows are used in small groups of color and texture on this three-sided sofa. All in Indian silks, with only one that is self-patterned, the pillows rely on a brown to pale gold spectrum.

center right Contrast and detail are important, particularly when using unusual or ethnic materials. Dark against pale provides the contrast, covered buttons the detail.

below right Against a buttoned figured damask in the palest of blues is another damask cushion in which the fabric is used as a background to display a tiny piece of fragile embroidery.

cushions and pillows

Although throw pillows seem an essentially modern element of decorative life, they have been used since furnishing began. Renaissance paintings show interiors with pillows and they are often mentioned in inventories of the Middle Ages as items of the movable possessions of a household. They were regarded as an outward symbol of luxury and ease, and could be very elaborate.

By the seventeenth century, pillows were usually of woven tapestry or embroidery – often with armorial symbols – and were trimmed with fringe, braid, and tassels. Pillows have fulfilled different functions in various parts of the world. In northern Europe, they were used on seats, chairs, sofas and benches, but in southern Europe, where the influences of the exotic East were felt, pillows became larger and were used on the floor as seating.

As any decorator or designer will tell you, the not-so-simple pillow today is an integral part of any interior decoration. Some will go so far as to say that no carefully worked-out scheme would be complete without a selection

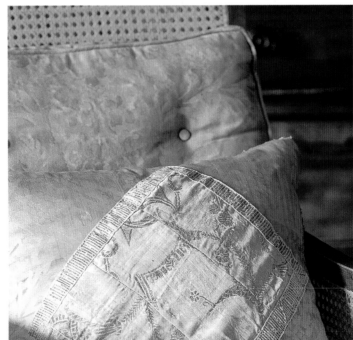

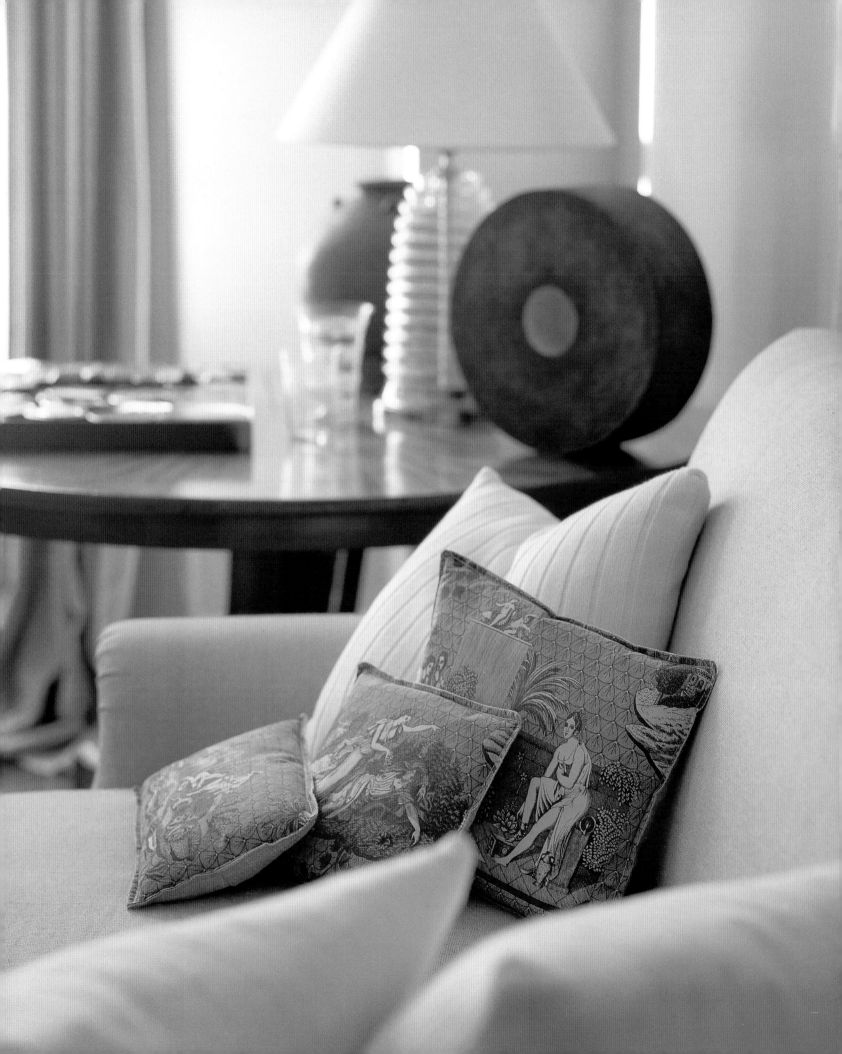

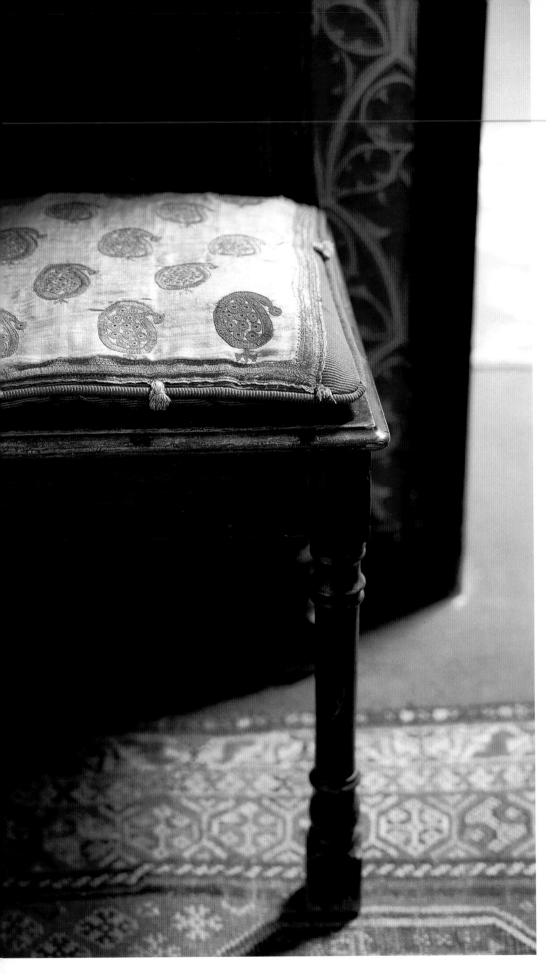

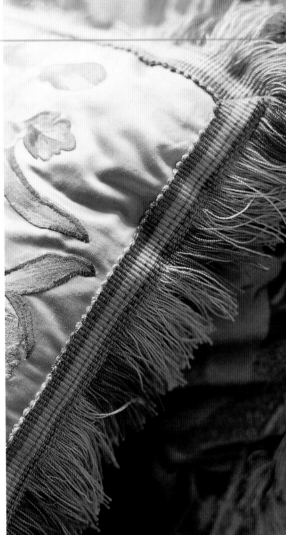

of well-chosen pillows of different sizes and designs. Pillows break up what might be boring expanses of upholstery and add pattern and quirky interest. Their very existence immediately makes a room personal and comfortable, as well as unique.

For collectors of textiles, pillows are a perfect way to display interesting fabrics, old or new. There are some designers who even feel that pillows should only be made from old material and keep a changing stock of pieces for precisely that purpose. Aged, by the way, does not necessarily mean expensive: an old scrap found at the back of a drawer or in a linen closet can work wonderfully well, even if it is used as a panel set into something else or as a wide border around another piece. An antique, embroidered linen towel, a torn Art Deco scarf or handkerchief, a piece of a frayed paisley shawl, or a small fragment of old carpet

far left To avoid damage, this fragile Indian silk is lightly sewn onto a heavier fabric.

above left Appliqué work is embroidered around the edges and within the motifs and edged with silk braid.

above Each chair has a cushion made from different contemporary *petit-point* embroidery.

right An unusual juxtaposition of pillows of antique traditional embroidery from Fez.

far right There is a harmony in printed materials of the same age and type: these are all French cottons.

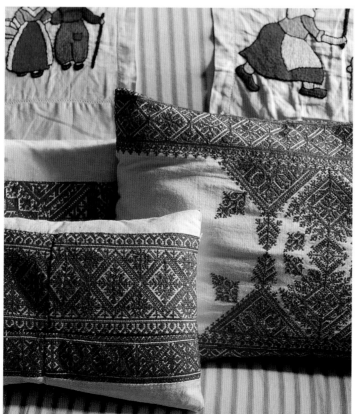

cushions and pillows **167**

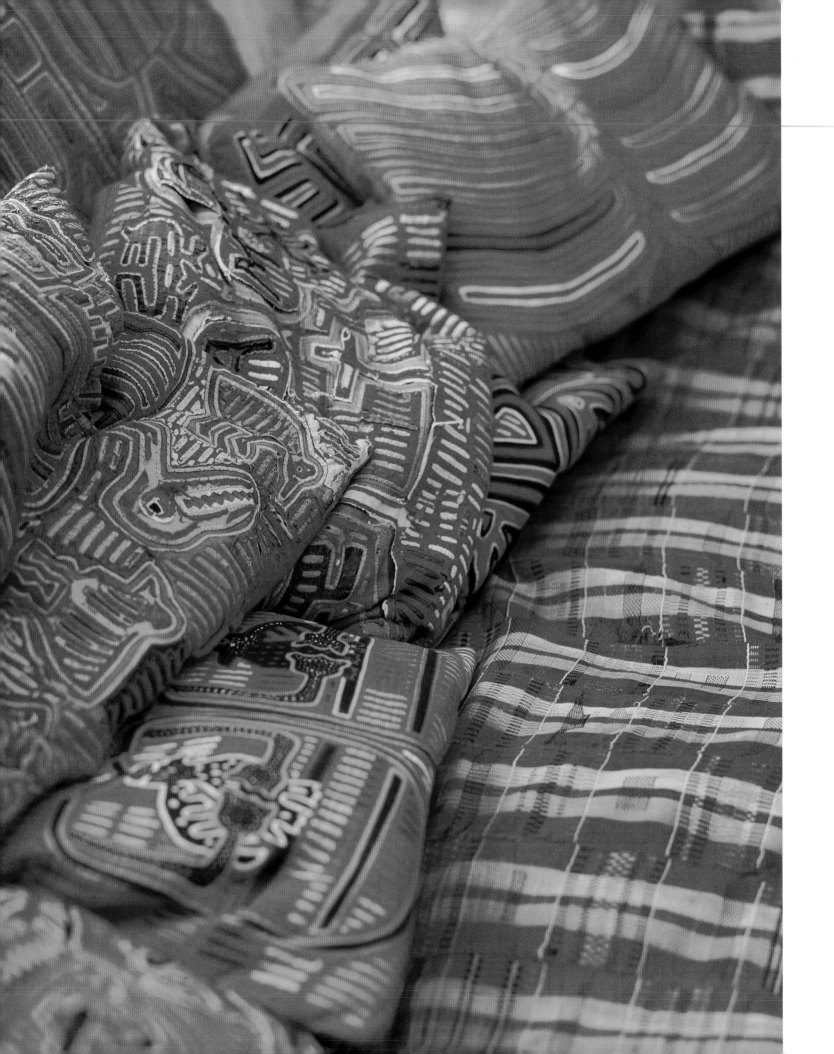

– all these remnants, rather forlorn in themselves, can have a new life as pillow covers. Even something as fragile as lace, whose delicacy has to be looked at closely to be appreciated, comes to life when used as part of a pillow over a plain, contrasting fabric that shows up the intricate, subtle work. Pillows can be made of the slightest of scraps. For example, a border can be cut out of an old piece of paisley and superimposed on a plain background – white linen, perhaps, as a contrast or, in keeping with the paisley palette, black or deep red, which are often the colors of the central field.

Although you may not have thought about how to put pillows together, maybe assuming that you just put them anywhere there is space; there is a skill to combining pillows, and taste does come into it. When you notice pillows, it's not usually because the pillows themselves

are particularly fantastic, it is because they are used well together – the conjunction of sizes, patterns, and colors. Pillows are to be played with, to make congenial groups from, and this is even more the case when they are made from old or exotic textiles or from a mixture of old and new.

The first thing to do is to make as many pillows as you want from every bit if material you have set aside for that purpose. The size of the pieces will determine the size of the pillows. It goes without saying that it is important to take the design of the textile into account when deciding what shape the finished pillow will be. Obviously, a fabric with a central motif should be placed centrally on the pillow, not wrapped around one edge. Then you should think about the arrangement and display of the pillows in the same way you would consider the hanging of pictures. And,

of course, you must take the background into account – not, in this case, the wall color or texture, rather the background material of the sofa or chairs. Pillows can also be used to link the upholstery – through color or texture – to the decoration of the walls.

When pillows are small, they are best grouped together rather than left in splendid isolation. Move them around and try varying sizes with other shapes. And even when pillows are the same or made from remnants of the same design, they have much more impact grouped together. Few are the pillows that look good on their own, unless they feature spectacular textiles or exactly fit the chair in which they are placed. One of the biggest mistakes is putting too small a pillow in a chair, for although a pillow is a decorative accessory, it should also fulfill the purpose of providing added comfort and support.

above An antique lacquered chair is given a flamboyant cushion of embroidered eighteenth-century Chinese silk. The combination is unexpected but totally right.

left Tumbled casually over a sofa are wonderfully bright and cheerful woven hangings and woven and embroidered pillows from South America. It is most effective to use such pieces in profusion.

above An assortment of pillows in traditional textiles of the Banjara – a nomadic Indian tribe – including a hand-embroidered dowry bag embellished with cowrie shells, are strewn over nineteenth-century Indian furniture.

above An ornately embroidered velvet Moroccan cushion and another made from a piece of a Kashmiri shawl and trimmed with a surprising cream fringe decorate a French daybed covered with Fortuny fabric.

right A set of small matching cushions are made from pieces of paisley cut and sewn in squares onto a dark background that emphasizes the design.

far right Printed skins are used sparingly against a handmade felted cushion by Mary Kirk and an Indian blanket from Isobel Frayss to create an entirely new decorating color combination.

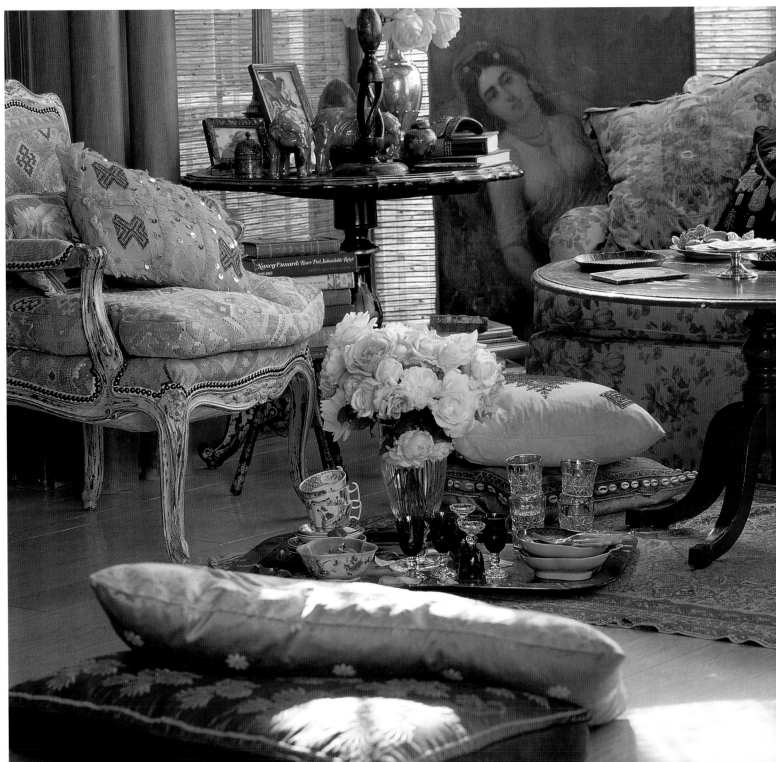

below In Lynn von Kersting's room of textiles, nothing is the same as anything else. The number of different designs and colors is dazzling, but it all works because of the tonal qualities of the textiles used. For example, although the faded chintz covering the sofa and the nineteenth-century kilim upholstering a chair are very different textiles, both are predominantly soft cream and pink, as are the Indian rug and the comfortable Moroccan floor cushions.

right This corner has a distinctly Eastern feel. In the foreground is a nineteenth-century woven Indian cushion in deep pinks decorated with cowrie shells and on the sofa an ocher nineteenth-century cushion boldly embroidered with fearsome beasts.

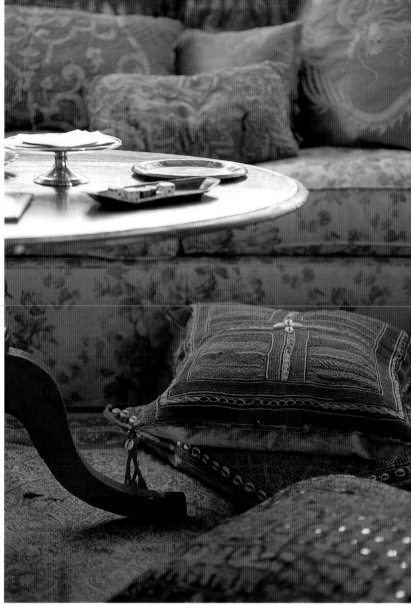

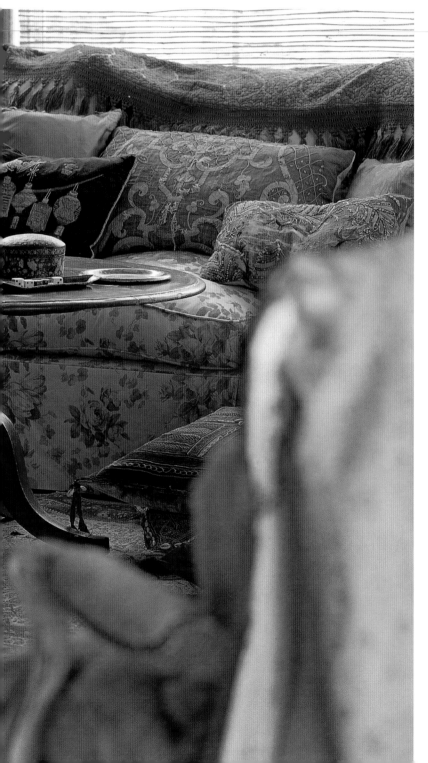

left A closer look at the multitude of patterns and colors within this group of sofa cushions shows that each is striking in its own right. The yellow is nineteenth-century Venetian, and the unusual black and pink, with its string of jaunty lanterns, is Franco-Chinese.

embellishment

Although lampshades are not often thought of in association with unusual textiles, they are actually a very useful and effective way of displaying decorative fabrics. Even a scrap of textile can be made into a small shade. A piece of woven silk or a scrap of cotton with a faded pattern will both show their designs in a new way silhouetted against the light.

top right Go to notions counters or specialty shops or rummage in bags of mixed lots at auctions and you may be lucky enough to find a piece of beading to add to a lampshade.

center right Lampshades aren't meant to be serious: a scrap of ribbon or a fragment of trimming can be added to a lamp and can only improve it.

above When is a hat not a hat? When it is a lampshade, of course, designed by Sera Hersham Loftus and made of stiffened black tulle and trimmed with full-blown orchids.

above right Decorative textiles most definitely lend themselves to lampshades. Even something as small as a scrap of lace can be commandeered.

Old cretonne and chintz look particularly attractive as shade fabrics for period lamps. When choosing a lampshade, remember that although fashions for the shape do not change much with the years, fashions for size do. A very small shade, particularly used on a candle lamp, can look slightly out of date.

It is not necessary to go the trouble of making a completely new shade to accommodate a treasured textile: a fragment can simply be draped over an existing shade. A finely embroidered handkerchief of the type so rarely seen nowadays or an antique printed scarf

work well used this way. Old trimmings are very effective, too – a scrap of handmade braid or fringe is better employed around the base of a lampshade than it is left languishing in a box.

In the widest sense, display and embellishment are what this and all other books concerned with interior decoration are about. More specifically, it is useful to consider how to display the pretty bits of textile that you don't know what to do with, but which are too enchanting to put away in a drawer and forget. In the process of displaying them, you embellish – and effectively decorate – a room.

below right A fragment of embroidered silk, a pretty handkerchief, or an old printed scarf from the 1950s doesn't even have to be cut and attached – it can simply be draped delicately over an existing shade.

far right Some lampshades become important features, as does this one swathed in silk and glittering dress ornament.

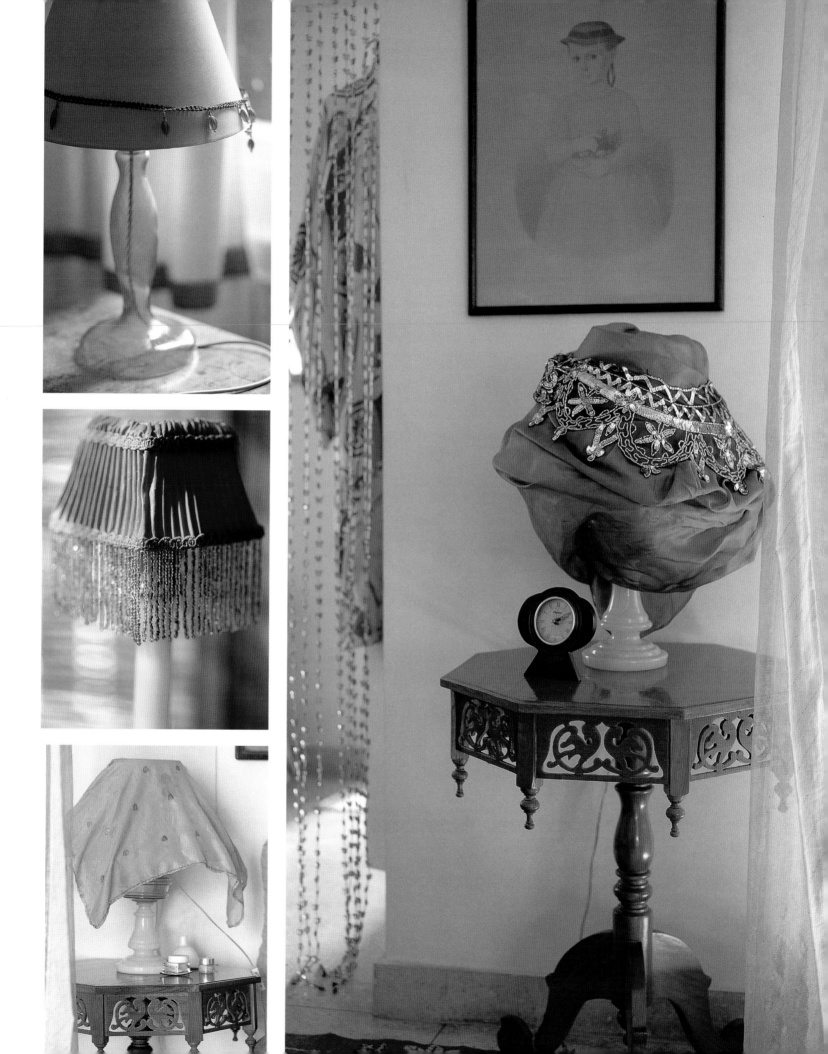

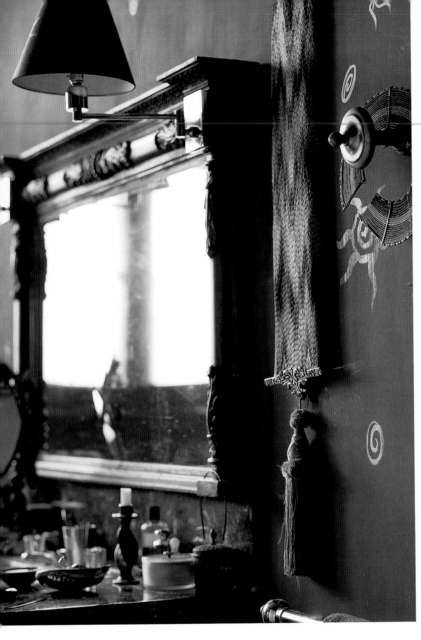

above A bellpull embroidered in Florentine stitch by Nathalie Hambro is utilized as a light switch and as a decorative element in this bathroom full of pretty and surprising objects.

right A wide band of red and silver nineteenth-century Indian ribbon is shown off to best advantage hung down the center of a panel. The rectangular umbrella stand grounds it and gives it a purpose.

Screens are the perfect vehicles for the display of textiles, whether they are old or new. Used during the seventeenth century as structures to keep out drafts, screens were usually made from an even number of sections, or frames, to which panels of textile were nailed directly. They could be covered with a variety of materials, from warm, thick, worsted wool to light and decorative silk. Their considerable decorative possibilities were soon recognized, and they were often used to display tapestry or panels of embroidery.

In contemporary interiors, screens, whether half- or full-height, can be used as canvases, blank walls to decorate with all kinds of textiles. Perhaps you have enough of one textile to cover the screen with the same material on every panel, or perhaps you want to use separate pieces on each panel. Or you could cover the screen with one material as a

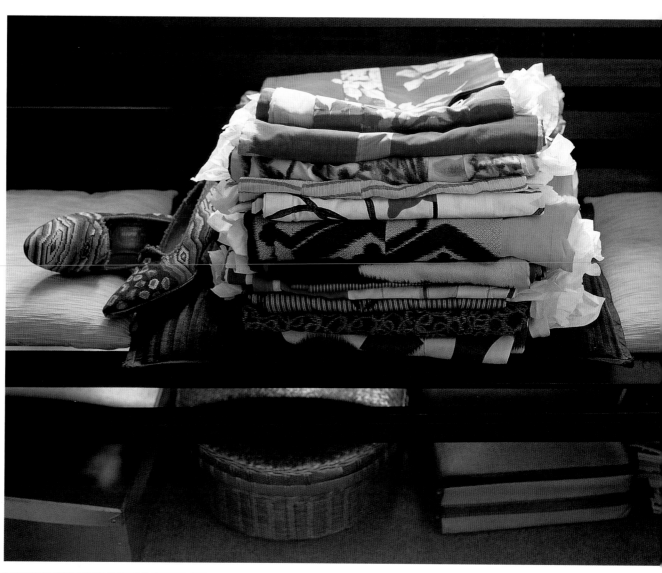

background and embellish it with fragments, appliquéd either in a regular design or in more haphazard fashion. As a piece of furniture, a screen is extremely versatile. It can be placed in a corner, following the angles of the room to define furniture and objects placed in front of it. A half-height screen can be stretched the length of the wall in place of a dado, to break up a room in which the proportions are unbalanced. In a bedroom, a screen can be used either as the headboard itself or behind an existing low one to give more emphasis to the room and to draw the bed back visually toward a wall.

Traditionally, embellishment and ornamentation of upholstery was always achieved with passementerie – all those wonderful pieces of braid, gimp, fringe, and tassel. In the seventeenth and eighteenth centuries, those same ladies, working at home and professionally, who produced fine pieces

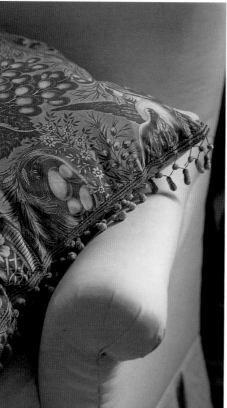

above Textile collectors prefer to look at their finds even when they are not using them in a specific place. The hint of undiscovered patterns and colors makes you want to go through this whole pile of early twentieth-century kimonos.

left This is a very subtle use of trimmings: a latticework of tiny beads emphasizes the beauty of an antique toile made into a cushion. Many types of beads could be used in similar fashion.

embellishment 175

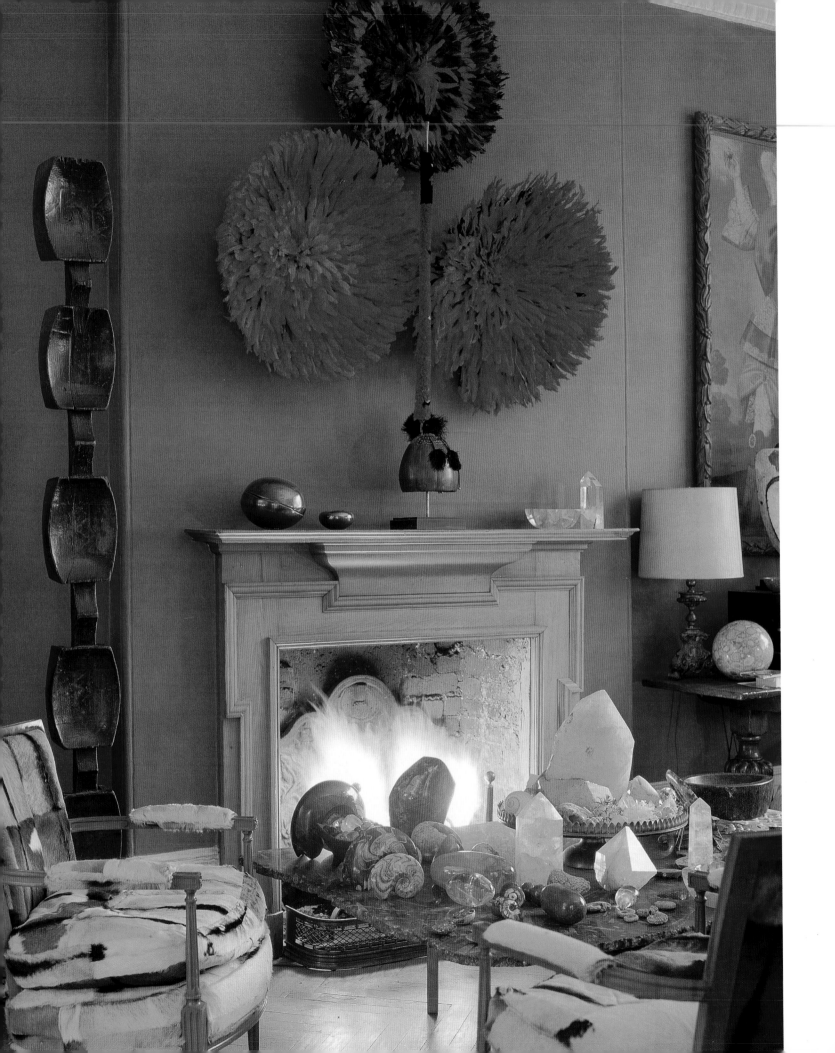

left Unique and wonderful, these very rare African tribal hats from Bamileke are made from dyed chicken feathers. For ceremonial use at agricultural festivals, they move effortlessly to the West.

below Passementerie is a wonderful way to embellish textiles old or new, as this lovely mix of braid, deep wool fringe, and heavy ornamental tassels shows.

right Using costume as display and decoration on the walls as Nathalie Hambro does gives the viewer an opportunity to savor the skills of the maker's art and craft.

bottom In the nineteenth century, fringing was often used along the edges of library shelves as a ready-placed duster for the chosen book. The device works equally well and stylishly on a more humble shelf.

of embroidery in wool, linen, and silk made equally elaborate trimmings for upholstery. Passementerie was used in profusion on beds, chairs, curtains, and drapes. The basic shapes – thick, cord-like gimp and feathery fringe, for example – were given different headings, such as fans, trellis, and gothic motifs. They were then further embellished with superimposed ornament in the shapes of tassels and flowers, bows, stars, and roundels, sewn in wool, silk, and gold and silver thread.

The imagination and taste displayed in these confections are certainly centuries away from the machine-made versions available today. If you find any of these trimmings – and they do exist still – use them wherever they will be seen to greatest advantage. Cushions are an obvious place for tassels or gimp-based ornaments; fringing can be used around the base of chairs or sofas; and gimp or braid can be well displayed on a simple colored cloth. There is no end to the possible uses of passementerie: to decorate lampshades, to flow along the edges of shelves, around the base of a stool, or on window shades. It is really a question of wondering where to stop.

glossary

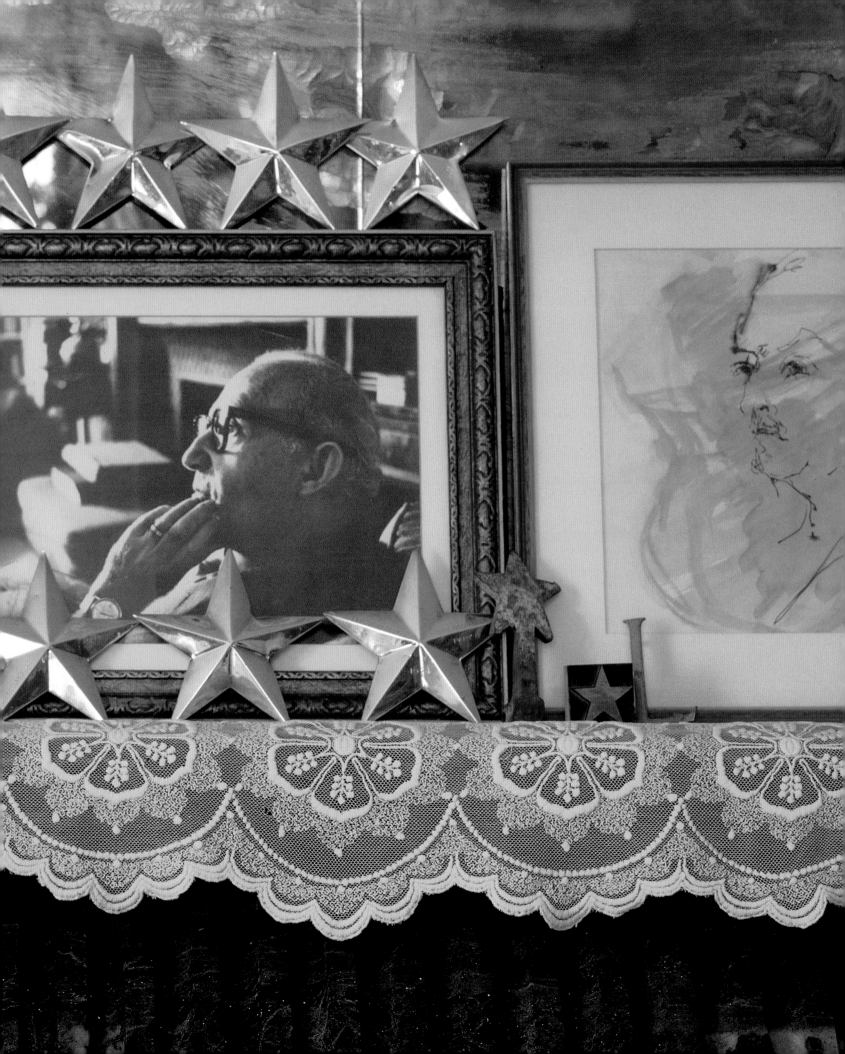

Appliqué A type of embroidery in which one fabric is applied on top of another and fastened with stitches. It is usually used decoratively, with the top fabric cut into pieces to form a pattern. Quilts made in the eighteenth and nineteenth centuries were often appliquéd with printed chintz, used as a border or as a central motif.

Asante A Ghanaian people who have given their name to a technique of weaving both cotton for general use and silk for ceremonial adornment for kings, chiefs, and other notables. Asante silk cloths are often known by the generic name of Kente cloths.

Asasia The name given to the finest silk or silk-blend cloths woven in West Africa and reserved as clothing fabrics for the nobility.

Aubusson A French tapestry-weaving center founded in the fifteenth century and made a Royal Manufactory by Louis XIV in 1665. It continued manufacturing into the nineteenth century and is known in particular for its rococo designs for hangings and furniture coverings.

Bargello Also known as Florentine stitchwork, this embroidery consists of upright stitches of varying lengths and angles that give an effect of flames or steps.

Beadwork The addition and application of beads to fabric. The technique was particularly popular in the seventeenth century, when everything from mirror frames to book covers were decorated with beads. The technique became fashionable again in the nineteenth century for cushions, footstools, and hand-screens, often combined with Berlin woolwork. Beads were also used in decorative stitching by Native Americans, strung onto short threads and stitched onto skins in evenly spaced rows.

Berber The name of a North African tribe noted for flat-weave kilims, tapestries, blankets, and clothing woven from sheep and goat wool, and now applied to describe the textiles themselves.

Berlin woolwork A popular nineteenth-century form of embroidery in colored wool on canvas, following designs drawn on graph paper. Such designs were first produced by a Berlin printseller in the early 1800s and depicted flowers, animals, and versions of famous paintings. Originally Berlin woolwork was worked with wool alone, but later silks and beads were added.

Braid A form of passementerie consisting of a woven fabric in the shape of a band, used for trimming and binding garments and furnishings.

Brocade A woven, patterned textile, often with parts raised above the general surface, giving it an appearance similar to embroidery. The pattern is produced in the weaving by the use of supplementary wefts. Gold and silver thread was often incorporated into the raised design.

Calico An Indian cotton cloth named after a city on the coast of Malabar. In the late sixteenth century, the cloth was imported from Calcutta and was sometimes woven with colored stripes or checks, painted or printed. In the U.S. the term denotes a cotton printed with small patterns, while in Britain it is now used for plain white, unprinted cotton cloth.

Cambric A fine linen fabric from Cambray in Flanders. The term now describes a fine linen or cotton, or combination of the two.

Canvaswork Any type of decorative stitching done on canvas, such as tent stitch and bargello stitch. Canvaswork is also known as "needlepoint" and was developed as a method of adapting the designs of woven tapestries for home use as chair backs, seats, and cushions. Threads of silk, wool, and cotton are used.

Chintz The name is derived from the Indian word *chint*, meaning a multi-colored cloth. It was originally a name for painted calico imported from India to Europe. During the eighteenth century, Europeans developed the art of printing on cotton and began to reproduce the earlier Indian designs, and developed new designs based on the current fashions – from classical monuments to Chinese wallpaper. Today the word is usually associated with a high-quality polished cotton print, often floral.

Cretonne An unpolished cotton cloth printed with patterns and once widely used for upholstery and curtainmaking.

Crewelwork Crewel thread is a tightly twisted, multistrand wool yarn, and crewelwork is embroidery using this worsted thread. It was often employed on bed hangings and curtains in the seventeenth and eighteenth centuries, usually in colors on a white background. American crewelwork was similar in design to English, but because wool was not as easy to obtain as it was in England, the patterns were often lighter, leaving more plain ground fabric.

Crochet A form of knitting or lacemaking done with a single hooked needle, using either cotton or wool thread. A variety of patterns is built up from a chain of stitches.

Cutwork Embroidery in which part of the ground fabric has been cut away and the space filled with crosshatched threads to form a lacy design. Until the sixteenth century, cutwork was mainly worked in convents, but it then became popular with all needlewomen. In Elizabethan times, it was widely used on cuffs and collars, chemises, and shifts.

Damask A rich silk fabric woven with elaborate designs in a flat weave. The cloth is therefore reversible. It was originally made in Damascus, from which its name is derived.

1 Eighteenth-century Chinese silk embroidery forms one side of a pillow cover.

2 A section of beaded Berlin woolwork upholstering a stool.

3 Nineteenth-century silk *broiderie de Fez* with a crochet fringe.

4 Contrasting pillows: on the left, a Gambian woven cloth; on the right, wool embroidery.

5 Part of a camel blanket from Rajasthan, lavishly embroidered and decorated with cowrie shells.

6 A faded cotton chintz makes a subtle pillow cover.

7 An antique embroidered silk shawl in rich bright colors is used as a bed cover.

8 Detail of the central medallion of a fine piece of antique linen lace.

9 A venerable old damask is used for a scatter cushion, with a bright chintz throw.

10 A wonderfully fanciful lampshade designed by Sera Hersham Loftus uses silk voile.

11 Antique crochet is pinned up to make a bed valance.

12 A sheer curtain is hung from a thin metal thread using ring clips.

13 Heavy cotton weave checks and stripes are used as simple upholstery materials.

14 An armchair is given plain upholstery as a backdrop for more colorful textiles.

15 A landscape scene painted on canvas and used as a wall hanging.

16 A Turkish velvet embroidered hanging is draped decoratively over a cupboard.

Dhurrie A flat-woven Indian carpet, usually made from cotton and one of the oldest forms of floor covering.

Eyelet embroidery A type of whitework embroidery popular in the nineteenth century in both America and Europe. A pattern of round or oval holes is cut and then overcast with stitching. The technique was often used to decorate babies' clothes, children's clothes, and ladies' nightgowns.

Flat-weave carpet A carpet made by weaving instead of knotting the yarn around a warp to give a pile surface, producing a flat finish.

Flax The plant *(Linum usitatissimum)* cultivated for its textile fiber, from which linen is woven.

Fringe A passementerie design consisting of a narrow band to which are attached threads of silk or cotton, hanging loose or formed into tassels.

Gauze An extremely thin, transparent material woven from silk, linen, or cotton.

Gimp Wire or other stiff cord bound with fine silk and used as a trimming.

Gros point The French name for crossstitch and used from the sixteenth century for decorative embroidery on pieces such as bed valances and seat coverings.

Haik Moroccan shawls woven in silk and cotton, often with hand-knotted fringes.

Hemdira Striped, heavy woolen woven throws from Morocco, with long ties. They are traditionally used as coat shawls and are always in dark and neutral colors.

Hooked rug An American nineteenth-century craft devised as a practical use of scraps of cloth. The rugs were made by looping pieces of cloth close together through a foundation fabric, giving a flat, rounded surface. Although some of the rug designs were original, many others were made on specially printed burlap on which a design was ready stamped in color.

Ikat An African technique of resist-dyeing yarn before it is woven. Several lengths of yarn are tied together at intervals before immersion in the dye.

Jacquard A loom perfected by Monsieur Jacquard and first exhibited at the Paris exhibition of 1801. It made the weaving of shawls and other fashion items infinitely easier and faster, and the technique brought shawl fashion to a wider public. The loom probably reached England in about 1816, creating a similarly large demand for patterned weaves.

Kashmiri Fine shawls designed and woven in the Kashmir district of India since the fifteenth century and becoming fashionable in Europe in the late eighteenth century. The vogue reached a peak after Kashmir came under British rule in 1846. Kashmir, or cashmere, shawls soon began to be manufactured in British weaving centers such as Norwich, Edinburgh, and Paisley.

Kente African woven cloth of silk and cotton; now used as a generic term for woven Asante silk cloths.

Khadi A heavy Indian cotton with a naturally crushed surface texture.

Kilim A flat-weave, pileless rug woven throughout western Asia by the tapestry process. Kilims were traditionally used as floor coverings, to cover benches, and as awnings.

Lace A generic term that includes crochet, knitting, macramé, knotting, and tatting. The most usual types are needlemade lace and bobbin lace, and there are many sub-divisions. One such variation is *point de Venise* – a closely worked type of needle lace that was widely used in the seventeenth century for cravats and delicate accessories.

Lawn A very smooth, fine, sheer type of woven cotton or linen.

Linen A textile woven from the flax plant and used widely since the medieval period for household furnishings, such as sheets and tablecloths, as well as for clothing.

Metal thread work Metal threads have long been used to enhance silk embroidery.

Medieval Opus Anglicanum pieces often featured gold and silver thread. Metal thread embroidery is a surface application, in which the yarn is laid on the fabric or over other stitches and couched into place.

Moquette A textile with a short but thick velvety pile or loop that was widely used in the nineteenth century for carpets and upholstery.

Muslin A plain bleached or unbleached cotton fabric used for backing and pattern-cutting.

Opus Anglicanum A term applied to delicate English embroidery of the late thirteenth and fourteenth centuries, seen at its best in ecclesiastical garments of the period.

Paisley The Scottish town where shawls based on Indian Kashmiri designs were woven in the late eighteenth and nineteenth centuries. It was the first center to use the Jacquard loom for shawl weaving and has given its name to describe the distinctive pattern of curving motifs.

Palampores The word describes painted cotton hangings and bed coverings imported to Europe from India in the seventeenth century, usually with colored designs on a white ground. Extremely popular at the time, the designs – often variations on the Tree of Life as well as exotic flowers and birds – influenced English embroiderers. When palampores had served their first purpose, the most decorative bits were often cut out and applied to a cotton background as the basis for a quilt or cover.

Passementerie The generic term used for trimmings of all descriptions – from gold and silver lace to braid, fringing, tassels, and other trimmings. Originally all passementerie was handmade, and early pieces are of an amazingly high standard and skill.

Patchwork Also known as pieced work, this is the art of stitching shaped pieces of fabric together to form a pattern ground or motif. They can either be applied to a ground fabric, or shaped and pieced together and sewn without a backing. The pieced design can be incorporated with quilting or other stitchery, and historically was sometimes

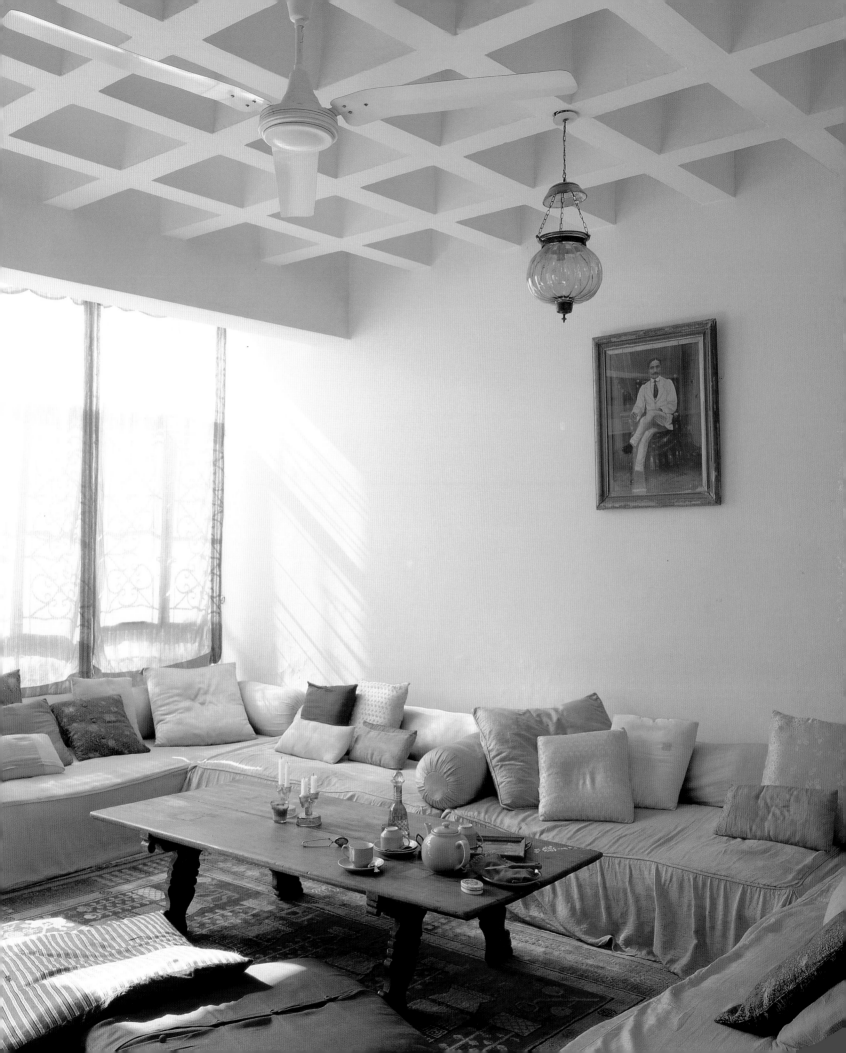

used around a central panel of printed fabric to make a wide border. The patches are usually worked on templates in geometric shapes. In the U.S., of necessity women used every piece in their scrap bags and made blocks of patches to be used for quilts, hence the name block quilts.

Petit point The French term for tent stitch or half crossstitch, this is the most generally used canvas stitch and gives a flat, hard-wearing surface. The small size of the stitch allows a great variation in the design and color toning of the work.

Pile carpet Carpets made with a knotted pile. Short lengths of yarn – wool or silk – are looped or knotted to form a pile standing proud of a vertical warp.

Pintado Originally the term described a number of painted cottons from the East brought to the West by Portuguese explorers. The Portuguese word means painted, colored, or spotted.

Quill work Embroidery worked by Native Americans using bird or porcupine quills dampened and softened and then held in place on the material – leather or birch bark – with hidden stitching or couching. Beads were sometimes added to early quill work, and gradually became the most popular type of decoration.

Quilting The craft of stitching together two or three layers of material to make coverlets and warm, light clothing. From being a basic, practical craft, it developed into a fine art, with the quality and pattern of the stitching becoming all important. Specific patterns developed, such as Ocean Wave and True Lovers' Knot. Quilts were often further embellished with embroidery, appliqué, or patchwork.

Raffia A palm tree (*Raphia ruffia*) native to Madagascar. Grasslike fibers are stripped from the long leaves to be woven into a textile, often used to weave baskets and hats. The fiber is often dyed before weaving.

Sampler Originally a narrow strip of fabric – usually linen – on which were worked designs and stitches, and embroidered border designs, usually including the letters of the alphabet. It was used both as a demonstration of skill and a source of

inspiration for future embroideries. Later samplers were often worked on canvas.

Satin Silk fabric with a glossy surface, describing the form of the weave. The term is also used as a name for other textiles with a similarly shiny surface.

Savonnerie The term is applied generically to French hand-knotted carpets, but derives from the fine carpet manufactory established in France in 1626. In 1826 it transferred to the Gobelins, where work continues today.

Taffeta A silk or imitation silk cloth with a crispness and distinct luster.

Tambour work Embroidery worked with a hook on a tambour frame. The frame is a circular, drumlike structure consisting of one hoop inside another, across which the fabric is stretched.

Tapestry A woven textile, usually large, with a design often based on a painting and depicting a scene – historical, legendary, or military. The fabric is woven by using colored weft threads over and under the warps to make the design. The art flourished from the

Middle Ages and tapestries were symbols of prestige as well as objects of practicality. The fineness of a tapestry was judged by the number of wefts that were contained within each inch of the work.

Toile de Jouy Now the generic name given to one-color prints with scenic figures, but originally the cotton textiles designed and printed at Jouy, near Versailles, in a factory founded by Christophe-Philippe Oberkampf in the seventeenth century.

Turkey work An early type of colonial American needlework that gave the appearance of hand-knotted pile and was used for chair seats, tablecloths, carpets, and small rugs.

Twill A method of weaving that results in a fabric with a distinctive pattern of parallel diagonal ridges.

Velvet A silk (or sometimes cotton) weave with an exceptionally thick and dense short pile. First woven in the East, it was introduced into Europe in the Middle Ages and has always been associated with luxurious garments and furnishings.

Verdure A style of tapestry design depicting, for the most part, verdant landscapes with a dominance of green plants and trees. *Verdures* were particularly popular for large-scale interior decoration.

Whitework A general term covering all the styles of embroidery done by using white thread and stitches on white fabric, including cutwork and drawn-thread work. Occasionally, during the Middle Ages, laws were introduced banning the use of color and rich threads in embroidery. During these periods, needlewomen concentrated on producing fine white embroidery. Without the distraction of color, the work had to be very skillful.

Worsted A wool fabric made from twisted yarn that makes the fibers parallel and therefore particularly smooth.

1 Another eighteenth-century Chinese dragon breathes heavy embroidered fire.

2 A bright wool crewelwork hanging is used as a chair throw.

3 Subtle braiding transforms a plain textile.

4 A pillow cover woven from the ribbons used to wrap cigars.

5 A dining-room chair seat is upholstered with North American appliqué.

6 A detail of a twentieth-century Native American quilt in the Seven Sisters pattern.

7 Very fine French antique needlework that almost looks woven.

8 A scrap of nineteenth-century red and white woven fabric is used to make a pillow's central motif.

9 Beautifully faded printed floral cotton is used as curtain material.

10 Books covered with fabrics and wallpapers by Nathalie Hambro.

11 Lavish antique curtain silk folds back on itself to form a distinctive draped valance.

12 A striking Eastern weave used as a wall hanging.

13 Rich French damasks teamed with simple striped cottons.

14 A heavy, woven upholstery textile is finished with thick coordinating braid.

15 An arrangement of pillows in contrasting textures, including plain linen and sheepskin.

16 A theatrical tassel is wrapped around a plain curtain to make a bold statement.

directory of sources

(Telephone numbers include area codes in parentheses but omit national codes.)

Shops and Dealers
with antique and unusual contemporary textiles

United Kingdom

Peter Adler
191 Sussex Gardens
London W2 2RH
(020) 7262 1775
(by appointment only)
African and Oceanic

Annie's Vintage Costume and Textiles
10 Camden Passage
London N1 8EG
(020) 7359 0796

Anta Scotland Fearn
Tain
Ross-shire IV20 1XW
(016862) 832 477
Tartans and plaids

Canal
42 Cross Street
London N1 2BA
(020) 7704 0222
Indian and Turkish

Carden & Cunietti
83 Westbourne Park Road
London W2 5QH
(020) 7229 8559
Contemporary textiles

Chelsea Textiles
7 Walton Street
London SW3 2JD
(020) 7584 0111
Crewelwork, needlepoint, embroidery from documents

Wendy Cushing Designs
Unit G7
Chelsea Harbour Design Centre
Chelsea Harbour
London SW10 OXE
(020) 7351 5792
Contemporary trimmings

Decorative Textiles of Cheltenham
7 Suffolk Parade
Cheltenham
Gloucs GL50 2AB
(01242) 574 546
Eighteenth- to twentieth-century textiles, tapestry, trimmings

Nicole Fabre
592 King's Road
London SW6 2DX
(020) 7384 3112
Eighteenth- and nineteenth-century French textiles, including toile

Esther Fitzgerald
28 Church Row
London NW3 6UP
(020) 7431 3076
(by appointment only)
Pre-Columbian, Indonesian, Chinese, Central Asian

Gainsborough Silk Weaving Co.
Alexandra Road
Sudbury
Suffolk CO10 6XH
(01787) 372 081
Hand-woven silk from documents

Marilyn Garrow
6 The Broadway
White Hart Lane
London SW13 ONY
(020) 8392 1655
Antique European and Eastern

Joss Graham Oriental Textiles
10 Eccelston Street
London SW1W 9LT
(020) 730 4370
Central Asian, African; kilims, grain sacks, saddle bags

Graham and Green
4 Elgin Crescent
London W11 2JA
(020) 7727 4594
Crewelwork

Judy Greenwood Antiques
657 Fulham Road
London SW6 5PY
(020) 7736 6037
French textiles, English quilts

Linda Gumb
9 Camden Passage
London N1 8EA
(020) 7354 1184
Seventeenth- and eighteenth-century textiles

Gurr and Sprake
283 Lillie Road
London SW6 7LL
(020) 7736 4638
Antique linen sheets

Jen Jones
Pontbrendu, Llanbydder
Ceredigion
Wales SA40 9UJ
(01570) 480 610
Antique quilts, blankets, linen and cotton sheets

Cath Kidston
8 Clarendon Cross
London W11 4AP
(020) 7221 4000
Old English and Welsh blankets and quilts

The Lacquer Chest
75 Kensington Church Street
London W8 4BG
(020) 7937 1306
Quilts and decorative textiles; some linen and lampshades

Marcos & Trump
146 Columbia Road
London E2 7RG
(020) 7739 9008
African mud and cuba cloths

Marcuson & Hall
1 Roman Way
London N7 8XG
(020) 7700 5193
Antique Indian, Islamic, European; Japanese and Chinese

Andrew Martin
200 Walton Street
London SW3 2LJ
(020) 7581 9163
Antique oriental textiles

Minh Mang
182 Battersea Park Road
London SW11 4ND
(020) 7498 3233
Vietnamese and Cambodian silk and embroidery

The Modern Saree Centre
26-28 Brick Lane
London E1 6RF
(020) 7247 4040
Wide range of sari fabrics

Pavilion Textiles
Freshford Hall
Freshford
Bath BA3 6EJ
(01225) 722 522
Domestic linen, French ticking, bed hangings, curtains

V V Rouleaux
54 Sloane Square
London SW1 8AX
(020) 7730 3125
Ribbons; trimmings, including beads and flowers

Dyala Salam Antiques
174a Kensington Church Street
London W8 4DP
(020) 7229 4045
Turkish, Moroccan, Syrian and Central Asian

Silvan
21 Blandford Street
London W1H 3AD
(020) 7486 5883
Lace trimmings; gold and silver lace

Tana Mana
150-152 Stoke Newington
 Church Street
London N16 OUJ
(020) 7249 5656
Contemporary Indian; hand-weaves from Nagaland

Warris Vianni
85 Golborne Road
London W10 5NL
(020) 8964 0069
Indian and Thai fabrics

United States of America

The Antique Textile Gallery
PO Box 237196
New York
NY 10023
(212) 787 0090
French, paisley, Kashmiri antique shawls

Common Ground Inc.
113 West 10th Street
New York
(212) 989 4178
Native American weaves and textiles

Conlon Siegal Galleries
702 1/2 Canyon Road
Gypsy Alley
Santa Fe
New Mexico 87501
(505) 820 7744
Peruvian, Bolivian, pre-Columbian, Indonesian, African

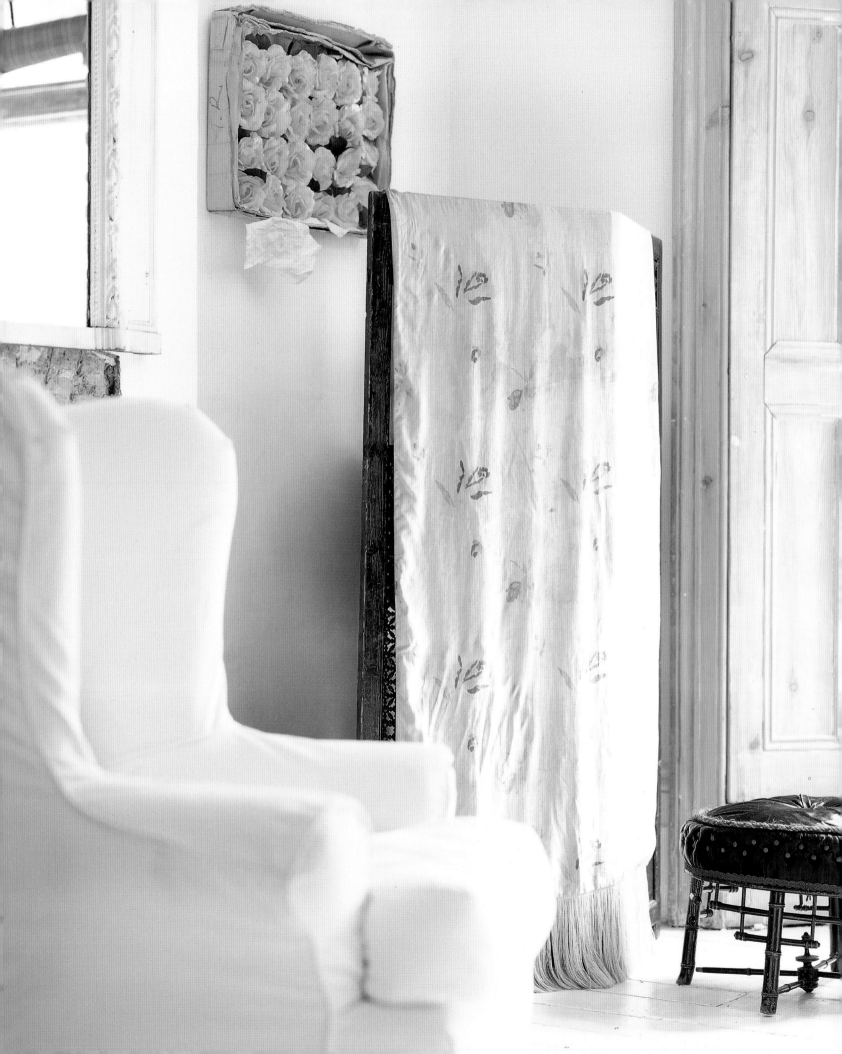

Peter Davies
125 Cedar Street
Penhouse
New York
NY 10006
(212) 732 0273
Middle Eastern kilims, bags; flatweaves

The Drawing Room
152-154 Spring Street
Newport
Rhode Island 02840
(401) 841 5061
Antique damask, tapestry, curtains

Michael Fitzsimmons Decorative Arts
311 W. Superior Street
Chicago
Illinois 60610
(312) 787 0496
Arts and Crafts textiles

Vito Giallo
222 East 83rd Street
New York
NY 10028
(212) 288 4672
(by appointment only)
Antique shawls

Kelter/Malcé
74 Jane Street
New York
(212) 675 7380
(by appointment only)
Native American tapestries, antique quilts, hooked rugs

Marla Mallett: Textiles
1690 Johnson Road NE
Atlanta
GA 30306
(404) 872 3356
Oriental rugs, embroidery; ikats, batiks; Bolivian and Peruvian

Gail Martin
310 Riverside
New York
NY 10024
(212) 864 3550
Pre-Columbian, African, Central Asian

Judith and James Milne
506 East 74th Street
New York
NY 10021
(212) 472 0107
Antique American quilts, hooked and braided rugs

The Old Quilt Warehouse
701 East 2nd Street
Wichita, Kansas
KS67202
(800) 562 5694
Antique American quilts

Paula Rubinstein
65 Prince Street
New York, NY 10012
(212) 966 8954
American quilts and blankets

Australia

Eastern Flair
319-321 King Street
Newtown
NSW 2042
(02) 9565 1499

Kashgar
451 King Street
Newtown
NSW 2042
(02) 9550 6666

Nomadic Rugs Traders
125 Harris Street
Pyrmont
NSW 2009
(02) 9660 3753

Sanshi
115 Palmerston Street
Mosman Park
WA 6012
(08) 9384 8244
Japanese fabrics

Silk Trader
237 High Street, Prahran
VIC 3181
(03) 9525 0855
Thai silk

France

La Boutique des Jardins
Boulevard Mirabeau
13210 St Remy de Provence
(4) 90 92 11 60
Textiles by Agathe Gérin

Galerie Blondeel Deroyan
11 rue de Lille
75007 Paris
(1) 49 27 96 22
Antique European tapestries

Françoise Dorget
Caravanne
6 rue Farée
75004 Paris
(1) 44 61 02 20
Eastern textiles

Simone and Rejis Dumont
10 Cour Cancadis
34410 Sauvian
Antique linens

Linum
(4) 90 38 37 38
Swedish textiles

Christine and Denis Nossereau
7 Avenue des Quatres Otages
Isle sur la Sorgue

Catherine and Michel Biehn
Espace Bechard
1 Avenue Jean Charmasson
Isle sur la Sorgue

Interior Designers
with a particular interest in textiles

Abraham and Thakore Limited
D351 Defence Colony
New Delhi 110024
India
(11) 699 3714

Alidad
The Lighthouse
Gasworks
2 Michael Road
London SW6 2AD
(020) 7384 0121

Anna Bonde
Bel-Air
84220 Goult, France

Nishma Chandé (London)
(020) 7586 1169

Jacqueline Coumans
Le Décor Français
1006 Lexington Avenue
New York, NY 10021
(212) 734 0032

Drysdale Inc.
1733 Connecticut Avenue North West
Washington DC 20009
(202) 588 0700

Stephen Fakke (South Africa)
(11) 327 6725/5368

Olivier Gagnère & Associés
47 boulevard Saint-Jacques
75014 Paris
(1) 45 80 79 67

François Gilles
Unit 28C1, Thames House
140 Battersea Park Road
London SW11 4NY
(020) 7622 3009

Christophe Gollut
116 Fulham Road
London SW3 6HU
(020) 7370 4021

Mariette Gomez
504/506 East 74th Street
New York
NY 10021
(212) 288 6856

Nathalie Hambro (London)
(020) 7834 1021

Sera Hersham-Loftus (London)
(020) 7286 5948

Lynn von Kersting
Indigo Seas
123 North Robertson Boulevard
Los Angeles
California 90048
(310) 550 8758

Robert Kime (England)
PO Box 454
Marlborough
Wiltshire SN8 3UR
(01264) 731 268

Baldassare La Rizza
21 Collingham Place
London SW5 0QF
(020) 7373 3660

Michael Trapp
7 River Road
Box 67
West Cornwall
Connecticut 06796
(860) 672 6098

index

acknowledgments

The author and publisher would like to thank the following for allowing photography in their homes: David Abraham; Peter Adler; Laurence Ambrose; Anna Bonde; Jacqueline Coumans; Eleanora Cunietti; Mary Drysdale; Francesca Findlater; Olivier Gagnère; Agathe Gérin; Vito Giallo; Christophe Gollut; Mariette Gomez; Nigel Greenwood; Linda Gumb; Nathalie Hambro; Lynn von Kersting; Bob & Pam Levin; Sera Hersham Loftus; Baldassare La Rizza; Anna Strasberg; Rakesh Thakore; Michael Trapp.

The work of the following designers can be seen on the pages listed.

Abraham & Thakore: 4-5, 8-9, 58, 125, 134 right, 139 above left, 143, 152-3, 169 center.

Peter Adler's house in London: 78-9, 168.

Laurence Ambrose's house in Provence: 44-5, 124 below right, 149, 170 above left.

Anna Bonde's house in Provence: 13 center and right, 14-15, 24-7, 40 left and center, 50-1, 62, 66, 70, 108 right, 146, 167 below.

Jacqueline Coumans' apartment in New York (with textiles from Le Décor Français): 93 left, 97, 98 below, 106 below left, 132.

Eleanora Cunietti of Carden & Cunietti's home in London (with fabrics from Kirsten Hecktermann): 59, 105, 109, 170 above right; 104 fabrics from India.

Mary Drysdale's house in Pennsylvania: 12 right, 20-3, 64-5, 112 above, 114 center, 115 center, 140-1, 156-7.

Francesca Findlater's house in London (with fabrics from Minh Mang): 36 left, 52-3, 56 below.

Olivier Gagnère's apartment in Paris: 82 left, 110-11, 113, 128-9, 138 right, 160 above.

Agathe Gérin's apartment in New Delhi: 36 right, 38-9, 60-1, 71, 114 left, 116-17, 120-1, 124 above right, 164 above and center, 173 below left and right.

Vito Giallo's apartment in New York: 68, 80 above right and below right, 134 left, 136, 137 left.

Christophe Gollut's house in Gran Canaria: 11, 12 left and center, 16-19, 37 right, 56 above, 63, 67, 82 above right, 84 above left, 86 right, 87 right, 89, 94, 98 above, 99 above, 100-01, 114 right, 135, 144-5, 147, 150 above, 151, 153 above, 154 right, 160 below, 160-1, 166 right.

Mariette Gomez's apartment: 148, 150 below, 164-5, 175 below.

Nigel Greenwood's apartment in London: 6, 74, 82 below right, 115 right, 118-19, 124 left, 167 below left, 173 above left.

Linda Gumb's house in London: 84-5, 106 below right, 108 left, 116 right.

Nathalie Hambro's apartment in London: 10, 13 left, 28-31, 77 center, 137 center and right, 167 above, 174, 175 above.

Sera Hersham Loftus' house in London: 1-3, 33-5, 41-3, 46, 48-9, 50-1, 80 left, 139 above right, 162 above left, 172.

Lynn von Kersting: 37 left and center, 40 right, 43, 56-7, 69, 72-3, 75, 77 right, 81, 83, 85, 86 left, 90-1, 95, 96, 100, 102-03, 104 above left and below left, 107, 110 left and right, 115 left, 123 above left, 138 left, 139 below, 150 above right, 153 below, 154 left, 155, 158-9, 162 above right and below, 164 below, 169 left and right, 170-1, 173 center left, 178-9.

Baldassare La Rizza's apartment in London: 36 center, 106 above, 112 below, 133 and 163.

Michael Trapp's house in Connecticut: 7, 47, 88, 92, 93 right, 122, 123 above right and below, 126-7, 130-1 and 142.

Author's acknowledgments

One of the supplementary pleasures of authorship is how much one learns in the process of writing. *TextileStyle* is a case in point. I had long appreciated from a distance the beauty of textiles – old and new – but it wasn't until I came to research the subject in depth that I realized for the first time the amount of inspiration, thought, and skill that goes into every tiny piece of stitched, woven, and printed material. I took to looking closely at everything we were going to photograph, amazed at the intricacy of the design and complexity of the coloring.

Making the book look as good as it does was a concerted team effort, and I cannot thank enough Jacqui Small for generally being calm, Judy Spours for always being calm, Andrew Wood for seeing the point, Nadine Bazar for getting us to the point, and Maggie Town for visualizing all the points.

I would also like to thank, very much, all the designers, decorators, and gifted people who allowed us to photograph the ingenious and imaginative ways in which they use their textile collections.